## Acknowledgements

Among the many people who helped make this book possible,
we wish to express our gratitude to the following:

The staff and students of RMIT University, Melbourne, for their support,
friendship and illustrative input.

To our respective families:

       Dorothy, Matthew and Teagan;
       Sue, Nikki, Cameron and Dannika;

for their love, endless support and ceaseless understanding, under the
pressure of our long absences.

## Picture Credits

reinput
18/7/03

778.3
GAL

essential skills

# digital
## imaging

second edition

mark galer

les horvat

**Focal Press**

OXFORD  AMSTERDAM  BOSTON  LONDON  NEW YORK  PARIS
SAN DIEGO  SAN FRANCISCO  SINGAPORE  SYDNEY  TOKYO

Focal Press
An imprint of Elsevier Science
Linacre House, Jordan Hill, Oxford OX2 8DP
200 Wheeler Road, Burlington MA 01803

First published 2001
Reprinted 2002
Second edition 2003

**British Library Cataloguing in Publication Data**
A catalogue record for this book is available from the British Library

**Library of Congress Cataloguing in Publication Data**
A catalogue record for this book is available from the Library of Congress

ISBN   0 240 51913 2

For more information on all Focal Press publications
visit our website at: www.focalpress.com

Printed and bound in Italy

# Contents

# Introduction

Digital Imaging is revolutionising photography. Most of what we now see in print has been created using digital technologies. Digital involvement extends from at one level, a basic retouching of news images, to the highly manipulated and preconceived photographic montages that are commonly used by the advertising industry. This book is intended for students of photography and design who wish to use the 'digital darkroom' rather than the traditional darkroom for creative illustration. The information, activities and assignments contained within provide the essential skills necessary. The subject guides offer a comprehensive and highly structured learning approach, giving support and guidance to both students and teachers. An emphasis on useful (essential) practical advice and activities maximises the opportunities for creative image production.

*Paul Allister*

## Acquisition of skills

The first half of the book concentrates on a basic understanding of the essential principles of digital imaging. Emphasis is placed on the essential techniques and skills required for high quality digital capture and production. The book builds student competence to deal with potentially confusing areas such as resolution and the control over tonality and colour. Adobe Photoshop Versions 5.0 through to 7 are primarily referred to as these now dominate the commercial industry.

**However, this is not a Photoshop manual**. The guides focus on the entire imaging chain from capture to print. Terminology is kept as simple as possible using only those terms in common usage by practising professionals. Nor is this book platform specific - palettes from both PC and Mac versions of Photoshop have been used extensively throughout.

## Application of skills

The second half of the book is devoted to a practical application of the digital skills and concepts addressed in the first half. Retouching is covered initially, to introduce some basic working practices and to enable students to optimise the quality of their later creative illustration. This is followed by a guide on essential practical montage skills and concludes with guides on digital manipulation and preparing images for the World Wide Web. Creative assignments are undertaken in each of the practical guides to allow students to express themselves and their ideas through the appropriate application of design and technique.

# Introduction to teachers

This book is intended as an introduction to digital imaging for full-time students of photography and/or design. The emphasis has been placed upon a practical approach to the subject and the application of the essential skills. The activities and assignments cover a broad range but avoid the need for the students to use large amounts of expensive equipment. The image editing software Adobe Photoshop is referred to throughout the book, as it is the industry standard and all information is compatible with Versions 5.0 to 7. The budget priced LE version is often shipped with the better quality scanners and contains many of the features of version 5.

## A structured learning approach

The photographic study guides contained in this book offer a structured learning approach that will give students a framework for the techniques of digital imaging as well as the essential skills for personal creativity and communication. The study guides are intended as an independent learning resource to help build these skills. The students are encouraged to research digital imaging both in the art world and the commercial world before attempting the creative assignments in the later study guides. This research should be kept in the form of a '**visual diary**'.

## Flexibility and motivation

The creative assignments contain a degree of flexibility, often giving students the choice of subject matter. This allows the student to pursue individual interests whilst still directing their work towards addressing specific criteria. This approach gives the student maximum opportunity to develop self-motivation. It is envisaged that teaching staff will introduce each assignment and negotiate the suitability of subject matter with the students. Individual student progress should be monitored through group meetings and personal tutorials. **Students should be encouraged to demonstrate the skills which they have learnt in preceding study guides whenever appropriate.**

## Implementation of the curriculum

The curriculum contained in this book will engage students in digital imaging practice for approximately 4-6 hours per week for two full academic years. The curriculum contained in this book can be combined with "Location Photography" and "Studio Photography" (also available in the series) to constitute a broad practical curriculum for a photography student.

## Web site

A dedicated web site has been set up to assist teachers with their usage of the book. Images from the text, available for download, are included on the site as are numerous links and up to date advice and references about digital imaging issues. The Internet address for the web site is: **www.photoeducationbooks.com**

# Introduction to students

The study guides that you will be undertaking within this course are designed to help you learn both the technical and creative aspects of digital imaging. The activities and revision exercises in the early study guides provide the framework for the creative assignments that follow in the second section. These will build the essential skills required to confidently undertake digital imaging from image capture to print.

## Activities and assignments

By completing all the activities, revision exercises and assignments in the study guides you will gain a full working knowledge of the digital image process. The guides will also address many of the key issues which are confusing and often mis-understood by students of digital imaging - and in the process will foster an understanding which will re-inforce and facilitate creative expression. In the assignments you will be given the freedom to express yourself visually and display the skills that you have learnt in the preceding study guides. Digital imaging is a process that can be learnt as a series of steps. Once you apply this knowledge to new assignments you will learn how to extend the creative possibilities above and beyond that which can be created using older analogue technologies. The information and experience you gain will provide a rich framework for all of your future imaging needs.

## Using the study guides

The study guides have been designed to offer you support during your digital imaging work. On the first page of each study guide is a list of aims and objectives laying out the skills covered and how they can be achieved. The activities are to be started only after you have first read and understood the supporting section on the preceding pages. If at any time you feel unclear about what is being asked of you, consult your teacher. At the end of each section is a revision test which should be tackled to determine the extent to which the information has been assimilated. Only after completion of the relevant activities and revision should the assignments be undertaken.

## The skills

To acquire the essential skills to communicate effectively and creatively takes time and motivation. Those skills should be practised repeatedly so that they become practical working knowledge rather than just basic understanding. Become familiar with the skills introduced in one study guide and apply them to each of the following guides wherever appropriate.

## Web site

A dedicated web site has been set up where it is possible to download images from the text to assist you in the activities within the study guides. In addition you will find useful links as well as up to date information about digital issues. The address for the Internet web site is: **www.photoeducationbooks.com**

# Research and resources

To gain the maximum from each assignment, use the activities contained in the study guides as a starting point for your research and practical work. You will only realise your full creative potential by looking at a variety of images from different sources. Artists and designers find inspiration in many different ways, but most find that they are influenced by other work they have seen and admired. Further, it is essential that the student of any creative endeavour has some understanding of the context within which their art may reside. Researching other relevant artists and practitioners is an essential stepping stone in this process.

## Getting started

If you have been asked to create a digital illustration as part of an assignment start by collecting and photocopying images and techniques that are relevant to the topic. This collection of images will act as a valuable resource for your future work. By taking different elements from these images, e.g. the imaging technique from one and the design from another, in addition to injecting your own ideas, you are not copying somebody else's work but using it as inspiration for your own creative expression. Talking through ideas with other students, friends, members of your family or with a teacher will help you to clarify your thinking, and develop your ideas further.

*The web site associated with this book has images available for download*

## Choosing resources

When you are looking for images that will help with your research, try to be very selective, using only high quality sources. Not all photographs that are printed are necessarily well designed or appropriate to use. Good sources of digital imaging may include high quality magazines and journals, photography and design books, electronically via the web, as well as digital imaging exhibitions. You may have to try many libraries to find appropriate material or borrow used magazines from friends and relatives. In addition, keep an eye on the local press to find out what exhibitions are coming to your local galleries.

# The work process

The structure and nature of your imaging work needs to be fashioned around a number of important principles and approaches.

## Visual diary

This diary is your record of all stimulus that may have influenced you or helped you to form an idea. In its most simplistic form this could be a scrapbook of tear-sheets (examples) and personal scribbles. It would however be of far more value if the visual diary contained detail relating to an awareness of style and context, as well as a development of your ability to critique images intelligently. This should include aspects of design, composition, form and lighting which would be applicable to any of the visual arts.

The visual diary should contain:
~   A collection of work by photographers, artists, writers, poets, songwriters and film-makers, relevant to your imaging studies.
~   Sketches of ideas for images.
~   A collection of images that illustrate specific techniques relevant to your work.
~   Brief written notes supporting and expanding upon each entry in the diary.

## Research

~   For each assignment provide evidence in your visual diary of how you developed your ideas and perfected the techniques you have been using. This should be presented neatly, in an organised way so that anyone assessing your work can easily see the creative and technical development of the finished piece.
~   Make brief comments about images that you have been looking at and how they have been of influence. Photocopy these and include them with your research.

## Presentation

Presentation of work can influence your final mark.
~   Ensure that all of your digital images are cropped neatly and do not display unwanted edge pixels.
~   Ensure that horizontal and/or vertical elements are corrected if this is appropriate (sloping horizon lines are visually unnerving to look at).
~   Mount all printed work neatly and label appropriately.

## Storage

It is best to standardise your final portfolio so that it has an overall 'look' and style.
~   Assignments should be kept in a folder slightly larger than your mounted work.
~   Film should be stored in file sheets, in a dust and moisture-free environment.
~   Digital files should be either burned to a CD or saved to a removable disk and stored away from magnetic devices that could corrupt the data.

# Essential information

The basic equipment required to complete this course is access to a computer with Adobe Photoshop Version 5, 6 or 7. Photoshop LE is a budget version of the software and comes shipped (supplied at no extra cost) with many film scanners and some higher quality flatbed scanners. It is also available from software suppliers at a greatly reduced price to the full version. LE stands for Limited Edition as many features that are essential to commercial image editing are missing from this version. The photographic and design industries predominantly use Apple Macintosh computers but many colleges choose IBM compatible PCs as a more cost effective alternative. When Photoshop is open there are minor differences in the interface, but all of the features and tools are identical. It is possible to use this book with either IBM compatible PCs or Apple Macintosh computers.

## Storage

Due to the large file sizes involved with digital imaging it is advisable that you have a high capacity, removable storage device such as a 'Zip' drive attached to the computer (see Platforms and output devices). It is advisable to use these removable disks as back-up or storage devices only - to ensure optimum performance always move the image file to a folder on the desktop or the hard drive before opening it in Photoshop.
Avoid bringing magnetic disks such as Zip disks into close contact with other magnetic devices such as can be found in mobile phones and portable music players - or even the speakers attached to your computer.

## Commands

Computer commands which allow the user to modify digital files can be accessed via menus and sub-menus. The commands used in the study guides are listed as a hierarchy, with the main menu indicated first and the submenu or command second, e.g. Main menu > Command or Submenu > Command. For example the command for opening the Image Size dialogue box would be indicated as follows: Edit > Image Adjustments > Image Size.

## Keyboard shortcuts

Many commands that can be accessed via the menus and submenus can also be accessed via keyboard '**shortcuts**'. A shortcut is the action of pressing two or more keys on the keyboard to carry out a command (rather than clicking a command or option in a menu). Shortcuts speed up digital image processing enormously and it is worth learning the examples given in the study guides. If in doubt use the menu (the shortcut will be indicated next to the command) until you become more familiar with the key combinations.

**Note**. **The keyboard shortcuts indicate both the Mac and PC equivalents.**

**Example**: The shortcut for pasting objects and text in most applications uses the key combination Command/Ctrl + V. The Macintosh requires the Command key (next to the spacebar) and the V key to be pressed in sequence whilst a PC requires the Control key (Ctrl) and the V key to be pressed.

# digital
## basics

digital imaging digital imaging digital imaging digital imaging digital i

*Mark Galer*

digital imaging digital imaging digital imaging digital imaging digital i

## aims ———————————————————————

~ To offer an independent resource of digital imaging theory.
~ To develop an understanding of the theory behind digital image structure.
~ To develop knowledge and understanding about the technical processes and procedures involved with producing a digital print.

## objectives ———————————————————

~ **Display** an understanding of digital imaging theory including:
- image mode
- file format and size
- resolution

# Introduction

The term '**digital photography**' is used to describe images that have been captured by digital cameras or existing photographs that have been scanned to create digital image data. The term also describes the processing of digital image data on computers and the output of '**hard copies**' or digital prints (on paper or plastic) from this data.

Digital photography is now revolutionising not only the process of photography but also the way we view photography as a visual communications medium. This new photographic medium affords the individual greater scope for creative expression, image enhancement and manipulation.

## Digital foundations

This guide is intended only to lay the foundations of practical digital knowledge. The individual may find it beneficial to supplement this information with additional guides specific to the equipment and computer programs being used. The information supplied by these additional guides, although valuable, may quickly become redundant as new equipment and computer programs are released frequently in this period of digital evolution.

*The continuous tone of a subject (no steps in brightness)*

*Ten pixels each with a different tone or level used to describe the above*

## Pixels and levels

A digital image is one in which the image is constructed from '**pixels**' (picture elements) instead of silver halide grains. Pixels are square and positioned in rows horizontally and vertically to form a grid. Each pixel in the grid is the same size and is uniform in colour and brightness, i.e. the tone does not vary from one side of the pixel to the other.

In the illustration above 10 pixels, each with a different tone, are used to describe the '**continuous tone**' above it. Each different tone is called a '**level**' and assigned a numerical value, e.g. 0 to 9.

In a typical digital image there are 256 different levels or separate tones to create a smooth transition from dark to light. If the pixels are sufficiently small when printed out the viewer of the image cannot see the steps in tone thereby giving the illusion of continuous tone.

# File size

Digital images are usually created using a large amount of information or data. This data is required to record the subtle variations in colour and/or tone of the original image or subject. The simple binary language of computers and the visual complexities of a photographic image lead to large '**file sizes**'. This data can require large amounts of computer memory to display, print or store the image. The text file for this book can comfortably fit onto a floppy disk whereas only a small portion of the cover image may be stored on a similar floppy disk.

---

**Units of memory**

| | | |
|---|---|---|
| 8 bits | = | 1 byte |
| 1024 bytes | = | 1 kilobyte |
| 1024 kilobytes | = | 1 megabyte |
| 1024 megabytes | = | 1 gigabyte |

**Storage capacity of disks**

| | | |
|---|---|---|
| Floppy disk | = | 1.4 megabytes |
| Zip disk | = | 100 or 250 megabytes |
| CD | = | 600 - 700 megabytes |
| Jaz drive | = | 1 gigabyte |

---

## Bits, bytes, kilobytes and megabytes

The binary digit or '**bit**' is the basis of the computer's language. One bit is capable of two instructions and can describe a pixel in two tones (0 or 1, black or white). Two bits can give four instructions (00, 11, 01 and 10). 8 bits (sometimes called a '**byte**') can record 256 possible values (2x2x2x2x2x2x2x2) whilst 24 bits can record 16.7 million possible values for each pixel (commonly used to record the data in digital colour images).

There are 1024 bytes in a '**kilobyte**' (KB) and 1024 kilobytes is a '**megabyte**' (MB). The '**digital file**' of the image that is used on the cover of a glossy magazine is likely to exceed 20MB. That is a lot of information to produce one colour image in print. Fortunately files can be '**compressed**' (reduced in memory size) for storage and it is possible to fit a large image file onto a floppy disk. Storing large files on floppy disks, although possible, is not practical. Removable hard drives (such as the inexpensive '**Zip**' drive made by Iomega™) are commonly used for storing and transferring large image files conveniently and quickly.

## Activity 1

Find one digital image file and identify its file size when the image is closed.

Open the same digital image using image editing software and identify its file size when open (go to the 'document sizes' underneath the image window or choose 'Image Size' from the 'Image' menu). It is common for the file size to be larger when the image is open. If this is the case with the image you have opened, image compression is taking place prior to the file being closed.

# Modes and channels

The colour and tonal information of pixels within a digital image can be described using a number of different 'modes', e.g. a black and white image can be captured in '**bitmap**' mode or 'grayscale' mode. In a bitmap image each pixel within the grid is either black or white (no shades of grey). This mode is suitable for scanning line drawings or text. For images that need to be rendered as continuous tone the grayscale mode is used.

## Grayscale
Black and white (continuous tone) photographs are captured or scanned in what is called 'grayscale'. Each pixel of a grayscale image is assigned one of 256 tones or levels from black to white. These 256 levels allow a smooth gradation between light and shade simulating the continuous tone that is achieved with conventional silver-based photography. A grayscale image is sometimes referred to as an '8-bit image' (see 'Bit depth').

| RGB Channels | R | G | B |
|---|---|---|---|
| Red: | 255 | 0 | 0 |
| Green: | 0 | 255 | 0 |
| Blue: | 0 | 0 | 255 |
| Cyan: | 0 | 255 | 255 |
| Magenta: | 255 | 0 | 255 |
| Yellow: | 255 | 255 | 0 |
| Black: | 0 | 0 | 0 |
| White: | 255 | 255 | 255 |
| Mid grey | 127 | 127 | 127 |

Colour

## RGB
A 'full colour' image can be assembled from the three primary colours of light; red, green and blue or 'RGB'. All the colours of the visible spectrum can be created by varying the relative amounts of red, green and blue light. The information for each of the three primary colours in the RGB image is separated into 'channels'. Each channel in an RGB image is usually divided into 256 levels. An RGB colour image with 256 levels per channel has the ability to assign any one of 16.7 million different colours to a single pixel (256 x 256 x 256). Colour images are usually captured or scanned in the RGB 'colour mode' and these colours are the same colours used to view the images on a computer monitor. A colour pixel can be described by the levels of red, green and blue, e.g. a red pixel may have values of Red 255, Green 0 and Blue 0; a yellow pixel may have values of Red 255, Green 255 and Blue 0 (mixing red and green light creates yellow); and a grey pixel may have values of Red 127, Green 127 and Blue 127.

**Note. 'CMYK' is the colour mode used in the printing industry and uses the colours Cyan, Magenta, Yellow and blacK. RGB images should only be converted to CMYK after acquiring specifications from your print service provider.**

# Bit depth

Each pixel of an 8 bit image is described in one of a possible 256 tones or colours. Each pixel of a 24 bit image is described in one of a possible 16.7 million tones or colours. The higher the '**bit depth**' of the image the greater the colour or tonal quality. An 8 bit image (8 bits of data per pixel) is usually sufficient to produce a good quality black and white image, reproducing most of its tonal variations, whilst a 24 bit image (8 bits x 3 channels) is usually required to produce a good quality colour print from a three channel RGB digital file. Images with a higher bit depth require more data or memory to be stored in the image file. Grayscale images are a third of the size of RGB images (same pixel dimensions and print size, but a third of the information or data).

 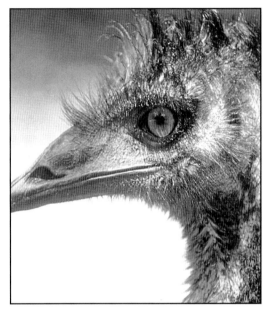

*RGB image, 256 levels per channel (24 bit)*                                    *256 levels (8 bits)*

## Scanning and editing at bit depths exceeding 8 bits per channel

Most scanners now in use scan with a bit depth of 30 bits or more. Although they are capable of discerning between more than 16.7 million colours (therefore increasing the colour fidelity of the file) they usually only pass on 24 bits of the data collected to the editing software.

Higher quality scanners are able to scan at 16 bits per channel (48 bit). In Photoshop it is possible to edit an image using 16 bits per channel instead of 8. Image corrections are usually restricted to colour and tonal adjustments. The file size of the digital image is doubled and the range of editing features is limited. Image editing in this mode is often used by professionals for high quality retouching (see '**Retouching and Image Adjustment > 16 bit editing**').

# Hue, saturation and brightness

It is essential when describing and analysing colour in the digital domain to use the appropriate terminology. The terminology most frequently used belongs to that of human perception. Every colour can be described by its hue, saturation and brightness (HSB). These terms are used to describe the three fundamental characteristics of colour.

~ **Hue** - is the name of the colour, e.g. red, orange or blue. All colours can be assigned a location and a number (a degree between 0 and 360) on the standard colour wheel.

~ **Saturation** - is the purity or strength of a colour, e.g. if red is mixed with grey it is still red, but less saturated. All colours and tones can be assigned a saturation value from 0% saturated (grey) to 100% saturated (fully saturated). Saturation increases as the colour moves from the centre to the edge on the standard colour wheel.

~ **Brightness** - is the relative lightness or darkness of the colour. All colours and tones can be assigned a brightness value between 0% (black) to 100% (white).

*B. RGB sliders and RGB colour values*

*C. Colour ramp for quick colour choice*

*D. Eyedropper for sampling colour*

*E. Foreground swatch*

*A. Hue, saturation and brightness control*

## Creating and sampling colour

Different colours can be created by mixing the '**primary colours**' (red, green, and blue) in varying proportions and intensity. When two primary colours are mixed they create a '**secondary colour**' (cyan, magenta or yellow). The primary (RGB) and secondary (CMY) colours are complementary colours. Two primary colours combined create a secondary colour and two secondary colours combined create a primary.

Colour in a digital image can be sampled by selecting the eyedropper tool in the tools palette. Move the tool over the colour to be sampled and click the mouse. The colour will appear in the foreground swatch in the tools palette and the foreground swatch in the colour palette. Double clicking the foreground swatch in the tools palette will bring up the full colour information in the 'color picker'.

# Colour and light

## Additive colour

The additive primary colours of light are Red, Green and Blue or RGB. Mixing any two of these primary colours creates one of the three secondary colours Magenta, Cyan or Yellow.

**Note. Mixing all three primary colours of light in equal proportions creates white light.**

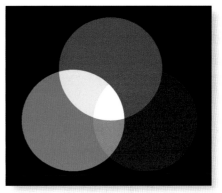

*RGB - additive colour*

## Subtractive colour

The three subtractive secondary colours of light are Cyan, Magenta and Yellow or CMY. Mixing any two of these secondary colours creates one of the three primary colours Red, Green or Blue. Mixing all three secondary colours of light in equal proportions creates black or an absence of light.

## Activity 2

Open the files RGB.jpg and CMYK.jpg from the supporting web site and look at the channels to see how they were created using PhotoShop. Use the information palette to measure the colour values.

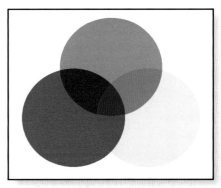

*CMY - subtractive colour*

## Hue, saturation and brightness

Although most of the digital images are captured in RGB it is sometimes a difficult or awkward colour model for some aspects of colour editing. PhotoShop allows the colour information of a digital image to be edited using the HSB model.
Hue, Saturation and Brightness or HSB is an alternative model for image editing which allows the user to edit either the hue, saturation or brightness independently of the other two.

## Activity 3

Open the image Hue.jpg, Saturation.jpg and Brightness.jpg. Use the color picker to analyse the colour values of each bar.

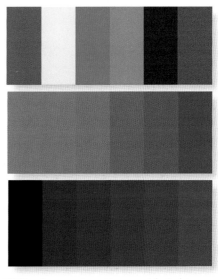

*HSB - hue, saturation and brightness*

## Colour perception

Our perception of colour changes and is dependent on many factors. We perceive colour differently when viewing conditions change. Depending on the tones that surround the tone we are assessing, we may see it darker or lighter. Our perception of a particular hue is also dependent on both the lighting conditions and the colours or tones that are adjacent to the colour we are assessing.

## Activity 4

Evaluate the tones and colours in the image opposite. Describe the grey squares at the top of the image in terms of tonality. Describe the red bars at the bottom of the image in terms of hue, saturation and brightness.

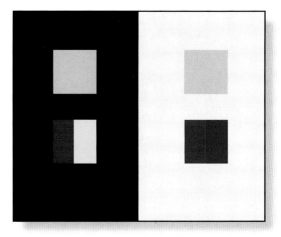

*Colour perception*

## Colour gamut

Colour gamut varies, depending on the quality of paper and colourants used (inks, toners and dyes etc.). Printed images have a smaller colour gamut than transparency film or monitors and this needs to be considered when printing. In the image opposite the out of gamut colours are masked by a grey tone. These colours are not able to be printed using the default photoshop CMYK inks.

*Out of gamut colours*

## Colour management issues

The issue of obtaining consistent colour - from original, to its display on a monitor, through to its reproduction in print - is considerable (see 'Colour Management' chapter). The variety of devices and materials used to capture, display and reproduce colour in print all have a profound effect on the end result. The image at right is used to discuss colour spaces in the 'Managed Workflows' chapter.

*Activity 3 logo, Managed Workflows*

## Activity 5

1. Set the palettes in Photoshop to their default setting - Window > Reset Palette Locations (Photoshop 6 - 7) or File > Preferences > General > Reset Color Palettes to Default (Photoshop 5). Open a colour digital image file.

 2. Double-click the hand tool in the tools palette to resize the image to fit the monitor.

 3. Click on the '**zoom tool**' in the tools palette to select the tool (double clicking the zoom tool in the tools palette will set the image at 100% magnification).

4. Click on an area within the image window containing detail that you wish to magnify.
Keep clicking to increase the magnification (note the current magnification both in the title bar of the image window and in the bottom left hand corner of the image window.

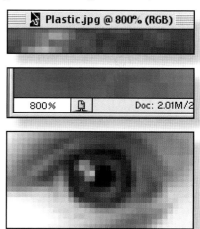

At a magnification of 400% you should be able to see the pixel structure of the image. Increase the magnification to 1200% (to decrease the magnification you should click the image with the zoom tool whist holding down the Option/ Alt key on the keyboard).

 5. Click on the hand in the tools palette and then drag inside the image window to move the image to an area of interest (pixel variety).

 6. Click on the eyedropper in the tools palette to access the information about a single pixel.

7. Click on different coloured pixels within your magnified image.

8. View the colour information in the colour palette (note how the colour of the selected pixel is also displayed in the foreground swatch in the tools palette).

9. The colour information is displayed as numerical values in the red, green and blue channels. These values can be altered either by moving the sliders underneath the ramps or by typing a new value into the box beside the ramp.
Drag the sliders or type in different numbers to create your own colours.

# File formats

When an image is captured by a camera or scanning device it has to be '**saved**' or memorised in a '**file format**'. If the binary information is seen as the communication, the file format can be likened to the language or vehicle for this communication. The information can only be read and understood if the software recognises the format. Images can be stored in numerous different formats. The three dominant formats in most common usage are:

~    JPEG (.jpg) - Joint Photographic Experts Group
~    TIFF (.tif) - Tagged Image File Format
~    Photoshop (.psd) - Photoshop Document

**JPEG** - Industry standard for compressing continuous tone photographic images destined for the world wide web (www) or for storage when space is limited. JPEG compression uses a 'lossy compression' (image data and quality is sacrificed for smaller file sizes when the image files are closed). The user is able to control the amount of compression. A high level of compression leads to a lower quality image and a smaller file size. A low level of compression results in a higher quality image but a larger file size. It is recommended that you only use the JPEG file format after you have completed your image editing.

*A close-up detail of an image file that has been compressed using maximum image quality in the JPEG options box.*    *A close-up detail of an image file that has been compressed using low image quality in the JPEG options box. Notice the artifacts that appear as blocks.*

**TIFF** - Industry standard for images destined for publishing (magazines and books etc.). Tiff uses a 'lossless' compression (no loss of image data or quality) called '**LZW compression**'. Although preserving the quality of the image, LZW compression is only capable of compressing images a small amount.

**Photoshop** - A default format used by the most popular image processing software. An image that is composed of 'layers' may be saved as a Photoshop document. A Photoshop document is usually kept as the master file from which all other files are produced depending on the requirements of the output device.

# Resolution

Digital images are constructed from square picture elements or '**pixels**'. Increasing the total number of pixels in an image at the scanning or capture stage increases both the quality of the image and its file size.

It is '**resolution**' that determines how large or small the pixels appear in the final printed image. The greater the resolution the smaller the pixels and the greater the apparent sharpness of the image. Resolution is stated in '**pixels per inch**' or '**ppi**'.

**Note. With the USA dominating digital photography, measurements in inches rather than centimetres are commonly used. 1 inch equals exactly 2.54 centimetres.**

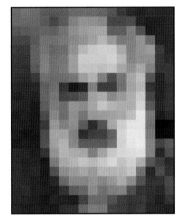

*10 pixels per inch*          *20 pixels per inch*

**Example:** If a 1 inch square postage stamp is scanned at 10 ppi the digital image will have a total of 100 pixels (10 x 10 = 100). If the image is displayed '**same size**' as the original the output resolution will be stated as 10 ppi and each pixel will measure 1/10 of an inch. If the same stamp is scanned at 20 ppi the image will now have 400 pixels (20 x 20 = 400). If displayed or printed 'same size' each pixel will now only be 1/20 of an inch.

Increasing the resolution will increase the quality of the image until it is limited by the output device. If the resolution exceeds that required by the printer to produce optimum quality the extra resolution is wasted (see '**Output resolution**').

Resolution can be confusing. Understand this now to avoid getting confused later. Resolution is essential to understand the quality of a digital image. Quality is defined by the resolution at the scanning stage (obtaining the optimum number of pixels) and the printing stage (reproducing the pixels at the optimum size for the print output device).

## Image size

A digital image can be quantified in the following ways:

~    Pixel dimensions and file size (e.g. 800 x 600)
~    Output resolution (e.g. 200 ppi or pixels per inch)
~    Output dimensions (e.g. 6 x 4 inches)
~    Colour or bit depth (e.g. 24 bit)

## Pixel dimensions

At the scanning or capture stage of the process the digital image is allocated a number of pixels or picture elements that describe the image or subject, e.g. if your scanner is set to scan at 100 ppi and the image that you are scanning is 4 x 6 inches in size the resulting file will measure 400 x 600 pixels. These pixels are arranged in a grid. The width and height of the grid can be measured by the number of pixels allocated to the row. This width and height give the image its pixel dimensions (e.g. 400 x 600). An image with fixed pixel dimensions can be displayed in a variety of different physical sizes from a very small print to a very big poster. A pixel has no fixed size. Pixel size is dependent on output size i.e. pixels grow or shrink in size when you increase or decrease the output size from the same file size, e.g. the pixels of an image printed at 100 ppi are twice as large as an image printed at 200 ppi. As the output resolution decreases the pixels increase in size.

**The pixel size is determined by the output resolution used to create the print.**

When the resolution is sufficiently low the pixels become visible and the print is said to be pixellated. If the resolution is 1 ppi each pixel will measure 1 inch square. Increasing output resolution renders the pixels smaller until finally they are invisible to the human eye. Increasing the resolution beyond the capability of the printer increases the file size and pixel dimensions but not the quality of the print (see 'Output resolution').

*104 pixels wide at 60 ppi*

*104 pixels wide at 30 ppi*

## Changing print size from the same file

Resolution drops as the print size is increased (the pixels are spread further).

Example: A 4 x 5 inch print is scanned at 60 ppi. If this digital image file is enlarged to 8 x 10 inches the resolution will drop to 30 ppi. Both the original size image and the enlargement contain the same number of pixels but the quality of the larger image appears to be lower.

**Note. A resolution of at least 150 ppi is required to prevent pixellation when viewing images in print.**

## Output resolution

Although output is the last step in the digital process it has to be considered first before you capture or scan your image. When scanning or capturing an image it is essential to know how large and on what device you intend to print the image. This information is essential to ensure the maximum possible quality of your final image whilst keeping the file size as small as possible.

If the resolution is too high the handling of the file will be slow. If the resolution or file size is too small the quality of the final image will be low. If the resolution of the file is very low the individual pixels of the image will be visible and the image will be said to be 'pixellated'.

If the intended print is very large, e.g. larger than A2, the resolution may be lowered without an apparent drop in sharpness. Large prints are usually viewed from further away and therefore require a lower output resolution. The important questions prior to scanning are:

~ **What is the final use for the digital image file?**
Scanning resolution depends on what the digital image will be used for, e.g. prints produced from digital files require a much higher scanning resolution than an image file required for display on the world wide web. Digital images produced from high quality printers require a higher scanning resolution than images produced from low quality printers.

~ **What is the optimum image resolution required by the printer you are using?**
Make some test prints. The optimum image resolution is the point at which any increase in image resolution does not result in improved quality.

## Dots per inch

Printers place or transfer ink onto the paper in dots not squares. Higher quality printers put more dots of ink down per inch of paper. Printing devices therefore define the quality or '**output device resolution**' in '**dots per inch**' (dpi) not pixels per inch. The resolution of the image (measured in pixels per inch) is usually much smaller than the output device resolution used to print the image, i.e. each pixel is defined by more than one dot of ink.

Although there is a relationship between dpi and ppi they should not be confused during the print output stage, e.g. a 720 dpi inkjet printer needs an image with a maximum resolution of only 240 ppi (an RGB A4 digital file with a resolution of 720 ppi would exceed 143 MB).

## Interpolation

If a digital image is captured with a fixed number of pixels the image is limited in both size and/or quality. It is possible with software to increase the number of pixels thus allowing an increase in size or resolution. Increasing the total number of pixels requires '**interpolation**'. New pixels are created from information obtained from the existing pixels. These new pixels are inserted between the existing pixels. These fabricated pixels cause a loss in overall quality. If an image has to be scaled to fit a certain format or the specifications of a printer you should aim to scale down (reduce the number of pixels) rather than up.

**Note. Avoid increasing the total number of pixels in a digital image whenever possible.**

## From original to digital print (an example)

*4x6 inch print*

*35 mm film*

**35 mm film** - scanned at 1800 ppi

**Print** - scanned at 400 ppi

*Scanner*

### Digital file
Pixel dimensions: **1600 x 2400**
RGB file size: **11 Megabytes**
Grayscale file size: **3.67 Megabytes**

### Adjustment in Photoshop
Go to 'Image > Image Size'
Change resolution to **220 ppi**
Change print size to 7 x 10.5 inches

**Note.  Retain pixel dimensions.**

### Output
Image printed on A4 paper* at 720 dpi
(image resolution 220 ppi).
*Coated paper recommended.

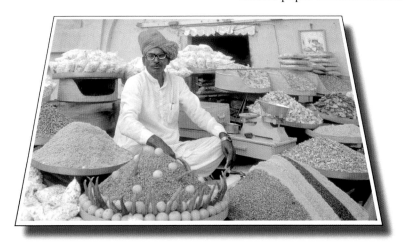

*A4 image*

# Calculating image resolution for output

The image resolution required to create a hard copy is dependent on the output device being used, the size of the enlargement and the quality required by the individual.

A commonly used method for calculating the optimum image resolution that can be utilised by an inkjet or laser printer is to divide the output device resolution (ODR) by a factor of three, e.g. 720 dpi divided by 3 = 240 ppi. If the resulting file size is unmanageable by your computer it is possible to increase this to a factor of four. The quality will still look reasonably good but will lower the working file size significantly.

If you are intending to send image files out for commercial printing consult the printer prior to creating the initial digital image file. It is very important to avoid having to increase the file size to accommodate a higher resolution required by the printer (see '**Interpolation**'). If an image setter is being used the printer may give you the screen frequency in lines per inch. If this is provided you should multiply this figure by a factor of 2, e.g. 133 lpi multiplied by 2 = 266 ppi.

---

## Image resolution requirements of print output devices

**Inkjet and laser:**  **Divide the output resolution by a factor of 3.**
**Dye sublimation:**  **Image resolution is the same as quoted output resolution.**
**Image setter:**    **Multiply the screen frequency by a factor of 2.**

---

## Output file formats

When printing to inkjet and laser printers directly from the image processing software it is permissible to use any of the file formats supported by the software, e.g. Photoshop, TIFF, JPEG etc. If the file is to be imported by word processing or desktop publishing (DTP) software the file will usually have to be saved as either a TIFF or JPEG. If the image file is to be printed commercially the standard file format is TIFF (without layers). Ensure that both the DTP file and all image files used in that file are kept together in one folder that can be easily found by the printer.

If an image is to be sent as an attachment to an email the file should be saved as a JPEG with no spaces in the file name and end with the file extension '**.jpg**'. The file should be saved without icons and previews to minimise the file size. Go to File > Preferences > Saving Files and select Ask when saving. If speed of transfer is required a high level of compression (low image quality) should be considered. Large file sizes may transfer very slowly via a modem. If the image file is going to be used as part of a web page the JPEG format should again be used. A high level of compression is required to minimise the time it takes to '**download**' the web page containing the image.

A file format that is being used increasingly for transferring DTP files to printers is the '**Portable Document Format**' or '**PDF**'. These can be created and viewed by the Adobe software '**Acrobat**'.

# Revision exercise

Q1. How may levels are used to describe the colour or tonal information in an 8 bit image?
   (a) 127    (b) 8    (c) 1,024    (d) 256    (e) 16.7 million

Q2. What two primary colours of light are combined to create the colour Yellow.
   (a) Magenta and Cyan.    (b) Red and Green.    (c) Yellow is already a primary.
   (d) Blue and Green.

Q3. What is a fully saturated colour?
   (a) A pure primary colour.          (b) A colour that is mixed with grey.
   (c) A pure colour with no percentage of grey.    (d) White.

Q4. What file format is commonly used when saving images for desktop publishing that are going to be commercially printed?
   (a) PSD    (b) Bitmap  (c) RGB    (d) TIFF    (e) JPEG

Q5. An image measuring 4 x 6 inches is scanned at 300 ppi. The image is not cropped and the file size is retained when the output resolution is changed to 150 ppi to meet the requirements of the output device. What will be the physical dimensions (in inches) of the image when printed?
   (a) 16 x 24 inches      (b) 8 x 12 inches      (c) 2 x 3 inches  (d) Same size

Q6. Which image displays the largest pixels when printed?
   (a) An image with an output resolution of 100 ppi
   (b) An image with an output resolution of 200 ppi
   (c) An image printed at 300 dpi
   (d) An image printed at 100 lpi

Q7. What is the approximate optimum image resolution for a 720 dpi inkjet printer?
   (a) 240 ppi      (b) 720 ppi      (c) 360 lpi    (d) 1440 dpi    (e) 240 dpi

Q8. What is the correct file extension for a photographic image destined for the world wide web that will display the image with the illusion of continuous tone?
   (a) .tif    (b) .JPEG  (c) .jpg    (d) .pdf    (e) .gif

# digital capture

*Les Horvat*

## aims

~ To develop an understanding of the principles behind the mechanisms of digital capture.
~ To create a resource for objective comparisons between digital cameras.
~ To foster an appreciation of when digital is the preferred choice for image capture.

## objectives

~ **Research** and evaluate the choices available in digital capture devices, including:
  - high end cameras
  - mega pixel cameras
  - scanning backs
  - point and shoot cameras

# Introduction

The ability to perform any digital manipulation requires image data to be **'captured'** and then entered into a computer system. This can be achieved by using either of the following:

~    A digital camera for initial capture with the data then transferred onto a computer, via direct link or storage card.

~    A traditional camera using film, then at some later stage scanning the image and transferring the data onto a computer.

Whilst both methods result in a similar data file which can be said to represent the image as **'seen'** by the camera and indeed the photographer, they actually produce data that have important differences. To understand these differences, let us first examine the processes involved.

## Traditional camera and scanned image as capture device

Any image taken on film will exhibit the general characteristics of that particular film emulsion, namely:

**grain, tonality, colour and sharpness**

When this image is scanned, these particular characteristics are overlaid with any characteristics (or limitations) that belong to the particular scanning hardware or software. The image file will then be a combination of all these particular attributes, resulting in **'noise', artifacts** or **'non-imaging'** data being an integral part of the information. The degree or significance of this non-imaging data will vary with the particular devices (film, camera and scanner) actually utilized, but may have a clearly visible influence on the final appearance.

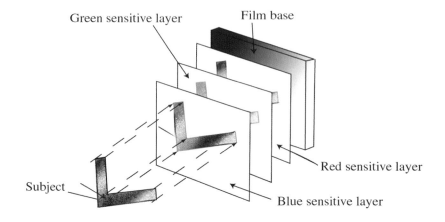

*Film capture showing silver halide formation on dye sensitive layers*

## Digital cameras as capture devices

An image file created with a digital camera bypasses the film stage and as a result of this single stage process, potentially produces a more accurate data file. Whilst digital cameras have their own problems, particularly with regard to resolution (see 'Image sensor types', page 23) and tonal range, such data files potentially do contain 'cleaner' information.

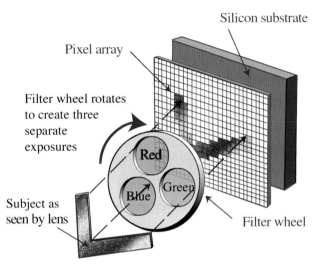

*Digital capture showing image formation within a pixel array (see '***Multi shot matrix***')*

## Digital versus traditional

An important issue to be considered, is the choice of method used to create the digital information representing our image - at what point does one form of capture become superior to another? Remember that digital manipulation can still be carried out by initially shooting with film and then later scanning. Whilst digital capture will always produce a more pure, cleaner file, it is essential to remember that shooting film still retains certain advantages. Apart from a significant price premium (cost of the digital camera plus batteries, storage devices etc., compared to an equivalent quality film based camera), the ability of film to act as both an inexpensive and very convenient archival storage medium has also to be considered. Digital files need to be archived in some way and although the cost of this process is dropping rapidly (particularly with the advent of relatively inexpensive CD burners), the long term storage and permanence of digital files still involves the use of a somewhat immature technology.

## Film as storage

On the other hand, the archival permanence and ease of storage of film has a long, proven scientific pedigree. The ease with which a new roll of film can be inserted into a camera, as the previous shot roll is dropped casually into a pocket, needs to be compared with the necessity and inconvenience of downloading files from a digital camera - or at the very least, maintaining a collection of quite expensive storage cards. These considerations need to be addressed in any comparison of film versus digital capture.

# Image formation

To help us understand the differences between digital and film (analogue) capture, together with the implications of those differences, we need to examine the ways in which the image is formed through each method.

## Conventional cameras (using film)

In a traditional camera, light passes through the lens and falls onto a film emulsion, with exposure adjusted by the aperture or shutter of the camera. Colour film itself is composed of a series of sensitive '**layers**' each containing crystals of '**silver halide**'. Exposure to light gives rise to a stimulation and subsequent movement of charged particles, resulting in the formation of a '**latent image**' in the form of '**metallic silver**' clumps. In colour films, these clumps are amplified and made visible by development with the metallic silver being replaced with colour '**dyes**' - resulting in colour '**film grain**'.

During exposure, each film layer responds to only one of the red, green and blue portions of the spectrum that combine to make white light. When the resultant image is viewed, it is the combination of colour dye specks or 'grains' within each layer that results in a 'full colour' image. The characteristics of the final image are to a great extent controlled by the film. A change in film type will result in not only a possible change in sensitivity (or film speed), but also a change in colour, tonality, grain and so on.

**Note. With a traditional camera, the same unit can be used to record images with very different characteristics, simply by altering the film.**

*Film with coarse grain*

*Fine grain film with smooth tones*

## Digital cameras (using image sensors)

Just as in traditional cameras, a digital camera uses a lens to focus the light, and an aperture and shutter to control exposure. Instead of film however, the light falls onto an image sensor composed of a series of light sensitive areas, usually referred to as 'pixels'. Each 'pixel' is connected electronically to a processor, which can measure the electrical stimulation the 'pixel' has received. These 'pixels', just like the 'silver halides' in films, only record light intensity - not colour. Colour is created by selectively allocating, or alternately sequencing pixels to record the red, green or blue components of white light.

The nature of the image sensor, unlike a camera using film, is integral to the construction of the camera. That is to say, all of the characteristics the sensor imparts to the image are fixed and unable to be changed, unless the camera is replaced. Thus the tonality, colour rendition and sharpness are a fixed signature of the device itself. This important difference is true for all but the most high end (or expensive) cameras, where interchangeable digital or film backs would offer, in theory anyway, some flexibility.

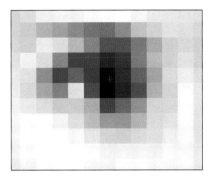

*Varying light intensity captured by pixels - hold the book at a distance to make out the image.*

**Note. Unlike film based cameras, the characteristics of the recorded image are determined by the sensors used and are part of the camera.**

As a pixel is exposed to light of increasing intensity, it produces a corresponding linear increase in electrical charge. This charge is amplified, measured and a corresponding grey tone or '**level**' is produced. This level is itself represented by a unique number, which can then be stored as digital information and subsequently easily manipulated on a computer.

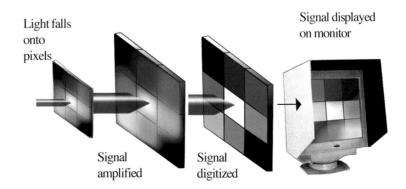

Light falls onto pixels

Signal amplified

Signal digitized

Signal displayed on monitor

*Analogue to digital conversion of light*

# Image sensor characteristics

Regardless of the type of image sensor used in a camera, they tend to have the following characteristics:

~    The pixels within them are regular in size and shape.
~    The pixels are laid out in a grid pattern.
~    The pixels exist only in one, single layer.
~    The pixels in standard sensors (see 'Colour sensors, page 24) register only brightness, not colour.
~    The size of the array is often smaller than the equivalent film format.

Due to these characteristics, images formed by the sensors mostly have these  attributes:

~    Pixels do not overlap (as they might with dye specks in the various layers within films), so the pixel generated image does not '**waste**' any information.
~    The regular pixel shape within an organised array is more '**efficient**' than the random nature of film grain.
~    Three pixels are required to produce a unique colour, therefore the number of pixels must be divided by three, when determining the actual pixel resolution of a sensor.
~    As the array is often smaller than the equivalent film format and although a digital camera may appear similar to a 35mm system, it is likely that the angle of view, or magnification of the lenses, will not be equivalent.  This difference can be indicated by the measure of '**aspect ratio**'.

*To calculate the aspect ratio of a camera, simply divide the pixel width by the pixel height.  For example the Canon Powershot S10 has a resolution of 1600x1200 pixels.  This results in an aspect ratio of 1.33:1, as compared to 8x10" photographic paper which has a ratio of 1.25:1.  The image at right shows the cropping effect that can result.*

The difference in aspect ratio (when compared to that of conventional film) may result in the need to crop the image when printing.  To understand this, consider what aspect ratio means - the ratio of the image height to the width.  For example a square has an aspect ratio of 1:1, whilst 35mm film has an aspect ratio of 1.5:1 (1.5 times wider than it is high).  Most sensors fall somewhere between the two, and so it is often necessary to choose between cropping part of the image or reducing the image size of the printout to fit the paper.

# Image sensor types

Whether within a camera or a scanner, most image sensors are made from either '**charge-coupled devices**' - '**CCDs**', or '**complementary metal oxide semiconductor**' - **CMOS**, chips, although newer sensors able to capture colour are also starting to be introduced.

*An image captured using a CCD sensor in a Kodak digital SLR camera*

## Battle of the sensors

For nearly thirty years, the relatively mature technology of CCD sensors has dominated the image sensor market, first within video camcorders and more recently as the imaging chip within still cameras, but the high cost of their very specialised production process has inhibited their acceptance. The newer CMOS imaging chip offers the advantage of being much cheaper to produce, due to a simpler means of production as well as economies of scale which result from the fact that a type of CMOS chip is the backbone of most desktop computer systems.

A further advantage of CMOS sensors is the ability of the chip to be designed in such a way as to also control other aspects of the camera itself, such as the internal clock, shutter, or exposure. This results in a much simpler and potentially cheaper camera with fewer chips required for its functionality. On the debit side, the CMOS chip suffers from more noise than CCDs and requires sophisticated mechanisms to reduce this problem to acceptable levels.

## How a sensor creates an image

Regardless of the type of sensor, the silicon pixels that make up the light sensitive array record the amount of light falling onto it by accumulating an electrical charge, which is then measured and converted to digital information in the form of a number.

**Note. The higher the number, the greater the amount of light falling onto the pixel.**

## Colour sensors

Until recently, image sensors could only 'see' in black and white - that is, they were not able to differentiate colour. However Foveon, a company who has been at the forefront of sensor chip technology, has begun production through National Semiconductors of a 3.53 million pixel sensor that is able to differentiate between colours in its capture. This means that in reality it is comparable in function to existing sensors with 7 million pixels or more (see 'How image sensors function').

The major difference between this sensor and other types of image sensor is that each pixel is designed to receive all three basic colours of light, instead of only one. In other words rather than break images into separate colours and allocate them in some way to separate pixels, this sensor captures the different wavlengths of light by measuring how deeply photons of light actually penetrate the surface of the pixel.

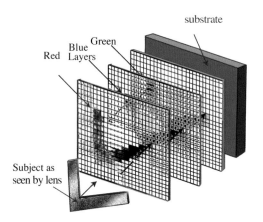

*Foveon's X3 digital colour sensor*

This is achieved by stacking three photodetecters within each pixel, each designed to capture a separate colour - one dedicated to red wavelengths, one dedicated to blue wavelengths and one dedicated to green wavelengths of light. This is rather similar to the way that conventional film records colour and so is the first digital capture process to successfully mimic film based capture. As a result, not only is there a need for fewer pixels for any given resolution, but there is also a smaller light loss - thereby enabling successful capture with less noise within low lighting conditions.

# How conventional image sensors function

Just as there are different chips that can be used to make up the sensors themselves, there are three major types of image sensor configuration. Each results in different modes of functioning and leads to certain advantages and disadvantages depending on their use.

## Linear array

These sensors are configured as an array of pixels, which read or scan information as they pass over the image area. Each array contains three parallel rows of pixels coated separately with red, green and blue filters, thus enabling a complete RGB reading from any one point - after the three rows have made a pass. This technology, whilst resulting in excellent image quality with high resolution, suffers from a number of limitations:

~    Any vibration in the motor will lead to 'banding'.
~    Variation in light output or colour during exposure will also result in 'banding'.
~    Exposure times can be very slow, since the image is scanned line by line.
~    The camera or device must be motionless.
~    The subject needs to be completely still, or must not change during exposure.

For example, photographing a glass of beer would pose problems with this type of sensor as the bubbles would probably be moving and the beer head slowly sinking.

**Note. Linear array sensors represent a proven technology but aside from special high end dedicated camera backs, have greatest use within desktop scanning devices.**

## Multi shot matrix

These sensors, also often known as '**area arrays**', use three separate exposures made sequentially through red, green and blue filters, across the complete array of pixels. They offer high resolution - since each pixel records red, green and blue sensitivity in turn enabling the resolution to be equal to the total number of pixels in the array. However, this technology does suffer from the following limitations:

~    Variation in light output during exposure may result in colour imbalance.
~    Filter misalignment may cause '**colour fringing**'.
~    The subject must remain completely still, as must the camera.

This type of array is most often found in high end studio type cameras as a removable back, used to photograph products and other still-life subject matter within controlled lighting situations. Examples of this type of camera back are:

~    CMOS PRO by Vision Limited
~    Volare by Leaf

## Single shot matrix

Complex filtration methods are utilised to capture instantaneously the full spectrum of light by using patterns of adjacent pixels. The final colour image is achieved by averaging information from surrounding pixels using software '**interpolation**'. This method suffers from the following limitations:

~    The quality of colour is not as accurate or pure as three exposure systems.
~    Fine high contrast details will often be surrounded by '**colour fringes**'.
~    The filter patterns may cause '**moiré**' effects on finely patterned subject matter.
~    Actual resolution is only about one third the number of pixels within the array as each pixel only records one particular colour.

Even with the limitations of the matrix array, this is the single most common type of sensor arrangement in digital cameras. The reason is simple. Not only is it potentially less expensive to produce, since it doesn't need expensive filters or motors, but it is the only technology that enables '**instant capture**'. In other words, this type of array enables the photography of moving subjects, or indeed any subject that will change over time.

*Portrait taken with a matrix array camera*

## Activity 1

Visit your local photographic retailer and collect a series of brochures on available digital cameras. Alternatively collect similar information via mail-order outlets or via the Internet.
Determine what type of image sensor each camera uses and what the 'actual' resolution, measured in pixels, is for each camera.

# Digital camera types

Now that we have examined the ways that a digital image can be created, let us consider the various types of digital camera available. The simplest method of categorising digital cameras is by cost - modestly expensive, expensive and hideously expensive! However with the improvements in technology and the speed at which these improvements are arriving, there is no doubt that prices of all types of digital cameras are coming down and coming down dramatically. It makes more sense therefore to discuss digital cameras in terms of their features and the uses to which they can be put.

## High end digital cameras

This group of cameras falls into two categories. Those that are mainly designed as camera backs which fit onto existing medium or large format camera systems (see discussion on 'Image sensor types', page 23 ) and those that are complete cameras in themselves. The camera back style is most often used by professional photographers where quality of image is the most important criterion. These units are extremely expensive, but in a busy studio the cost can be offset by the flexibility, the immediacy and the savings in film and processing.

## Removable digital backs

Until recently, most digital camera backs used a linear array or multi-shot matrix system to be able to achieve quality that was comparable to that which could be gained from film. However the most recent generation of film backs are of the single shot variety and are able to produce images with up to 16 megapixel resolution. An example of this type of camera back is the Kodak DCS Pro Back Plus, suitable for medium format cameras and able to produce a 48 MB file with one instantaneous exposure on its 4k x 4k CCD sensor. This type of digital back sets the benchmark in the pursuit of high end digital capture, although at a significant price.

*Kodak DCS Pro back*                              *Phase One Powerphase FX*

## Professional quality digital cameras

This  group of digital cameras are most often designed around existing 35mm camera bodies, which are then adapted to accommodate the image sensor, the LCD screen and the associated hardware.

An example of this type of camera is the Fuji FinePix S2 Pro, which has a 6.17 megapixel CCD sensor and utilizes Nikon F mount lenses.  This particular camera uses a specially constructed  pixel array that instead of being rectangular, is octagonal in shape.  This allows Fuji to claim that images captured with this camera can be interpolated to over 12 megapixels, producing crisp, highly detailed image files.

*Fuji FinePix S2 Pro*

*Kodak DCS 760*

In a similar vein, is the Kodak DCS 760 which uses a true 6 megapixel sensor to produce images able to be captured at a burst rate of 1.5 frames per second, for up to 24 frames.  This enables capture of moving subjects such as in sports photography.  Like the Fuji version this camera is also based on a Nikon body.

The Canon EOS 1D is a camera based on a Canon body.  This 4 megapixel unit - one of the fastest available - can shoot at 8 frames per second for 21 frames, and is designed to allow professionals to use their existing lens systems, due to a sensor size approaching that of 35mm film.

*Canon EOS 1D*

One major advantage of these types of cameras is the creative control possible, with most camera features working in the same way as their film based counterparts.  However the high cost of these cameras prohibits their use by all but those who can readily utilise them to produce income.  They are capable of producing photographic quality images suitable for reproduction at all but the largest of sizes.

## Medium and large format digital cameras

As discussed in the previous section, most self contained digital cameras are based on the 35mm bodies of conventional film based cameras. They are not however the only possibilities available.

Sinar, the makers of large format cameras, have produced a digital camera specifically designed to mate with their range of scanning backs. This camera, the Sinarback, has a built in LCD shutter that updates the image up to seven times per second on a viewing monitor, and has been designed for use as either a self contained unit or one that integrates with a Sinar view camera.

*Sinarback in combination with digital back and view camera*

*Hasselblad DFinity*

Also of particular interest is the first, true medium format one shot, digital camera, released by Hasselblad in partnership with Silicon Valley based Foveon Inc. This camera, known as the DFinity, incorporates a 12 megapixel sensor array grouped as three separate 4 megapixel sensors.

Inside the camera is a colour separating prism designed to split the light into red, green and blue components, each focused onto one of the 2k x 2k sensor groups. This enables the capture to be more pure than that of mosaic filtered, single shot cameras and results in far fewer artifacts being created. The camera is designed specifically for studio use and is controlled from the keyboard with a monitor functioning as a viewfinder.

## Image sensor resolution

An exciting development for digital cameras is the introduction of the high resolution CMOS sensor. Whilst as discussed earlier this chapter (see 'Battle of the sensors', page 23), CMOS sensors have been anticipated to reduce the price of digital cameras due to their inherent cheaper production processes, the image quality produced with these sensors has not been able to match the CCD chip. However, Foveon Inc. have recently announced the first 16 megapixel CMOS based image sensor with not only a resolution to match the best CCD sensors, but also the quality. The development of this chip is a quantum leap in the quest for cheaper and better digital cameras and will find its way into many devices being produced in the coming years. This will have a major effect not only for high end systems but also filter through to the volume end of the megapixel camera market.

## Multi mega-pixel cameras

The most crowded area of digital camera development, this is the group of cameras that are changing the nature of popular photography. These cameras are typically easy to use, often including zoom lenses as well as programmed exposure control, and produce images capable of being printed with photographic quality at over 8 x 10" in size. They are finding a ready market with keen photographers wanting to embrace the digital age. These cameras have sensors rapidly increasing in size - most are over three or four megapixels.

Despite rapidly becoming more affordable, they still however cost more than their similarly featured, film based cousins. Examples include the Olympus C-4040, Minolta Dimage 7i and the Canon G2 - although new models are being released almost daily, each with more features and at a lower price-point.

*Minolta Dimage 7i*

*Canon G2*

*Olympus Camedia C-4040*

## Entry level digital cameras

These cameras are usually fully automatic, with fixed focal (or limited zoom) lenses and resolutions of approximately two or three mega-pixels. They are more than adequate for photographic images up to A5 size and are also often used for the Internet. Even though this group of digital cameras are more expensive than the equivalent film based version, they are very affordable and becoming more so by the day. The convenience of being able to transmit pictures electronically, or at the very least see results of your creativity immediately, are advantages that are encouraging the ready acceptance of this technology.

*Fuji FinePix 2600Z*

*Nikon Coolpix 885*

## Digital video cameras

Although we think of video and still photography as two very different and unrelated areas, technology is encouraging a blurring of that delineation, to the point where the same camera is able to capture both types of images. The latest digital video cameras already digitise each frame as it is captured, hence it is possible to select individual frames from the video tape and use them as still photographic images. Given that video cameras shoot at 25 or 30 frames per second, you can imagine the range you have to choose from - a de facto 'motorwind' for capturing fast action!

The debit side is the resolution of each frame, which is generally lower than that possible with a dedicated still camera. You can however also record sound, for notes or narration, to help keep track of your shots. Software, such as PhotDV by Digital Origin, enables transformation of video into still images that are ideal for web page use - as single images, 360 degree panoramas or even animated GIFs.

*Canon   Optura   100MC   digital   video camera*

*Sony  Cybershot DCSF 707*

To complicate matters further, many digital cameras can capture short bursts of video in addition to still images. Add to this the ability also to capture sound and the multi function camera is definitely a technology whose time has come. Current examples of this 'all in one' camera  are the Sony Cybershot range or the Canon range, but the list is growing rapidly.

Without doubt however, as the technology improves, the ease of use and flexibility of such cameras will no doubt ensure that these hybrids become more and more popular.

## Activity 2

From your earlier research in Activity 1, list each camera you have information about and decide into which category it would belong.

Consider under what circumstances or type of use each digital camera may be most appropriate. Make a list of possible photographic activities and categorise each camera as being suitable or unsuitable.

In addition, determine the cost of each camera and decide which camera is the most cost effective option.

# Choosing a digital camera

So far in our discussion we have examined one of the more important aspects of digital cameras (aside from price), namely the image sensor and its relationship to resolution. But what other features are important when comparing digital cameras? As new cameras are released, the specifications and feature list seem to grow - without always giving the consumer information that can be readily understood. What then are the really important aspects to look for in a digital camera?

## Portable storage media

The larger the storage capacity of the camera, the greater the number of images that can be taken without downloading files. Think of it as similar to replacing a roll of film when all frames have been exposed. Most cameras use a form of storage that can be read directly by your computer via cable, or through a removable '**memory card**'. The most commonly used forms of card storage available are PCMCIA cards and Flash media. At present, a number of different formats exist for Flash media and they are vying for dominance. These are:

~   CompactFlash cards
~   Memory sticks
~   SD (Secure Digital) memory

The latter two are significantly smaller in size and even more importantly offer a secure environment for data exchange. This has implications for future storage uses, not just in cameras but in audio players and devices as diverse as home security and in-car navigation systems.

Storage cards vary in size and capacity as well as price, but unfortunately are not interchangeable. If your computer doesn't have a particular card reader built in, an external reader can be connected by cable. Some of the newer card readers are even able to read multiple formats, so that most cards can be taken straight from the camera and downloaded onto a computer with ease.

*Kodak DX3500*

*Smart Disk and OmniFlash card readers*

A recent innovation being introduced to (mainly entry level) domestic cameras is the use of a docking station. This further simplifies the process of transferring images to a computer ready for printing or further transmission.

## Computer interface

Aside from using the portable card storage within the camera, the ease with which files can be transferred to the computer via a direct link is of paramount importance - particularly for larger image files. The interface itself will control the speed of the file transfer and must be compatible with the computer hardware. The major interface types are:

~   **Serial port:** slowest, but standard on most PCs although not available on Macs
~   **ADB:** similar to serial port, but usually only on older Macs
~   **SCSI port:** faster transfer but not often available as standard on PCs or newer Macs
~   **USB port:** fast transfer, widely available on newer computers - Mac and PC
~   **Firewire port:** fastest transfer but only common on high end systems and iMacs

The speed and flexibility of file transfer is a major consideration as far as workflow is concerned, as the number of images and hence the size of files can grow very rapidly. Whereas film itself is a natural storage medium, to archive digital images usually requires download, some form of 'album' style organisation and a subsequent burning onto CD. New interface options, such as the docking station mentioned previously, are being developed very rapidly. Some digital cameras have connections for displaying images onto a television set, whilst camera/printer combinations allow printing without the need for a computer with the image storage medium being placed directly into the printer.

## Lenses

Whilst some digital cameras come equipped with the same (or at least similar) lenses to film based cameras, the sometimes novel design of the camera bodies allows for other innovations such as swivelling or rotatable lenses. An optical zoom lens, generally of higher quality than a digital zoom (which uses electronics rather than optics to create a larger image) is also useful, whilst faster fixed or interchangeable lenses allow for picture taking under more challenging lighting conditions.

*Nikon Coolpix 995*

## Power source

Alkaline batteries are the most inexpensive but can be consumed extremely rapidly and are not rechargeable. As a result a camera that relies on this type of power source can become expensive and inconvenient in the longer term. Rechargeable batteries vary from the memory prone '**NiCd**' to the better performing '**NiMH**', the longer lasting but more expensive '**LiOn**', or the newer '**MnLi**'. An AC adapter that allows mains power usage when the batteries are dead is also very important.

## Image quality

This critical aspect of any digital camera does not rely exclusively on the number of pixels within the sensor, but also on the way the colour image is created (see 'Sensor types'). In this regard it is important to note the '**true resolution**' of pixels rather than an '**interpolated resolution**'. Such an interpolated figure can be misleading as it relies on the creation of pixel data by 'best guess' **algorithms** within the camera's hardware - rather than on information read from the subject.

*Fuji FinePix S602*

In addition to the pixel resolution, the '**bit depth**' of each pixel is a measure of how many shades of grey each pixel is able to discern. An 8 bit depth is equivalent to 256 different shades (or tones) and is the norm for full colour imaging, but a higher figure (10 or even 12 bit) will lead to an increase in image quality. This bit depth allows for losses sustained in any processing or manipulation of the data.

**Note. A full colour image is created by the addition of the red, green and blue components of light and so an 8 bit colour depth creates a 24 bit (8 x 3) colour image.**

## Sensor advances

The latest breakthrough in sensor technology promises to herald a new era in digital camera design. The latest sensor from Foveon is a chip which can record the three colours of light on **any** pixel within the array. It determines colour depending on how deeply the light photons from the focused image penetrate the sensor, which itself is made up of three sesitive layers - somewhat like film. With this sensor it may be that 'digital film' has truely arrived.

*Sigma SD9 which is the first camera to use the new Foveon chip*

## Bundled software

As a minimum, software to control the taking, preview and storage of the images will be included. However, some cameras also include a histogram display of the tones within the image, a download utility or even manipulation software such as Live Pix, Photostitch or Photoshop Elements. Whether you actually end up using this software or not, it is a good idea to compare the cost of extra software in relation to the overall camera price.

## Is digital better than film?

Resolution is comparative. Even today's top benchmark of up to 16 megapixel resolution fails in comparison with 35mm film at approximately 25 mega pixels, or indeed the human eye at around 120 mega pixels!

**So what relevance have claims that a digital image is better than film?**

High end digital camera backs that use scanning array technology can indeed produce images of very high resolution and fidelity. However, due to the nature of the scanning mechanism, the subject matter must remain perfectly still - see 'Image sensor types', page 23. In addition, the file sizes are extremely large and this requires a cable connected to a computer for downloading. Instant capture cameras, even at their best, are still struggling to compare. Whilst rapid improvements are constantly being made, the fidelity and convenience of film is a very difficult medium to match.

*Phase One Lightphase digital camera back on a Hasselblad medium format camera*

The relative cost of film based versus digital cameras, not to mention the cost and time taken for image storage, is at this moment still balanced in film's favour. No doubt, technology will continue to make improvements and the divide - both in terms of quality and overall cost - will continue to diminish.

As far as the present is concerned, if there is a need for instantly viewable, electronically transmitted images, or for the creation of content for web based publishing, then the balance is already in digital's favour.

Who knows where this balance will be in a few years' time.

## Activity 3

1. Make a list of photographic activities that would be better suited to digital capture and discuss your reasoning.
2. Create a similar list using film based capture and compare the two. Be sure to consider the economics of the two forms of capture, but remember that digital is fast becoming cheaper and rapidly improving in quality.
3. Research (via the internet) some of the newer technologies coming on stream, as well as those just around the corner, particularly the advances being made in sensor design. Also consider the various storage solutions available on the market as well as the ease of transfer of digital files from camera to computer or printer.

# Revision exercise

Q1.    A colour image recorded onto film is made up of:
(a) A series of randomly scattered silver specks that look coloured when light shines onto them.
(b) Layers of dye specks clumped together to form grain.
(c) Microscopic holes through which a series of coloured layers combine to form colour specs.
(d) Groupings of coloured dots that when viewed from the correct direction appear as multi-coloured dye spots.

Q2.    A digital image is recorded by:
(a) A series of zeros and ones formed by patterns of pixels.
(b) Layers of pixels turned either on or off, each representing a dot of a particular colour.
(c) A series of pixels representing colour by measuring resistance to electrical current flow.
(d) Groups of light sensitive pixels responding to varying intensities of light by a corresponding increase in electrical charge.

Q3.    What are CMOS and CCDs?
(a) Types of camera battery.         (b) Image sensors.
(c) Storage devices.              (d) Computer connection ports.

Q4.    The advantage of a single shot matrix array over a multi shot matrix array is:
(a) Image capture is instantaneous.    (b) Image capture is higher quality.
(c) The image is automatically stored.   (d) Downloading the image is faster.

Q5.    Portable storage media are useful in digital cameras because:
(a) Photographers can store notes about the pictures they have taken.
(b) Personal identification information can be safeguarded.
(c) Programmed exposure information can be transferred from one camera to another.
(d) Image files can be stored for later download.

Q6.    Which is the fastest file transfer link?
(a) SCSI  (b) Serial Port  (c) USB  (d) Firewire

Q7.    Interpolated resolution is:
(a) Mathematically constructed pixel information used to increase resolution.
(b) One third of the actual sensor resolution.
(c) Highest resolution which gives the best quality of image.
(d) Resolution that matches the aspect ratio of film formats.

# Gallery

*Zac Watt*

*Les Horvat*

*Les Horvat*

# Gallery

*Les Horvat*

*Saville Coble*                    *Hugh Peachey*

# digital

*Les Horvat*

## aims

~ To develop an understanding of the hardware options available within digital imaging.
~ To be able to make decisions about the most appropriate form of digital output.
~ To understand the available options for scanning images.

## objectives

~ **Research** and evaluate the various hardware devices available for digital imaging, including:
- monitors
- scanners
- disc storage
- printers

# Introduction

Today, the selection of computer platform does not itself define the choice of imaging software. It is true to say that some software is written specifically for PC or Mac, but the accepted benchmark, Adobe Photoshop, works equally well on both. Although most professionals prefer the Mac, the main difference between the two systems these days is in colour management. Because of this it is best to use Windows 98 or later, rather than earlier operating systems if using the PC platform (see '**Colour Management**', page 71).

## System Requirements

Any computer system is only as good as the individual parts that comprise it, so let us consider each major component in some detail.

### Monitor

In many ways this can be considered as the heart of any imaging system. Aspects to consider are the size, the quality and the reliability of colour that the screen can display. '**Screen real estate**', an often used term, refers to the amount of **usable** space within the viewing area. This is influenced not only by the physical size of the monitor itself but also by the space taken up with palettes and other software controls.

*LaCie Electron Blue 19" monitor*

For this reason, many professionals actually use two monitors - one for palettes and tools and the other exclusively for the image. This may sound unusual, but in fact as long as a second video card is able to be connected to the '**motherboard**' of the computer, it is often a cost effective option - especially as the second monitor does not have to be of such high quality as the main unit and the alternative of a large single monitor can be extremely expensive in its own right.

*Mitsubishi Diamond View 1770 monitor*

In addition to the monitor itself, the choice of '**video card**' and the amount of '**video memory**' will also determine the quality and speed of '**screen re-draws**'.

In general, it is fair to say that in the area of displays, you get what you pay for - in the long run, your budget will determine the best options for your needs.

*Sony CPDL 133 flat screen monitor*

## Memory

Editing and manipulating images makes great demands on the computer's RAM (random access memory). Software such as Photoshop routinely uses 3 to 5 times the file size in RAM to function efficiently. In other words a 20MB image will require up to 100MB of RAM or it will slow down considerably as it substitutes '**scratch disk memory**' from the hard drive instead of available RAM. Adding more RAM to the system is often a quite cost effective means of increasing overall speed.

## Processor

The speed of software such as Photoshop and how it functions on a system will depend on many considerations - not merely the amount of RAM available. The speed at which the computer processor can perform calculations, the number of calculations it can perform at once, the speed of data transfer as well as the number of processors within the system will all have a profound effect on performance. In most cases the fastest processor speeds will be much more expensive than those just a little slower, so unless you are a high end digital professional who will be using your computer to earn income, it is not advisable to purchase a machine with the absolute fastest processor available.

## Hard disk

The price of hard disk storage has tumbled in recent years, almost as fast as the capacity has increased. This is important for digital imaging as the hard drive performs three main functions, all of which can consume large amounts of its available volume:

~ **Scratch disk space:** As previously mentioned, the overflow 'working space' that the software uses which does not fit into the available RAM (3 to 5 times the file size) is created on the hard drive. If the file is very large this can be considerable.

~ **Storage space**: Downloading files from your camera, scanning film originals or simply storing manipulated images - even if only temporarily - will consume vast amounts of disk space. In addition, during the image editing and manipulation process, it is a sensible idea to save multiple versions of the image file itself (see 'Save, save and save', page 116).

~ **Software:** The days of 'lean and mean' software are well and truly over. In today's computer environment, not only the operating system, but also most applications are quite large and will take up considerable space in their own right.

All of this suggests that a large hard disk drive is important, especially in terms of choosing a system that will meet future requirements. However, just as with processor speed, the largest and fastest hard drives are significantly more expensive than those just a little smaller. Choose a drive that is appropriate for requirements, but also remember that a second hard disk can be added at a later time. In fact some users set up their system with two hard disk drives, so that one can be kept reasonably free for use exclusively as a scratch disk. This option reduces '**crashes**' which tend to occur when the computer software runs low on memory or scratch disk space!

# External storage

Various methods exist for both increasing overall storage capacity and at the same time offering maximum user flexibility. Working with digital images requires the ability to transfer files easily - from input, to computer, to output - as well as ultimately archiving the completed images. Being able to create conveniently stored '**galleries**' may also be an important requirement. There are many different options for external storage, each having their own advantages and disadvantages, so it is worth examining them.

## External disk array

Otherwise known as '**RAID**' (Redundant Array of Independent Disks), this type of external hard disk storage is made up of an array or 'stack' of disks and is most often found in high end systems. A RAID disk enables a large amount of information to be broken up into smaller segments each being stored onto a separate disk. So for example if five disks make up the array, the data file is broken up into five chunks. The advantage is that this multiple storage occurs simultaneously, hence the original file takes much less time to be written to the disk. This is of obvious value for the very large files used in professional work environments where multi-layered files can be of the order of many hundreds of megabytes.

An alternative type of RAID disk can store multiple sets of the same file onto different disks - all at the same time. This creates a much more secure storage system, which is of importance in data critical systems - if one version becomes corrupted or the hard disk crashes, then another saved version can be used.

## Magnetic tape

Originally created as a form of audio tape, this type of storage known as '**DAT**' (Digital Audio Tape) comes in the form of a small cassette tape. It has become popular as a storage or backup medium mainly due to its low cost. Some units can accommodate up to 80 GB of information (with compression) onto a single cassette. The only disadvantage with this type of device is the length of time it can take to find particular files, as the tape has to be wound and re-wound in a sequential fashion.

*External DAT drive with tapes*

## CD-R and DVD-R writers

Writable CDs and DVDs are fast becoming one of the cheapest storage mediums available, particularly with the rapidly reducing prices of CD burners as well as that of blank CDs. Since the data can only be written once onto a CD or DVD, they are best suited for archiving images that are finalised and require no further manipulation.

## Removable media

This type of storage comes in many different formats - none of which unfortunately is compatible. However, since they all require their own dedicated drive mechanism, as long as the means of connection to the system is available (see Computer interface in the 'Digital Capture' study guide) compatibility is not an issue. These units come in the form of small removable hard disks inside a plastic cartridge that slots into the respective drive unit.

*Zip USB Drive*

*Jaz USB Drive*

Common types of removable media are 100 MB and 250 MB **'Iomega Zip'** disks, 2 GB **'Iomega Jaz'** disks, 120 MB **'Imation Super'** disks and 2.2 GB **'Castlewood Orb'** disks.

*Castlewood Orb Drive*

## Activity 1

Storage units vary in price, speed and flexibility depending on their overall design.

1. Make a list of devices available in your area - include tape, removable disks, CDs and DVDs. Find out the prices of the drive units for each type of storage and also the cost of the blank media itself - remember to make a note of how much information can fit onto each.

2. Create a table that compares the cost per MB of each type of system. Be sure to include the overall cost of initial setting up as well.

3. Include in the table the speed of transfer of data with each system. Make a recommendation for the best device for your purposes.

# Scanners as input devices

If film is used as the method of capture, to be able to perform further manipulations or even transmissions of that image electronically it is necessary for that film to be scanned. There are different types of scanner to chose from - the choice depends on the quality required and the budget available.

## Drum scanners

The traditional high-end scanner used by pre-press houses and printers for the production of colour separations. These scanners use a **PMT** (PhotoMultiplier Tube) to achieve the greatest possible dynamic range and sharpness. Very high in cost, these scanners are still considered to be the benchmark for scanning quality.

## Film scanners

These scanners are dedicated to scanning film formats from 35mm to 5x4 inches and can vary in price quite considerably, depending on quality. At their best they can rival drum scanners in terms of output but not in terms of speed. They can therefore be a good compromise when used under circumstances that do not require rapid throughput or efficiency.

*Imacon Flextight II*

## Flatbed scanners

The most commonly available type of scanner, it is suitable for scanning both reflection art and film. The quality of these scanners varies from entry level, low cost (but extremely good value), to high end flatbeds that are positioned as alternatives to drum scanners, particularly for use with reflection art.

*Kodak RFS 3600*

*Epson Perfection Series Scanner*

Since flatbed scanners use a moving array of sensors to digitise the image, considerations of noise, dynamic range and consistency of light need to be addressed in their design - in a similar way to that of digital cameras (see 'Sensor types', page 23).

# Workings of a flatbed scanner

Flatbed scanners are the most widely used desktop units and can be utilized in a variety of situations. Until recently, most flatbed scanners used 'CCD' sensors, but 'CIS' or 'Contact Image Sensors' are now also used, replacing the larger optical pathways of earlier units. Illumination is provided by a row of tightly packed LEDs very close to the glass plate, enabling flatbed scanners to become as slim as notebook computers.

Price points for this family of scanners vary enormously, depending on their construction and the purpose for which they are designed. In general, the quality is rapidly improving for all flatbed scanners whilst price is falling. However, it is worth discussing a number of the criteria by which scanners can be assessed and compared.

*Microtek ScanMaker 4700*

## Sampling depth

The sampling rate or bit depth (see 'Digital Basics') is a figure that can be dubious when examining scanners. Whilst 8 bits (or 256 steps for each channel of RGB) is all that is needed to produce a full colour image, many scanners boast bit depth figures of 10, 12, 14 or even 16. So instead of rating the scanner as being capable of 24 bits (8 x 8 x 8) of colour, some are rated as offering up to 48 bits (16 x 16 x 16). However, it is doubtful that prints or reflection art actually have the subtlety of tone that can be measured or discerned with these extra steps.

## What value is high bit depth?

If all that is required for full colour is 24 bits, then what happens to the extra - is it simply lost? The answer unfortunately is not clear cut. Common engineering practice utilises over-sampling, i.e. creating more data than is actually required, in the interests of avoiding noise. This is part of the internal workings of a scanner and applies simply to gain a result as free of noise as possible. However, aside from this over-sampling, the extra tonal separation that a high bit depth can determine is potentially useful to differentiate particularly subtle tones - mainly in the deep shadows and extreme highlights. However, it has to be said that this extra information is extremely subtle, perhaps not even noticeable at all and certainly not of as much consequence as the overall sharpness of the scan or as important as the consistency of the scanning mechanism itself. So whilst a high bit depth can be of value, the visible benefit may often not be very significant.

**Note. If the editing software can work with the 16 bit scanned image without conversion, then the extra information is quite valuable as a way to avoid data loss in the editing process (see 'Scanning and image adjustment', page 51).**

## Resolution

Scanner manufacturers sometimes quote a resolution figure that is actually an interpolated resolution (see 'Digital Basics') rather than an optical resolution. Interpolation is a means whereby the software associated with the scanner attempts to invent values between the actual pixels scanned. Although this software interpolation is often quite sophisticated in its application, the outcome is usually a slight softening of the scan. Consequently it is rather misleading - only the optical resolution is of any real value when making comparisons between scanners.

## Optimum scanning area

Most flatbed scanners have minor inconsistencies in their scanner mechanism which result in uneven scanning areas across the scanner window. These can particularly affect large areas of smooth tone and show up as dark or light bands or 'blotches'. Sometimes the edges of the scanner window are particularly affected.

## Activity 2

Since most often the original to be scanned is smaller than the window size, it makes sense to determine where the optimum area of the window actually is located, i.e. where is the best place to situate the original?

1. Take a clean white piece of paper cut to the exact dimension of the scanner window. If the scanner is of the type which has a calibrating slit over which originals must not be placed, then be sure to leave this blank.
2. Setting the resolution to 100 ppi, magnification to 100%, scan a sheet of white paper.
3. Open the file in Photoshop and select Image > Adjust > Equalize to exaggerate the subtle differences in the scan tonality. Examine the 'cleanest' area of even tone - this is the best region to situate original when scanning.
4. Make a black cardboard template with a window that corresponds with this region and use it when scanning.

*Scan of white paper*

# Printers as output devices

It is probably true to say that the most commonly required output for all types of photography is still the printed image. Whether the original is taken digitally or via film (and not withstanding the new areas of electronic reproduction such as the web) most photographers still want to hold a print in their hands for viewing. Technology has moved very rapidly in the area of digital printers and there are quite a few options available - the choice, as always, is dependent on purpose and price.

## Dye-sublimation printers

Sublimation is a process where a solid is converted to a gas and bypasses the liquid stage - for example 'dry ice'. In printing, sublimation describes inks that when heated turn into a gas and bond with a surface. Dye-sublimation printers use a sheet of ribbon made of plastic impregnated with cyan, magenta, yellow and sometimes black dye, which is heated by thousands of elements capable of temperature variations, moving across the ribbon.

The dyes vaporize when heated and bond with the underlying coated paper. The advantage of this process is the high image quality, due to the richness of tone and the lack of any grain. In addition images can be transferred to other surfaces such as fabric, ceramics etc., by re-heating and reactivating the sublimation dyes. However, due to the nature of the large ribbon, the cost per print is usually quite high.

*Kodak XS 8650 Dye-Sub printer*

## Thermal wax printers

This process is rather similar to dye sublimation as it relies on heat. The difference is that in this case the dye is suspended in a wax impregnated ribbon which is applied to a specially coated paper after application of quite low heat, which causes the wax to melt. The final image is composed of very small dots of coloured wax. The advantages of this printer are the bright colours possible and the relatively high speed at which the print can be produced. The disadvantages are the need for specially coated paper and the dot pattern produced throughout the image.

## Colour laser printers

Laser printers, using a technology similar to copiers, apply coloured toner to a drum via a finely focused laser beam. This drum is electrostatically charged to accept the toners and is then rolled onto the receiving paper and heat fused. The advantages of this method are that the printers can be extremely fast and do not require special paper. Although improving rapidly, unfortunately the quality of the output is not as high as other forms of printing, but these printers are very useful for preliminary output within a commercial work environment.

## Digital photographic printers

Rather than inks, this family of printers uses light to expose directly onto photographic paper.   Units such as the Durst Lambda, Kodak Pegasus and Ilford Lightjet use a beam of light created by LEDs or  lasers to expose onto light sensitive paper or backlit film. The result is an archivally stable, ultra-sharp, continuous tone enlargement without any inherent grain or visible dot.  Although these printers are extremely expensive, their accuracy, sharpness and speed mean that they are rapidly being introduced into commercial laboratories where the savings in labour costs make the high capital outlay worthwhile.

*Durst Lamda 130 printer*

## Hybrid digital printers

Rather like the true digital printers mentioned above, the Fuji Pictography series of printers use light instead of inks.  However, instead of exposing directly onto photographic paper, these printers expose a light sensitive donor sheet which is then dye transferred onto a receiving paper - resulting in a continuous toned print that has the look and feel of a photograph.  Although not quite as versatile as digital photographic printers, they are significantly cheaper and more viable for smaller work environments.

## Film recorders

Although the output from a film recorder is a transparency or negative film, it is nonetheless a printer.  However, rather than expose light directly from the digital file onto paper this device exposes onto film.  This photographic film is then developed in the normal manner. The original role of these devices was for the purpose of creating slides for presentations. However, the technology has been adapted so that large format film output is also possible. The costs for this type of output are quite high and with the improvement in digital printing technologies, the reason for returning once again to a film based photographic print is not as easily justifiable as it once was.

## Inkjet printers

This category of printers has benefited from technological improvements in the last few years and has become one of the most common types of printer available.  Although a number of different techniques exist to deliver the ink to the paper surface, the most common is the '**piezoelectric**' method.  This approach uses certain types of crystals that can be made to expand or contract when different voltages are applied.  This vibration of the crystal causes precise volumes of ink to be sprayed onto the paper.  Different 'families' of inkjet printer are in common usage today - each designed for a particular purpose.

## Desktop inkjet printers

This group of printers has revolutionised the accessibility and quality of digital output. At a modest cost, printers from manufacturers such as Epson, Hewlett Packard and Canon are able to produce photo-quality printouts on various paper stocks. Although the units themselves are quite modestly priced, it is via the consumables - the ink and paper - that the cost per print can become high. Some printers use six inks rather than the usual four, with the addition of a Light Magenta and a Light Cyan ink, resulting in purer highlights and smoother gradations. Although these printers are not extremely fast, the convenience and quality of the prints has meant that the desktop inkjet has found a place within many of today's digital imaging systems.

## Wide-carriage inkjet printers

A group of inkjet printers that specialise in the production of large banner style outputs. These printers are becoming extremely popular for commercial purposes where one-off banners or posters are required for advertising or display. Although not usually of as high resolution as their smaller desktop cousins, in most instances the prints would be viewed from a greater distance so that the inherent dot pattern is not apparent. The outputs are not intended for long term display so the lack of archival permanence of the images is not usually an issue.

*Epson Sylus Pro 9600*

## Giclée inkjet printers

This type of inkjet printer (pronounced zhee-clay) is named after the French term meaning 'spray of ink'. Derived from the Iris inkjet printer, which was initially used in the production of proofs for four colour printing, this style of printer is able to output onto watercolour papers, thereby making it suitable for high quality, original art works, multiple originals or extremely accurate reproductions. Printed onto specially coated watercolour papers or canvas with specifically developed inks, these prints have all the continuous tone characteristics and colour saturation of the original artworks. In fact, with further unique embellishment by the artist, they can become individual works of art in their own right. The printer comprises a large rotating drum upon which a stream of ink is directed through a series of nozzles slowly traversing the surface. Each nozzle delivers either cyan, magenta, yellow or black ink droplets smaller in size than a human red blood cell. Although taking considerable time to produce a single print, the quality and accuracy of the results are such that Giclée prints are being accepted by galleries and museums around the world. Advances in archival inks and paper combinations mean that this method of printing is rapidly gaining a respected place within art circles.

# Revision exercise

Q1.    'Screen real estate' is a term that is used to describe:
(a) The number of monitors from which the best model can be chosen.
(b) The overall size of the monitor.
(c)  The size of the palettes and toolbars on the screen.
(d) The area not taken up by palettes, for viewing an image on a monitor.

Q2.    What is the name used to describe the memory utilised by Photoshop when all available RAM is used up:
(a) Scratch disk    (b) Hard drive    (c) Video memory    (d) Cache

Q3.    A RAID is;
(a) A series of hard disks which fill up sequentialy to boost capacity.
(b) A stack of floppy disks which add up to the equivalent of a hard drive.
(c) A combination of RAM chips upon which data can be stored permanently.
(d) A series of hard disks that are used to speed up data storage by dividing the data into smaller units and saving them simultaneously.

Q4.    Which of the following is **not** a removable storage device.
(a) Jaz    (b) Zip    (c) CIS    (d) Super Disk

Q5.    Which of the following scanners would be best for a large format transparency:
(a) Flatbed scanner  (b) Film scanner  (c) Drum scanner  (d) Hand held scanner

Q6.    Interpolated resolution refers to:
(a) Resolution that is in excess of that required for final printing.
(b) The resolution required  to print an image without pixels being visible.
(c) The hardware resolution multiplied by the bit depth.
(d) Resolution achieved through software calculating values for missing pixels.

Q7.    CD-R writers are an effective storage medium which however have one limitation.  This limitation is:
(a) Disks can only be written to once.     (b) They are extremely expensive.
(c) They can only store small packets of information.
(d) They deteriorate when exposed to the atmosphere.

Q8.    Which of the following printers do **not** print using inks or dyes?
(a) Colour laser printers.              (b) Giclée printers.
(c) Digital photographic printers.      (d) Thermal wax printers.

Q9.    Which of the following printers is **not** a continuous tone printer?
(a) Film recorder.    (b) Wide carriage inkjet.   (c) Hybrid digital printer.
(d) Digital photographic printer.

# digital
# scanning and image adjustment

Sandra Walker

## aims

~ To offer an independent resource of technical information.
~ To develop an understanding of procedures involved in scanning photographic images.
~ To develop knowledge and understanding about the control that can be exercised over digital image structure.

## objectives

~ **Capture** digital image files using knowledge concerning:
  - resolution
  - image mode
  - file format and output size
  - image correction and control

# Introduction

It is essential that the information captured during the scanning process is as faithful to the original detail as possible. The complete tonal range of the original (from the deep shadow detail to the bright highlight detail) should be captured. The colour should be recorded accurately (a colour cast should not be apparent). Missing information cannot be replaced later (magic wand or no magic wand).

> **To maximise the quality of the final digital image use a high quality original and spend some time getting the best possible scan from the print or film.**

## Preparing to scan

A good scan will:

~    Have sufficient pixels for the required image size and output device
(see '**Digital basics > Calculating image resolution for output**', page 15).
~    Capture the full range of highlight and shadow detail of the original
(see '**Adjusting tonality and colour**', page 55).
~    Be colour corrected to that of the original
(see '**Removing a colour cast**', page 61).

To ensure a good scan you must have:

~    Knowledge of the file size and/or scanning resolution
(see '**Scanning resolution**', page 54).
~    A clean original image and scanning device.
~    Knowledge of the scanning software controls.

# Scanning procedure

The following sequence of steps is usual in the scanning process:

1. Correctly position the original within the scanning area of the device.

2. Open the image editing software.

3. Go to 'File > Import/Acquire > Twain' to launch scanning software.

4. Select the reflective (print) or transmissive (film) scanning mode.

5. Select an appropriate image mode (RGB or Grayscale).

6. Select a '**descreen**' facility (if available) if the image is from a magazine or book.

7. Select image '**preview**'.

8. Realign original if necessary (preview again if this is performed).

9. Define scanning area using the marquee tool.

10. Select scanning resolution and magnification until required file size is achieved.

11. Adjust highlights, shadows and midtones using available controls.

12. Adjust colour balance using available controls.

13. Select 'Scan'.

14. Check the effectiveness of the scan by assessing the available information via '**levels**' in the imaging software (see '**Levels**', page 56).

---

## Assessing a scan using the image editing software

### Highlights
Highlights with detail and/or texture should be no lighter than level 245 (anything brighter is likely to register as paper white).

### Shadows
Shadows with detail and/or texture should be no darker than level 10 (anything darker is likely to register as solid black).

### Midtones
A fully desaturated midtone in a colour image will be approximately 110 in all channels. If the channels are not similar in value it indicates that the tone is not fully desaturated. A colour cast is present.

# Scanning resolution

Scanning resolution is rarely the same as the resolution you require to print out your image. If you are going to create a print larger than the original you are scanning, the scanning resolution will be greater than the output resolution, e.g. a 35mm negative will have to be scanned in excess of 1200 ppi if a 150 ppi A4 colour print is required (see '**Resolution**', page 11). If the print you require is smaller than the original the scanning resolution will be smaller than the output resolution.

**The smaller the original the higher the scanning resolution.**

In determining the file size and resolution required when scanning a negative, transparency or print you need to know the following:

~    Size and '**mode**' of the final image you require, e.g. A4 RGB, A3 Grayscale, etc.
~    Optimum image resolution required by the printer (proportional to, but not the same as, the dpi of the printer), e.g. 240 ppi is usually the optimum resolution for a 720 dpi inkjet printer (see '**Calculating image resolution for output**', page 15).

| Size & Mode | Optimum resolution required by output device | | | |
|---|---|---|---|---|
| | 72 ppi low quality | 150 ppi medium quality | 200 ppi | 300 ppi high quality |
| **A3 RGB** | 2.86M | 12.44M | 22.20M | 49.80M |
| **A3 Grayscale** | 1.98M | 4.14M | 7.40M | 16.60M |
| **A4 RGB** | 1.43M | 6.22M | 11.10M | 24.90M |
| **A4 Grayscale** | 0.49M | 2.07M | 3.70M | 8.30M |
| **A5 RGB** | 733K | 3.11M | 5.52M | 12.50M |
| **A5 Grayscale** | 245K | 1.04M | 1.84M | 4.14M |

*File Size*

If you know the image size, mode and resolution required to make your final print you can then do either of the following:

~    Create a '**dummy file**' in your image processing software. Go to 'File > New...'. Type in the specifications (size, mode and resolution). This will give you a file size you can aim for when scanning. The dummy file is then discarded. Simply increase the scanning resolution to obtain the appropriate file size.

~    Multiply the proportional change in size (original to required output size) by the resolution required by the printer, e.g. if an output size of 8 x 10 is required from a 4 x 5 original the dimensions have doubled (x2). If the printer requires a resolution of 150 ppi the original should be scanned at 300 dpi (2 x 150 = 300).

**Note. Always scan with a slightly higher resolution or larger file size if you are unsure.**

# Adjusting tonality and colour

The simplest and most basic way to change the appearance of a digital image is via the '**brightness**' and '**contrast**' controls. Although they are simple to adjust they often sacrifice detail and information in the shadow and/or highlight tones. Scanning and image editing software that offer image adjustment via '**levels**' and '**curves**' afford the photographer increased control over the tonal characteristics of the image without sacrificing detail. Levels offer increased control over 'brightness and contrast' whilst 'curves' is the most sophisticated but also the most difficult to master.

## Scanning software

Software that allows for adjustments to be made using levels and/or curves is preferable to software that allows only tonal control using contrast and brightness. This usually comes at a price, as budget scanners usually only come shipped with budget software. Although offering good value for money the software usually limits control and final quality.

Input
adjustment
sliders

Output
adjustment
sliders

*Levels*

## Histograms

A histogram is similar to a bar graph and it shows the relative number of pixels for each of the 256 levels. The sliders beneath the histogram can be used to modify the shadow, midtone (gamma) and highlight tones or levels.

The first action when opening an image in the image editing software should be to check the histogram showing the amount of pixels allocated to each of the 256 levels. In all but exceptional circumstances the histogram should display the fact that pixels have been allocated to most if not all of the 256 levels. The digital image should also display the detail present in both the brightest highlights and deepest shadows contained by the original image. If detail is missing a second scan should be made either by adjusting the brightness and contrast or making use of the adjustments offered by levels and curves if available.

# Levels

After the original image is scanned it is usually necessary to view the histogram to check that sufficient detail in all the levels has been captured during the scanning process. The factors that will degrade the final digital image are excessive or insufficient contrast and an excessive colour cast. In Photoshop go to Image > Adjustment > Levels.

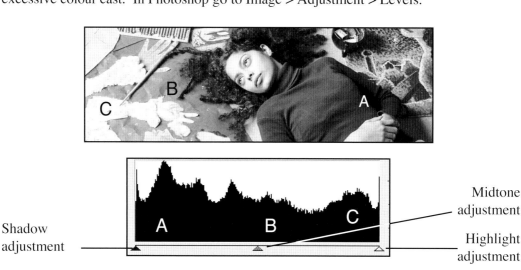

Shadow
adjustment

Midtone
adjustment

Highlight
adjustment

*Original image and the resulting histogram produced after an effective scan capturing both the highlight and shadow detail. Notice the broad spread of peaks representing pixels assigned to all of the 256 levels from 0 (black) on the left to 255 (white) on the right. The letters A, B and C on the histogram correspond to the tones A, B and C on the image.*

*The image above displays a loss of deep shadow and bright highlights (low contrast image). The histogram confirms the absence of pixels assigned to the high and low levels. This could be rectified during the scanning stage by setting '**highlight**' and '**shadow**' values to the image (see '**Correcting a poor scan**').*

*The image above displays a loss of detail in the shadow and highlight tones when compared to the original. The histogram displays insufficient pixels assigned to the midtones. This can be rectified during scanning by altering the highlights and shadow tones using the '**curves**' adjustment (see '**Correcting a poor scan**').*

# Levels adjustment

The adjustment of levels using a computer software program can greatly enhance the visual quality of an image. The finest quality digital images however are produced from digital files (captured from a camera or scanning device) that have a broad dynamic range. This dynamic range is dependent on correct exposure in the camera and/or careful scanning.

The brightest highlights with detail should generally be no higher than 245 and the shadows with visible detail should be above 10 (this can be checked using the information palette). Not all images should have both a white and black point (see image below).

*High key image and histogram*

*Low contrast image and histogram*

*A high-key image with low pixel totals in the midtones and shadows. Some of the lower levels show a complete absence of pixels. The shadow slider could be moved to the right to increase the spread of tones but the overall effect of a high key image would be lost.*

*This low contrast image is due to a poor scan and the resulting dynamic range is narrow. The dynamic range can be improved using the sliders but an improved scan or 16 bit per channel scan should be the preferred options.*

*Improving the tonal range using the sliders*

*The end result*

*To improve a narrow dynamic range using the image editing software click and drag the black and white point sliders to the first levels showing pixels. Moving the centre midpoint slider will lighten or darken the midtones.*

*The results of the adjustments show an image with a broad range of tones and increased contrast. The software cannot however replace missing information in the highlights and shadows. Note the spikes in the histogram indicating levels with missing information.*

# Curves

'Curves' is the adjustment tool that allows the greatest amount of control over tonal and colour characteristics. The use of the curves tool is particularly useful because of the flexibility it provides. Curves lets the user isolate a narrow or broad range of pixel values anywhere between 0 and 255, whereas 'levels' allows adjustments using only highlights, shadows, and midtones. The brightness/contrast tool makes changes to all pixels in the image, e.g. if the brightness command is used to make an image darker, every pixel in the image or selection is decreased by 20 levels. Tonal variations in levels below 20 will be lost as the lowest 20 levels will all be set to 0. If curves are used to make the same adjustment these tonal variations can be preserved.

## The curves dialogue box

When the curves dialogue box is opened the tonal characteristics of the image are represented by a graph (a 45° diagonal line appears in a grid). The horizontal axis of the graph represents the current levels of the pixels (input) whilst the vertical axis represents the changed values of the pixels (output). The straight diagonal line indicates that the input and output values are the same.

At the top of the dialogue box is a drop down menu that allows individual channels to be modified separately or all together.

> **Use the master RGB channel to effect tonal changes and the individual red, green or blue channels to correct colour casts.**

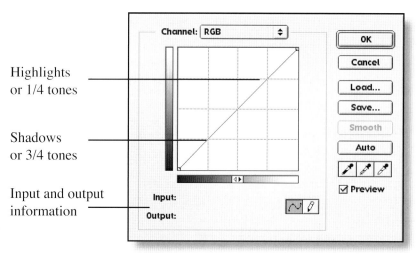

Highlights or 1/4 tones

Shadows or 3/4 tones

Input and output information

Press the option key on the keyboard to access the 'Reset' option.

Double-click the eyedropper icons to set target values.

*Curves*

The graph or curve can be returned to the start position by depressing the Option/Alt key and clicking the 'Reset' feature. The grid of the graph can be changed from a 4 x 4 grid to a 10 x 10 grid by clicking inside the grid box whilst depressing the Option/Alt key.

Black, white and grey target colours or tones can be selected by double-clicking the eyedropper tools (see '**Retouching and Image Enhancement > Target values**', page 130).

## Correcting a poor scan

If information has been lost during the scanning procedure then ideally the image should be re-scanned rather than being corrected using the image editing software. Missing detail cannot be replaced in highlights and shadows. Using the image editing software to correct a strong colour cast will result in a limited range of hues. Likewise resetting the black and white points will limit the broad tonal range in the midtones.

## Tonality

If the initial scan reveals insufficient contrast (no pixels recorded in the low or high levels) or excessive contrast then a number of actions may be possible at the scanning stage.

~    Brightness and contrast
~    Black and white eyedroppers
~    Shadow and highlight eyedroppers
~    Levels and curves adjustment

### Adjusting tonality using black and white eyedroppers

It may be possible to assign black and white points (0 and 255) to the preview image at the scanning stage. Great care must be taken only to assign a black or white point to the darkest or brightest tone in the image (as selected by viewing the **original**). An appropriate white point can be selected from a paper white border on a print or from the brightest highlight such as a light source or reflection of the light source within the image area. A black point can be selected from the film edge or deepest shadow tone visible.

### Adjusting tonality using shadow and highlight eyedroppers

The ability to select shadow and highlight points allows the user to assign the darkest and lightest tones within the image that require detail (typically 8-10 and 245). This requires the user to study the original prior to scanning as this may not be apparent in the preview image.

The 'Epson Twain' software, featured to the right, allows the user to select both the highlight (A) and shadow (B) points with detail. These points can be adjusted (lighter or darker) using the connected sliders. These points can be measured again once the image is opened in the image editing software. The gamma slider is used to control the midtones whilst the threshold slider is used when scanning line art only.

## Adjusting tonality using curves and levels

If the initial scan reveals low or excessive contrast this can be controlled by modifying the levels or curves adjustment if available at the scanning stage. For levels see 'Levels adjustment' in this study guide.

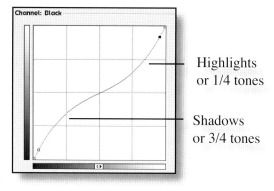

Highlights or 1/4 tones

Shadows or 3/4 tones

The typical shape of a curve intended to reduce contrast by lowering the brightness of the highlights and lightening the deep shadow tones is illustrated in the diagram to the right. The 3/4 tones or shadow tones are raised to reveal detail whilst the 1/4 tones or highlights are lowered.

**Note. If the shadow and highlight tones are moved too far posterization can occur.**

Scanning software such as Epson Twain feature preset curves which can be accessed via a pull-down menu. The standard values used are:

|  |  |
|---|---|
| Highlight: | 245 |
| 1/4 Tone: | 192 |
| Midtone: | 128 |
| 3/4 Tone: | 64 |
| Shadow: | 8 |

To the right are examples of preset curves that increase or decrease the contrast of a scanned image.

## Activity 1

Using a flatbed or film scanner capture an image from an original photograph that has a broad tonal range from deep shadow tones to bright highlight tones (try 600 x 400 pixels @ 72 ppi).

Open this image in your image editing software and describe the shadow and highlight detail when compared to that contained by the original image.

Measure the highlight and shadow tones to see what level has been assigned to each by the scanning process.

Look at the histogram that illustrates the total number of pixels in each of the 256 levels.

Move the shadow, midtone and highlight sliders and record the effects of each on the tonality of the image.

Discuss the difference between effects created by moving the input and output sliders.

## Removing a colour cast

If the initial scan reveals a colour cast when viewed in the image editing software this should be removed at the scanning stage. This may be controlled by using the individual channels in the curves adjustment, moving a target within a colour wheel, a 'gray balance intensity' (Epson Twain) or clicking a grey eyedropper on a neutral or fully desaturated tone within a preview of the image.

*Epson Twain colour adjustment controls. Click the eyedropper on a desaturated neutral tone and move the slider to the right.*

*Including a 'Grey Card' for the purpose of colour analysis. Levels should read:*

R:110          G:110          B:110

## Including a 'grey card' in your scan

A photographic '**grey card**' can be included within the scanning area to assist in colour correction at the scanning stage. The grey card can be placed along one edge or in the corner of the original being scanned using a flatbed scanner and can later be removed by cropping after it has served its purpose. If 'levels' are available at the time of scanning the grey card should read approximately 110 for all channels. Epson Twain scanning software uses a 'gray balance intensity' slider. This requires the selection of a neutral tone within the image area using an eyedropper tool. A gray balance intensity slider is then used to remove the colour cast from the image.

*Grey-card should read approximately 110 in all of the channels*

## Including a 'grey card' in your image

If a film scanner is going to be used to capture the images from 35mm film the 'grey card' can be included in one of the frames at the time of the shoot (making sure the grey card shares the same light that was used to illuminate the subject matter on the rest of the film). If 'levels' are available at the time of scanning the grey card should read approximately 110 for all channels.

# Image size

Before retouching and enhancement can take place the '**image size**' must be adjusted for the intended output (scanning resolution will probably require changing to output resolution). Choose Image > Image Size. This will ensure that optimum image quality and computer operating speed is achieved. Image size is described in three ways:

~ pixel dimensions (the number of pixels determines the file size in terms of kilobytes).
~ print size (output dimensions in inches or centimetres).
~ resolution (measured in pixels per inch or ppi).

If one is altered it will affect or impact on one or both of the others, e.g. increasing the print size must either lower the resolution or increase the pixel dimensions and file size. The image size is usually changed for the following reasons:

~ Resolution is changed to match the requirements of the print output device.
~ Print output dimensions are changed to match display requirements.

*'Resample Image' and 'Bicubic' options selected. Interpolation will lead to increased pixel dimensions and file size.*

## Image size options

When changing an image's size a decision can be made to retain the proportions of the image and/or the pixel dimensions. These are controlled by the following:

~ If '**Constrain Proportions**' is selected the proportional dimensions between image width and image height are linked. If either one is altered the other is adjusted automatically and proportionally. If this is not selected the width or height can be adjusted independently of the other and may lead to a distorted image.

~ If '**Resample Image**' is selected adjusting the dimensions or resolution of the image will allow the file size to be increased or decreased to accommodate the changes. Pixels are either removed or added. If deselected the print size and resolution are linked. Changing width, height or resolution will change the other two. Pixel dimensions and file size remain constant.

# Resampling

An image is '**resampled**' when its pixel dimensions (and resulting file size) are changed. It is possible to change the output size or resolution without affecting the pixel dimensions (see 'Resolution', page 11). Resampling usually takes place when the pixel dimensions of the original capture or scan do not precisely match the requirements for output (size and resolution).

Downsampling decreases the number of pixels and information is deleted from the image. Increasing the total number of pixels or resampling up requires '**Interpolation**' (new pixel information is added based on colour values of the existing pixels).

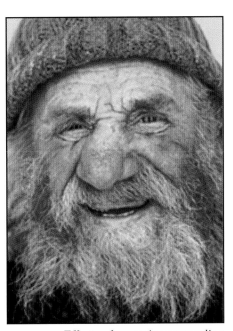

*Image scanned at correct resolution*          *Effects of excessive resampling*

Excessive resampling up can result in poor image quality. The image will start to appear blurry and out of focus. Avoid the need for resampling up by scanning in at a high enough resolution or limiting output size. Applying the '**Unsharp Mask**' filter to an image that has been resampled up can help sharpen a blurry image.

## Bicubic resampling

Resampling an image so that the file size increases will lower the visual quality. If this is necessary use the '**bicubic**' option in the resample preferences and limit the increase to double the original size to minimise the loss in quality. Use the unsharp mask after resampling rather than before and restrict the amount of resampling that is performed on a single image. If the software allows the user to crop, resize and rotate the image at the same time, this function should be utilised whenever possible.

# Cropping

It is possible to rotate, crop and resample an image in one action. Crop to a specific size and resolution in order to optimize the file size and reset the resolution from the scanning to the output resolution.

35 mm film                              4x6 inch print

A scanning resolution of 1800 ppi for
35 mm film and 400 ppi for 4" x 6" prints
results in an 11 MB file size

Width: 10.5 in    Height: 7 in    Resolution: 220    pixels/inch

Output size and resolution
10.5 x 7 inches @ 220 ppi
10.2 MB file size

## Activity 2

1. Scan a photograph to obtain a file size a little over 11 Megabytes.
2. Click the crop icon to display its 'Options'. When using version 5 double-click the crop icon to display its options palette and select 'Fixed Target Size' together with the units of measurement you want from the options.
3. Enter values for the size and resolution of your output image (enter 'in' for inches or 'cm' for centimetres after the unit of measurement when using Photoshop 6 and 7).
4. Drag the cropping marquee over the image to select the area for cropping. When the mouse button is released, the crop marquee appears with handles.
5. Adjust the crop marquee by dragging the handles: Rotate the marquee by dragging the curved arrow icon that appears when the pointer is positioned near a corner handle.
6. Press the Enter/Return key to complete the crop or Esc. to cancel.

**Note. To crop using precise measurements constrains the 'aspect ratio', e.g. an 8 x 10 inch print has an aspect ratio of 4:5 whilst a 35mm negative has the different aspect ratio of 2:3. If the aspect ratio of the fixed target size does not conform to the aspect ratio of the original capture or scan then some loss of the original image will result.**

# Experimenting with levels and curves

It is possible using levels and curves to control the tonal and colour characteristics (contrast and brightness of selected tones and their relative hue) within an image. In this way it is possible to optimize or manipulate the image viewed on the monitor and in print.

## Activity 3

What follows is a simple practical experiment using Photoshop to help you understand the control over tonal characteristics that levels and curves allow.

1. Create an RGB file 450 pixels high and 600 pixels wide. From the File menu choose New (Command/Ctrl + N).

2. Set the default foreground and background colours in the tools palette to black and white.

3. Click the 'Linear Gradient' icon in the tools palette to view the gradient options (double-click the icon when using Photoshop 5 to view the options palette).
Ensure that 100% opacity and foreground to background gradient is selected.
Starting from the far left of the image, drag the cursor to the extreme right side of the image area. This will create a gradient from black to white (0 to 255).

4. Select the top half of the image using the rectangular marquee tool.
From the 'Image' menu choose Adjust > Posterize.
Type 9 in the 'Levels' box with the 'Preview' left on (try typing different numbers in the levels box to observe different effects). Click OK to apply nine tones to the selected area.

5. The tonal range of the top section of the gradient is reduced from 256 levels to just nine. When we adjust the tonal characteristics using levels and curves it will be easier to identify and measure the changes than with the portion of the image that has retained 256 levels.

Level values
18%K (CMYK)

*The levels palette*

The specific levels of these nine tones are indicated on the illustration. The tones in this digital step-wedge are reminiscent of the tonal values used by photographers in the 'zone system'.

6.    From the Image menu select Adjust > Levels. The levels indicate nine very high peaks to show the large number of pixels present in the nine tones created for the step wedge. Drag the input highlight and shadow sliders towards the centre to see the effect on the highlight and shadow tones of the step wedge.

Slide the middle slider to various positions. Observe the effects on the midtones shadows and highlights.

Now drag the output sliders and observe the effects on the highlight and shadow tones. These output sliders reduce the contrast of the image whilst the input sliders increase the contrast.

*The levels is similar to a bar graph and shows the relative number of pixels for each of the 256 levels. The sliders beneath the levels can be used to modify the shadow, midtone (gamma) and highlight tones.*
*The white and black eyedropper tools can be used to set white and black points within the image, e.g. click on the darkest tone within the image with the black eyedropper to move it to level 0.*
*The grey eyedropper tool in the centre is used to remove colour casts from selected tones in colour images.*

7.    From the Window menu choose Palettes > Show Info.

Move the cursor to the centre midtone and note the levels in the RGB info (127). This is the digital midtone if all three channels are 127. A tone sampled in a grayscale file will give only a percentage black reading in the information palette and no specific information regarding its precise level.

**Note. A photographic 'grey card' scanned accurately will register a level of 110 in each of the three channels.**

8.    Select cancel to close palette or hold the option key and click 'reset' to return the levels to their original setting.

*The information palette*

## Activity 4

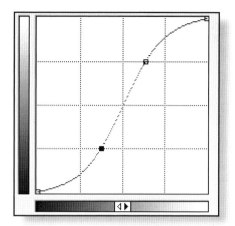

1.   Open the step wedge created for the previous activity.   Open the 'Curves' dialogue box from the 'Image > Adjust' sub-menu.

Click on this diagonal line to add an 'adjustment point'.   Click and drag this adjustment point to create a curve.  Adding additional adjustment points to the line allows a variety of different shaped curves to be created.

Try to create an 'S' shaped curve using two adjustment points.  Observe the effects on both the step wedge and the gradient.

Hold the option key and click 'reset' to return the curve to the original setting.

2.   Move the cursor to different tones on the **step wedge** and click to observe the corresponding points that these tones occupy on the curves scale.  Select a point on the **curve** that corresponds to a dark shadow tone, e.g. Tone 3.

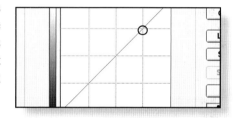

3.   Click on the curve to select a light highlight tone (tone 7).  Move this point up or down to lighten or darken your selected highlight.  You will notice that the shadow tone adjustment point is effectively anchored and will not move.   This technique of isolating tones that are not to be adjusted is called 'pegging'. If you click on the highlight adjustment point you can observe the change of level in the output box at the bottom left-hand corner of the curves dialogue box.

4.   Now use curves on a grayscale image with 256 levels.  Choose a narrow range of tones and attempt to adjust these by using the technique of pegging.  If you are unable to adjust these effectively try selecting a smaller area within the total image area using the selection tools and then proceed to use the curves adjustment.  The curves will now only take effect on the pixels in the selection.

**Note.  When using Photoshop it is possible to apply changes to the levels and curves of an image or part of an image by using an 'adjustment layer' (see 'Retouching and Image Enhancement > Layers', page 123).**

# Revision exercise

Q1. A fully desaturated midtone in a colour image will:
(a) Register 0 in all the colour channels    (b) Register HSB values of 0
(c) Register 110 in all the colour channels      (d) Have a gamma value of 1.0

Q2. A high quality A4 inkjet print is required from a 35mm negative. Which one of the following procedures would produce the optimum digital file for the requirements of the print output device?
(a) Match the scanning resolution to the output device resolution.
(b) Use a scanning resolution that will produce a file size that will exceed 11 MB.
(c) Use a scanning resolution twice that of the output device resolution.
(d) Divide the output resolution by a factor of three to find the scanning resolution.

Q3. What is the average optimum image resolution required by a 720 dpi inkjet printer?
(a) 720 ppi     (b) 720 dpi     (c) 360 ppi     (d) 240 ppi

Q4. What is the purpose of creating a '**dummy file**' in your image processing software prior to scanning?
(a) Provide a canvas for the scanned image.
(b) Identify the correct output resolution.
(c) Identify the correct scanning resolution.
(d) Identify the appropriate file size.

Q5. What is the disadvantage of using the '**Brightness and Contrast**' image adjustment controls?
(a) Does not allow gamma control.     (b) May result in loss of image data.
(c) Does not allow control over the shadow levels.     (d) No disadvantage.

Q6. What does the gamma slider control when using '**Levels**' adjustment?
(a) Midtone values.     (b) The brightness of the monitor.
(c) Overall contrast of the image.  (d) Output print quality.

Q7. Which of the following is not possible using the '**Curves**' image adjustment feature?
(a) Adjust highlight and shadow values independently.
(b) Correct colour casts present in the image.
(c) Increase or decrease colour saturation independently of brightness.
(d) Increase or decrease contrast.

Q8. What is the purpose of '**pegging**' tones using the '**Curves**' image adjustment feature?
(a) To anchor a selected range of tones to prevent them from being modified by the curves adjustment.
(b) To select a range of tones to be modified by the curves adjustment.
(c) To measure the colour values of a range of pixels within the image.
(d) To create movable adjustment points for the creation of 'S' shaped curves.

# Gallery

*Seok-Jin Lee*

# Gallery

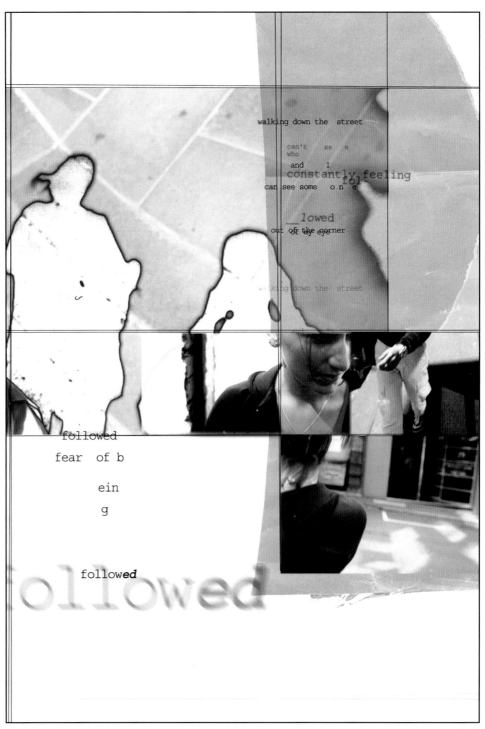

*Andrew Boyle*

# digital colour management

*Les Horvat*

## aims

~ To develop an awareness and understanding of colour management issues.
~ To develop an understanding of how colour is formed and defined in the digital medium.
~ To understand how to implement a colour managed workflow.

## objectives

~ **Research** the different forms of how colour is defined, both with light and with inks. Record your observations and findings.
~ **Analyse and evaluate critically** your findings and exchange with others.
~ **Create** a personal target file for output and testing to facilitate further colour control.

# Introduction

As noted in 'Digital Basics', the three fundamental aspects of colour are hue, saturation and brightness. However, as we are only too well aware, perceptions of colour vary from person to person and are also affected by the history of colour experience of the individual. To add further complexity to an already subjective issue, the different ways that we reproduce colour, through the mechanical and electronic devices at our disposal, have significant limitations that may ultimately alter the actual colour produced.

## What is colour management?

This is a question that often leads to confusion and misunderstanding, so let's begin with a definition of three important terms:

~   **Colour management** - is the adoption of a system whereby all '**devices**' within a chain used to create a colour image are referenced and linked together to produce predictable, consistent colour.

~   **A Colour Management System (CMS)** - is the calibration and profiling of both input and output devices, so that the colour image printed is an accurate interpretation of the image and is consistent with what is viewed on the monitor. Examples of input devices are scanners and digital cameras, whilst output devices include your monitor, desktop printer and the press that has printed this book.

~   **A Colour Management Module (CMM)** - is the software that defines the mathematical manipulations by which colour conversions are made. Some of the manufacturers who make CMMs are Kodak, Apple, Agfa and Adobe.

The degree of sophistication of the particular CMS chosen for any given work environment will depend on many factors, such as cost, portability and complexity of implementation. In this study guide we will examine a number of options that result in satisfactory solutions for predictable colour '**work flows**'.

*From vision to print*

# What is a colour space?

There are two distinct ways we can create a range of colours. The first is by using light and the second is with pigments, dyes or inks. A '**colour space**' is a map of all the colours we can observe when we use a particular method to create that colour in the first place. This colour space is often represented graphically to try to indicate which colours can be 'seen' and which fall outside that particular space. It is possible in fact to create a greater range of colours by mixing light than we can by mixing dyes or inks. To complicate matters further, different inks, different ways of applying that ink as well as different papers upon which it is printed, all have an effect on the final colours.

## RGB colour

Although our perception of all colour is through the reflectance and absorption of different parts of the spectrum by various objects, we can in fact mix different coloured light beams directly to produce new colours. This method of producing colour is known as RGB colour and is made up of the primary colours **red, green and blue**. In fact, red, green and blue light can be added together in various combinations and amounts to theoretically produce all possible colours - hence the term '**additive colour**'. Looked at another way, white light itself is merely a combination of equal amounts of red, green and blue and indeed can be broken up into its respective components via prisms. This additive colour space is therefore known as RGB colour.

**Note. Red, green and blue light mixed in equal proportions forms white light.**

## Activity 1

1. Collect three torches of the same type and size, making sure that the batteries are new in each and that the bulbs are of the same type and wattage.
2. Using the '**tri-colour**' filters red, green and blue, place one onto each of the torches. (Tri-colour filters are merely accurate hues of the selected colour and are available through camera suppliers. If it is not possible to obtain these filters, then any filter gels will suffice although the results will not be as clear.)
3. In a darkened room fix each torch onto a stand and point the red and green side by side onto a screen or white wall, adjusting the beams so that they overlap by approximately one half. Make a note of the colour that appears in the middle.
4. Turn the green torch off, and point the blue torch beam underneath the red beam, overlapping by about a half. Note the colour that appears in the overlapped area.
5. Now turn the green torch back on. (The beams should be positioned so that the blue intersects across both the red and green beams and all three cross each other in the middle.) What is the colour of the area in the middle where all three beams intersect?
6. Discuss what factors may influence the accuracy of this experiment.

**Note. This additive method of colour creation, using three projectors, was the first way that the earliest colour images were produced.**

## CMYK colour

As mentioned earlier the alternative to mixing light to create colour is the mixing of inks. It needs to be understood however that coloured dyes and inks appear colourful due to the action of light upon them. In other words, without light there is no colour. You might care to contemplate the question - in a darkened room does colour not exist or is it merely not visible to the viewer? Each ink absorbs or subtracts light of all colours except the ink's own colour, which is reflected back to the viewer - hence the term '**subtractive colour**'. The three primary subtractive colours are **cyan, magenta and yellow.**

> **cyan** ink: absorbs **yellow** and **magenta** light, but reflects *cyan*
>
> **magenta** ink: absorbs **cyan** and **yellow** light, but reflects *magenta*
>
> **yellow** ink: absorbs **cyan** and **magenta** light, but reflects *yellow*

**Note. When cyan, magenta and yellow inks are mixed in equal proportions on a white page, theoretically all light is absorbed, so the page appears black.**

In practice however, when we print coloured images, rather than relying on the mixing of inks to produce black, a black ink is also commonly used. This is due to the fact that:

~    Black ink is less expensive than coloured inks.
~    The ink formulations of the primary subtractive colours (cyan, magenta and yellow) are not perfectly accurate in reflecting only one third of the spectrum, so the 'black' they produce when mixed is often a 'muddy' brown colour.
~    The paper dries faster as there has been less ink applied.

**Note. With the addition of black as a fourth ink, this subtractive colour space is known as CMYK, where to avoid confusion with B for Blue (in RGB) the K comes from the last letter of the word Black.**

Additionally, an equal layering of CMY inks (resulting in a grey tone on paper) can be replaced with an amount of black ink. This ink replacement technique has two variants - '**UCR**' or Under Colour Removal and '**GCR**' or Gray Component Replacement. Either can be utilized depending on the exact printing process used. It should be noted however, that not all of the colours in a RGB colour space can be reproduced in a CMYK space. In fact, the colours produced by using inks are far less than those that can be created by mixing light - for example in a monitor where the colours are made by firing phosphors of red, green and blue at the screen. Notably, neither method is able to produce the range of colours our eyes can perceive, nor can our eyes perceive the complete spectrum of light. For example, the infra-red and ultraviolet ends of the spectrum are not visible to the eye. We live in a colourful world, but not only is our perception of that colour restricted, but when we try to represent that colour in a printed environment, it is at best merely an approximation!

## Painters and subtractive colour

It is worth taking a little detour here to examine an area of common confusion regarding colour. We have just established that an additive colour system - which uses light - has as its primary colours red, green and blue. In addition, a subtractive colour system - which uses inks and dyes - has as its primary colours cyan, magenta and yellow. How then is it that in art class at school we are often told that the primary colours for painting are red, blue and yellow! Is this not a subtractive system? The answer to this question lies in the fact that what is actually used as red paint is often a very dark magenta/red and the blue is actually most often a dark cyan. If we used pure magenta and pure cyan paints, then a much larger range of colour could be created. The lack of accuracy of these paints is clearly demonstrated by the chocolate brown colour achieved when they are mixed together - as any pre-school teacher cleaning up after an enthusiastic art class will attest!

cyan ink
magenta ink
yellow ink
black ink
final CMYK image

## Activity 2

The inks used in the printing process are often applied at high speed and with very large printing roller presses. It is important that as part of this process as the inks are applied to the paper they exactly register with each other. If that was not the case, a double image would result. To assist in this step, registration marks are often printed in areas of the paper surface to be later trimmed or folded. In addition, as each colour is applied a colour swatch of the ink is also usually printed.

1. Take a box of breakfast cereal and open the bottom flaps. Examine to see if any colour shapes are printed in any folded flaps. How many colours can you find?

2. Find a box with a prominent logo or particular colour scheme on it as part of its overall design. (A pack with gold or silver colours would be ideal.) Open the flaps and look for any colour swatches. Are there more than might be expected? Knowing the deficiencies of the four colour printing process, can you offer an explanation for the extra colours?

3. Examine the areas around the colours. Do any of the swatches have numbers associated with them? To what do you think these refer?

# Colour gamuts

Whilst each colour space depends on the device used to create it, some spaces are inherently able to represent more colours than others. As discussed previously however, none is able to match the colours perceived by our eyes - or in fact that exist in our world.

The range of colours possible within a particular colour space is known as the '**colour gamut**' of that space. In the diagram below, the colour gamut is reducing as we travel down from the original scene to the printed representation of the scene.

greatest colour gamut

smallest colour gamut

*The printed representation of a scene has the smallest colour gamut*

There are sections of the electromagnetic spectrum emitted by the sun, that even the human eye cannot perceive. When a particular space - in this case the colour space of our eye - is unable to define a particular colour it is said to be '**out of gamut**'. The CMYK, subtractive, ink/dye based colour space has the largest number (or greatest amount) of 'out of gamut' colours. For that reason, any printed colour image will only ever be an approximation of both the image as displayed on a monitor and as it exists in our known world.

## How does RGB relate to CMYK?

The visible portion of the spectrum of light can be reproduced by combinations of additive primaries red, green and blue in varying amounts. It would stand to reason that the subtractive primary colours - cyan, magenta, and yellow - created by the absorption and reflection of sections of the spectrum can also be created by directly mixing together combinations of red, green and blue light. This is indeed the case, as demonstrated by the following table which indicates the relationship between the two sets of primary colours.

| | | | | |
|---|---|---|---|---|
| **Red** and **Green** | make | **Yellow** | the opposite of **Yellow** is - | **Blue** |
| **Red** and **Blue** | make | **Magenta** | the opposite of **Magenta** is - | **Green** |
| **Green** and **Blue** | make | **Cyan** | the opposite of **Cyan** is - | **Red** |

*The subtractive and additive primaries and their relationship together - a colour's opposite is sometimes referred to as its '**complementary**' colour.*

## Device independence

Whilst both the RGB and CMYK colour spaces depend on the physical attributes of the devices used to create them, light itself can be measured accurately and consistently. It is therefore also possible to measure the colour produced by light in a pre-defined and accurate manner. As a consequence, various smaller RGB colour spaces can be defined as a subset of the RGB space itself. This means that these colour spaces contain most, but not all, of the possible colours of the RGB colour space. Some of the more common ones in use are sRGB, Adobe RGB, Colormatch RGB and Bruce RGB.

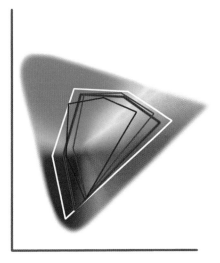

These colour spaces are '**device independent**' since they can be defined and measured completely independently of any hardware that may utilise, or have even initially created them. It is this capacity to replicate colours independently of the device that is the basis of any colour management system - allowing the mapping of colours from one space to another.

*A diagram showing the theoretical colour space of light based on the CIE model (Commission Internationale de l'Eclairage). Within this diagram is the RGB colour space (shown as a white line) and inside that area are a number of actual RGB colour spaces.*

## Device dependence

Unlike RGB colour spaces based on light, those that rely on the application of inks are not as easy to measure and control. Some of the variables that may affect the reproduction of colour when using inks and dyes are:

- ~ Ink absorption characteristics of the paper stock
- ~ Ink texture and viscosity
- ~ Amount of ink applied to the surface
- ~ Ink formulations
- ~ Application methods used to place the ink onto the surface
- ~ Paper colour and formulation
- ~ Paper surface texture

All of these will impact upon the colour of the finished piece. As a result, CMYK colour spaces are said to be **device dependent,** since each printing device will produce a colour space (or a map of possible colours) that is to a greater or lesser extent different from another device.

> **As a result a CMYK colour space is defined in terms of a particular printing device and is not necessarily applicable to a different printer.**

Because of this close relationship to the particular printer, for the colours to be at all accurate, any file converted to CMYK will need to be printed on the type of printer defined in the CMYK space used. For this reason it is important not to archive digital files in CMYK format unless they will be outputed via a known device - but even then a 'master' RGB version should be saved.

## What is a profile?

Since all hardware devices reproduce colour slightly differently, for any CMS to be useful, hardware must be calibrated and an accurate profile created. A profile is a set of mathematical measurements that defines the reproduction of colour for a particular device. With a properly calibrated system, the various profiles interact to ensure each bit of data matches with the particular device to give the expected result. This is often termed WYSIWYG or 'what-you-see-is-what-you-get', an outcome that is the ideal requirement for all digital imaging outputs. Now, as a result of our understanding of colour spaces and profiles, we can examine what is meant by colour management in a more sophisticated way. The following sentence gives a more accurate definition.

**Note. Colour management or 'colour workflow' is the translation of an image file from one colour space to another, using the profiles associated with the devices within that workflow.**

# Colour concepts in practice

So far we have examined various aspects of colour and how they relate to the construction and representation of images. Whilst this topic in itself can become quite complicated and confusing, it is essential that a sound grasp of the fundamentals is achieved. The following activity is designed to re-inforce those fundamentals in a practical manner.

## Activity 3

1. Click in the foreground palette and open the colour picker.
2. Slide the colour slider to the top of the range, which should be showing red. Move the selection circle to the top right of the picker window, thereby choosing a bright red colour. Make sure that Hue is selected in the radio buttons at the right of the window.

**Remember, the monitor is an RGB device, i.e. it produces the image by mixing light, therefore a wide range of colours is available.**

3. Examine the detail on the right side of the colour picker. The two columns of numbers refer to the values of the chosen colour in three different ways. In other words the colour is being described in three different colour spaces. The first is HSB, or hue saturation and brightness - see **'Colour'**, page 6. In addition there is RGB, CMYK and finally there is LAB. This colour space (sometimes also known as CIELab) is the space that describes all the colours theoretically possible. As such it is the largest space we can define.

4. Take a note of the values in the RGB and CMYK boxes. The amount of black is zero, indicating that the colour is pure - no grey has been added. In addition, the cyan is also zero - as expected, because red is made up of yellow and magenta. In the RGB domain, we see that pure red contains no additional green or blue, again as one would expect.
5. Click on the selection circle and move it around the picker window. Notice how the red becomes darker as more black is added. Likewise, it becomes less pure in hue as it is defined by additional amounts of green and blue (in RGB), or cyan (in CMYK). Move the selection circle about and note the values in both RGB and CMYK as the colour changes.

## Activity 4

1.  Go to File > New and create a new file of 75 pixels/inch resolution and 295 x 295 pixels in dimension. Using the red colour chosen in the previous activity, fill the file with this colour by going to the menu command Edit > Fill.

2.  Now chose the elliptical marquee selection tool and draw a circular selection within the image area. Then choose the gradient tool in the toolbox and click on the gradient window under the menu bar - the gradient editor should now appear.

3.  Pick a rainbow style gradient and apply it within the selected area by dragging a line from the top to the bottom of the circle. The circle should now be filled with a rainbow of colours.

**Note. The end result should be a vivid circle of colours within a red background.**

4.  Save this file and repeat step 2, this time using a pure green and a pure blue colour as the background. Save each file.

5.  Draw a circular selection in each file and fill with a rainbow gradient.

6.  Taking each file in turn, create a new window for the file by selecting View > New View and choosing View > Proof Setup > Working CMYK in Photoshop 6 or View > Preview > CMYK for Photoshop 5.0/5.5. Preview each of the files in turn with both the CMYK and RGB versions on screen at the same time and compare the two. What do you notice about the colours in the CMYK previews? Which colours are most affected? What does this indicate about CMYK as a colour space?

# Applying colour management

Any environment where colour management is to be applied will as a first priority require calibration of the devices that are being used. Of these devices, the monitor is perhaps the most critical as any subjective judgements relating to an image will depend on the monitor and how it displays the image. If the monitor is totally uncalibrated, it is akin to looking at an image with tinted glasses - and not even knowing what colour the tint is!

## Calibrating the monitor

Whilst all monitors function in a RGB space, each monitor behaves a little differently depending on its mechanical and electronic design. In addition, monitor colour changes over time - over short periods as the unit heats up and stabilizes, as well as over longer periods as it ages. For this reason, to maintain accurate colour a monitor should be calibrated frequently, but only after it has been on for at least half an hour. Before calibration, the viewing environment should be examined and a number of simple steps taken.

~   Reduce glare and reflections from nearby walls or windows.
~   Construct a viewing hood out of black cardboard and drape it over the monitor to minimise glare. This hood should protrude at least 30 cm over the top of the monitor.
~   Reduce the room light so that it does not 'overpower' the monitor.
~   Make sure the room lighting is consistent. If necessary, remove some bulbs or connect all lights to the one switch.
~   Use lighting that is as neutral as possible. This is equally important for the viewing of printed outputs.
~   Remove any coloured and heavily patterned wallpaper on the monitor desktop as this may interfere with the visual perception of colours.

## How computer systems vary

Unfortunately, there are differences in the way that Macs and PCs use colour management. With a Macintosh the CMS is known as '**ColorSync**' and is built into the operating system and available for applications which are designed to use it. This system level software is one of the reasons that the Mac is favoured by imaging professionals. On a Windows platform the CMS is known as '**ICM**' and uses the same basis as ColorSync to manage colour reproduction. It is at last also available (since Win 98) to be used at system level and should lead to fewer differences in the way that colour is reproduced on a PC and Mac than in the past.

## Software calibration

This method is the least complex to implement and involves the use of software such as '**Adobe Gamma**' (available with Photoshop on both Windows and Mac platforms). Accessed via a control panel, this software includes calibration of the white point, contrast, brightness and '**gamma**' of the monitor. The resulting profile is saved as an '**International Color Consortium**' (ICC) file, the industry standard for profile description.

## Activity 5

Although this type of software takes the user through the process step by step, in reality it can take a little practice to be accurate with the settings as they rely on subjective assessments. For this reason it may be a good idea to enlist the support of an experienced friend during the procedure. Also make sure the monitor has been on for at least 30 minutes so that the display has stabilized.

1. Open Adobe Gamma either by Start > Settings > Control Panel in Windows or Apple Menu > Control Panels with the Mac OS. (Win 95 and Win NT users cannot incorporate the resulting profile at system level, so Win 98 or above is recommended for PC users.)

2. Upon opening the Gamma control panel, you will be asked if you wish to use the 'Step By Step' method or simply the control panel itself. The former is the option described - so choose this approach. The next step allows the loading of an ICC profile to describe the monitor characteristics. The profile initially offered is the standard profile that shipped with the monitor and this default is usually a good starting point.

3. Next, we need to make changes to the brightness and contrast. Using the monitor controls, adjust the contrast to the highest value. Then adjust the brightness so that the inner square is only just visible. (Due to factory settings which vary from monitor to monitor, this step may be difficult to achieve - simply choose the closest possible adjustment.)

4. The following screen requires selection of the phosphors used by your particular monitor. To determine these settings either consult the supplied handbook or choose between the two most common types - Trinitron or P22-EBU. Any tube manufactured by Sony (of which there are many including Apple) uses Trinitron, whilst Mitsubishi, Hitachi and Radius all use a Diamondtron tube which uses P22-EBU phosphors. Remember that all tubes age and alter their characteristics over time, so that the actual settings may not exactly match these settings anyway.

5. To adjust the gamma of the monitor, ensure the View Single Gamma checkbox is **not** ticked. Select either 2.2 or 1.8 depending on whether your system is Windows or Mac OS, then adjust the sliders under each box to fine tune the result. To perform this rather tricky step, sit back a little from the monitor and squint your eyes until the lines on the outer boxes begin to disappear - this will enable a better blend with the inner tone.

6. Next, the white point of the monitor needs to be determined. Ensure step 5 has been completed accurately or this step will also be affected. Since monitor phosphors change with age, the actual white point will need to be chosen - so select the Measure option for Hardware White Point.

7. The Adjusted White point is the setting you want the monitor to use when displaying images. This can be settings such as paper white (5000°K), or daylight (6500°K). However, in practice it is advisable to chose the Same as Hardware option which selects the setting you determined in step 6, as this avoids any truncation of the monitor's dynamic range.

8. Finish and save after viewing the 'before' and 'after' options to determine how the display has changed. (If necessary go back to adjust any settings again.) Make sure the profile is saved to a new name such as MonitorDateSetting - this will now be the profile used by the system and defines the Monitor Space.

**Note. Do not touch any brightness or contrast buttons on the monitor after calibration, as any alterations will interfere with the created profile.**

## Hardware calibration

Without doubt the most accurate means of calibrating a monitor is through the use of a hardware device, known as a 'colorimeter', which sits on the face of the screen via a suction cup and actually measures the red, green and blue light being emitted.

The associated software then builds a profile based on any variations from the expected values.   This approach eliminates any individual colour bias which could affect a subjective method such as using Adobe Gamma.  Whilst the use of a colorimeter is more complicated and expensive than simple software calibration, prices have come down radically over the last few years and the applications themselves are becoming easier to use.   Some very sophisticated monitors even have built-in calibration capabilities.   These special monitors are more expensive than most entry level displays, but are capable of re-calibrating themselves throughout their life and thereby offer unparalleled performance.

*X-Rite and Colorvision colorimeters, used to calibrate the monitor via screen attachment.*

**Note. If a monitor is not calibrated there can be no confidence in the on-screen colours displayed being a true representation of the image.**

## How is this monitor profile used?

The aim of colour management is to produce consistent and expected outputs, but the type of system we need to implement depends on our particular requirements.  The least complex solution is where we have a 'closed' system - the computer being connected to an input device such as a scanner or digital camera and an output device such as an inkjet printer. In such a system, the image files will only ever move from one of these devices to another, so it does not really matter if our profiles are not accurate (in terms of an accepted industry standard), as long as they operate successfully within the loop.  This type of arrangement is extremely easy to set up and if the need to use outside printing or scanning services is not an issue, is a very functional means of achieving consistent results.

**Note. This was the only type of colour management possible before software able to work with ICC profiles was introduced.**

The alternative to the above system is based on ICC compliant profiles.  These profiles are tagged onto images, which then results in adjustments being made to image data as it moves from one device to another -  an open, universal colour management system.

# Gallery

*Justin Ridler*

*Hock Loong Goh*

# Gallery

*Seok-Jin Lee*

*Les Horvat*

# digital
# managed workflows

*Les Horvat*

## aims

~ To offer a resource of technical information about colour workflows.
~ To develop an understanding of the procedures involved in producing printed outputs that match colour expectations.
~ To develop knowledge about the ways that managed workflows can influence colour.

## objectives

~ **Research** a range of managed workflows using the input and output devices available.
~ **Analyse and evaluate** the effectiveness of the workflows implemented and exchange ideas and opinions with other students.
~ **Personal response** - produce a series of digital ouputs that demonstrate the outcomes of the workflows investigated.

# Introduction

The purpose of a colour managed workflow is to endeavour to get one device to represent accurately the colours depicted on another device - or perhaps even the colour of the 'original' document. As discussed in the previous chapter, there are many reasons for inconsistencies in colour reproduction. Different devices represent colour differently, depending on whether they are RGB or a CMYK devices - whether they use inks or light to 'manufacture' their colour. In addition each device has its own range of colours that it is capable of reproducing, some having a large colour gamut, others possessing a quite restricted gamut (see 'Colour gamuts', page 76).

## Implementing a workflow

Setting up a workable system of colour management which will deliver consistent results - in effect creating a managed workflow - requires either the first or both of the following:

~   **Calibration of devices.** This needs to be addressed at regular intervals as all device capabilities and performances will change over time (see 'Calibrating the monitor', page 81). Calibration ensures that all devices conform to an established state or condition. Note that this is **not** the same as a '**default**' state.

~   **Creation of device profiles.** A profile is a 'signature' for a particular device that describes the colour capabilities of that device. This enables software (either ColorSync on a Mac or ICM on a PC) together with a CMM to convert colour between device dependent and device independent colour spaces. This implementation of a profile based workflow enables consistency, even if a file is moved from one chain of devices to another - as long as the new device chain also uses ICC based profiles.

*A closed loop system*

In the diagram above, the closed loop set-up requires calibration of devices but does not rely on the use of profiles.

# Using a closed-loop system workflow

This is the simplest implementation of a colour workflow - relying entirely on being able to match all of the devices within a specific hardware loop. This method is most suitable for those users who:

~ Operate with software that does not include options for colour management, e.g. Photoshop LE.

~ Operate within a completely controlled environment where all input and output is regulated to the hardware that forms the workflow loop. For this system to be totally effective, files will not originate from sources other than from the loop input devices themselves - such as a scanner or digital camera.

## Activity 1

1. Go to Edit > Color Settings and select one of the pre-press default options under Settings. This will result in Adobe (1998) RGB being set as the working space. For further discussion on this topic, see 'What is meant by a working colour space?', page 91.

2. Choose an RGB file that has a large range of colours and tones - your target image, making sure to include subtle shades of grey and skin colour. See Assignment at the end of this chapter for production of such an image. (Similar files are sometimes supplied with scanners or printers.)

3. Output the file via the printer attached to the system and do not make any colour or tonal adjustments through the printer driver software. Hold the print under neutral lighting conditions as close as possible to your monitor and using Adobe Gamma, fine tune the settings for the gamma of the monitor (as for Activity 5, page 82) so that the monitor display matches the printed output as closely as possible. Make sure the 'View Single Gamma Only' check box is **not** ticked so that individual colour adjustments can be made.

4. Save the created profile under an appropriate name, such as 'myMonitorPrint'. This profile has now adjusted the monitor so that it displays the file to match as closely as possible the target print. (Use this monitor profile as a preview of how an image will appear when using the system's printer for output, see 'Using soft proofs', page 105).

5. Now take the print and scan it with the scanner attached to the system. Alter the scanner settings via the supplied scanner software until the displayed, scanned file on the monitor looks as much like the original file, as well as the print. Save this setting for the scanner under an appropriate name and make sure it is used for all scans.

**Note. The system has now been calibrated so that a WYSIWYG outcome is achievable. However, it does not mean that the colours are 'correct', in fact the quality will depend largely on the quality of the devices - particularly as both the monitor and scanner have really been set to match the printer's limitations.**

# Using profiles in a managed workflow

In a closed-loop system of colour management, since all the variables of input, display and output are dealt with by a limited and known series of devices, the end result can be controlled and predictable. However, if at any stage another device external to the loop is used, e.g. a different scanner or printer, then the results can be impossible to predict. This is when a more formalised process of colour management is necessary. Such a system, based on universally recognised ICC profiles, enables files to be moved from one system or device to another - with associated predictability. Software such as Photoshop can help in the creation of this universal approach, which relies not on visual, subjective adjustments to colour outputs, but on ICC profiles which control the necessary changes to achieve consistency.

**Note. As the image moves from one device to another, it is adjusted by the CMS via its associated profile, so that the image is consistently displayed on all hardware in the chain.**

*Profiles as applied through the workflow*

## Tagging

Calibrating the monitor within a system (whether via software or hardware) results in the creation of a unique ICC profile. As each monitor has its own unique characteristics (and profile), identical RGB values are displayed somewhat differently on each system. Differently, that is, unless the particular profile is embedded into the image file itself. Then the system could adjust the RGB values so that they display identically on both monitors. This process is known as '**tagging**', and is supported as an automatic step in many versions of image editing software available today. However, tagging the image with the monitor profile would mean constant changes to the image data are required as the image is transferred from one system to another. This is where the '**working space**' becomes important.

## What is meant by working colour space?

As discussed in the previous section, every monitor will reproduce colours in its own way, within its RGB colour space. Since each monitor is slightly different, this unique monitor colour space (characterised by its profile) if tagged onto the image would result in changes to the image data **every** time the file is displayed on a different monitor. The more often the file travels backwards and forwards between different systems, the more the file is altered; resulting in greater potential for loss of information. It would therefore seem that tagging the monitor profile onto the image is not a total solution to consistent colour, since it could lead to image degradation, as the file is moved from one system to another.

**Note. The solution to this problem is not to embed the actual monitor profile used by the system, but a pre-defined 'working space' RGB profile instead.**

*An image displayed on two monitors, with each display adjusted by its own profile.*

This 'working space' is precisely defined and even more significantly is device independent. Which means that any two systems running the same working space profile will not require changes to the **actual image data**, only to the **image display data**. This is a big advance in colour management, as now whatever platform or hardware is used the device independence of the RGB image colour is assured.

**Note. In practice, the *monitor profile* determines how the image displays on the screen, whilst the *working colour space* determines the actual RGB colour data of the image. Monitor profiles are often included with software such as Photoshop, as well as the operating system.**

## Activity 2

1. Open any RGB image that has a wide range of colours.

2. Go to Image > Mode > Assign Profile. Make sure the preview box is ticked, click on Profile and choose any monitor profile from the drop down list. Click OK.

3. Observe how the image colour changes as each new profile is selected. The changes can be compared by simply toggling the tick on and off in the preview box. Notice how this change is not necessarily uniform in nature, but affects some colours more than others.

## How to choose the working space

A number of RGB colour spaces are included in Photoshop (aside from individual monitor spaces) as alternatives that can be selected as a working colour space. Each has certain characteristics and requires some further explanation:

~    **Apple RGB** is based on the Apple 13" monitor and is the old default space.

~    **sRGB** is a restricted monitor space most suitable for web based usage.

~    **CIE RGB** is based on the CIE colour model.

~    **Adobe RGB (1998),** which was previously known as **SMPTE-240M**, is a very useful standard, wide enough for most RGB and CMYK print work. It is the space of choice for many image professionals working in print.

~    **Wide gamut RGB** is an extremely large space that will cover all RGB possibilities, but it includes many colours that are not printable.

~    **NTSC** is a TV standard.

~    **PAL/SECAM** is a European TV standard.

~    **ColorMatch RGB** is a standard based on a commonly used pre-press monitor. It has a slightly smaller gamut than the AdobeRGB space.

~    **Monitor RGB** is the space associated with the profile made for your individual monitor. Only use this space if broader colour management is not required, e.g. for closed-loop setups.

**Note. In Photoshop the default colour space is sRGB, which due to its restricted gamut is not suitable for print work. Therefore it is important to change the working space to a wider one that is more suitable for printed output - for example Adobe RGB (1998). Photoshop 6 and 7 will automatically set this as the default if you change Settings in the Color Settings window to any of the press defaults. See step two in 'How to set up an ICC profile based system', page 94.**

## A colour space analogy

To be able to make sense of the theory behind a colour managed workflow, it is essential to understand the difference between a monitor space and a working space and to be clear on how they are each utilized. To clarify this concept, consider the following analogy:

**The working space can be thought of as a large box of coloured pencils and the monitor space as a piece of paper.**

As long as the box of pencils is large enough, we have no problem in reproducing most of the colours of a viewed scene. If the range of pencils in the box is too small however, then some colours cannot be reproduced. I\On the other hand, if the range of pencils is very large, we may even have some left over that are not being utilised! The paper we choose, or more precisely the colour of the paper we choose, will determine exactly which pencils we need to reproduce each colour. In this analogy, a large box of pencils equates with a large gamut working space, whilst the display vehicle of our image - the paper upon which we use the pencils - equates to our monitor space.

## Activity 3

Imagine you are a graphic artist given the task of copying onto paper the logo of a particular company. This company, called Spectrum Enterprises, has a logo that contains a rainbow coloured band with a white square. You are given a box of twenty coloured pencils (your 'working space') and a sheet of white paper (your 'paper space').

1. Take a set of coloured pencils and copy the logo onto a white piece of paper, as accurately as possible.

2. Now take a yellow piece of paper and with the same set of pencils copy the logo again. Notice this time you have to use a white pencil to create the centre square - but the yellow coloured pencil is not required at all. In other words, to replicate the logo accurately, different pencils from the set need to be used when the paper colour changes. If this were expressed in terms of a mathematical expression or profile, it could be said that a 'paper profile' needs to be applied, so that the right pencils are selected for the logo to be reproduced correctly onto the yellow paper. It then would follow that each time the paper colour changes, a new 'paper profile' needs to be used - even though we are still using the same set of pencils!

White pencil needed          Yellow pencil not needed

Yellow paper

3. This time, try to draw the logo with only three pencils. Try again on the yellow paper. Observe how when the coloured pencils are reduced in number, no matter what paper we use, the logo cannot be reproduced properly. It is clear that this small set of three pencils is a working space that is simply too small to draw the required logo. The relationship between the paper (display space) and the pencils (working space) becomes apparent.

**Note. In digital imaging the 'display space' is the monitor space and the 'working space' is the selected RGB space assigned via the colour set-up.**

# How to set up an ICC profile based system

Setting up a workflow that is compatible with universally accepted standards requires the use of ICC profiles. This enables colour management that will give predictable results - no matter what devices are used in the process. To set up such a system requires a number of steps. Each step in the process needs to be followed carefully, and once implemented the system settings should not be arbitrarily altered. The biggest obstacle to proper colour management is the lack of understanding of the process by some users who then alter one or more aspects of their system thereby breaking the process chain. For users of Photoshop LE the only step possible is Step one, as LE does not have colour management available.

## Step one: calibrate the monitor

As described in the earlier section, the monitor must be calibrated so that the representation of the image on the screen is accurate. Whilst it is possible to work purely using the actual values as indicated through the info palette, image creation is a subjective activity that relies on constant aesthetic judgements being made and without doubt to be able to see the image accurately on screen is important.

## Step two: configure Photoshop

The process of configuring Photoshop is one of the most important steps towards creating predictable colour. In this regard, significant changes have been made from earlier versions of Photoshop (i.e. prior to version 6) and would alone justify the price of an upgrade. Aside from fixing numerous aspects of functionality, Photoshop 6 fundamentally changed the way working spaces were set up and applied. The most significant change was that unlike Photoshop 5, where all open documents had to have the same working space, from Photoshop 6 onwards document specific colour - profiles tagged within the files themselves - enabled the correct display of multiple documents at the same time regardless of the working space set by the user. This is most important when two or more images are being merged together - especially if they originate from different sources and unnecessary conversions from one space to another can thereby be avoided.

## Choosing a working space

Whist the choice of working space to ensure the correct display of an image is not as critical as it was with Photoshop 5 (since later versions incorporate document specific colour), the choice of appropriate work space should be based on the needs and intentions of the user. For example if most image creation is for web based purposes, then the sRGB space is recommended as it has a gamut around that of many PC monitors. On the other hand if images are usually printed, then a space such as Adobe (1998) or ColorMatch would be most appropriate as they are wider than sRGB. If the chosen colour space is too large, e.g. Wide gamut RGB, many colours will not print and so images that look great on the monitor will look disappointing when printed. Where the choice of working space does have a definite bearing is in the CMYK space chosen, as this will affect the way an image will print when sent to a specific printer.

## Colour settings

One of the most information rich dialogue boxes in Photoshop is Colour Settings which can be found under Edit > Colour Settings. Whilst at first glance it may appear a little daunting, the fact that most of the options available to the user are grouped together is in fact a real benefit. In addition, Adobe have created a number of pre-sets to help with the decision making. Ticking the Advanced Mode box expands another two sections.

The first section is a pop-up menu entitled Settings, where various pre-installed configurations are stored, as well as any custom settings you may subsequently create. This menu actually controls the settings on the other areas of the dialogue box, so it is possible simply to choose the required option from the menu and all the individual choices will be taken made automatically.

The second section is entitled Working Spaces and it is here that the device independent RGB colour spaces stored on your machine are accessed. For mainly printing outputs, Adobe RGB (1998) is a suitable choice (see 'How to choose the working space', page 92). Notice that Monitor RGB is also available, but it is not recommended as a working space, since this will restrict files to the characteristics of your monitor (see 'What is meant by working colour space?', page 91).

## CMYK working space

Because CMYK is a device dependent colour space (since it is defined by the printer's capabilities) it is this choice of space that will affect the way a CMYK file will print on a press or **'PostScript'** printer. Photoshop has a number of pre-sets under the 'Settings' section mentioned previously, which will take care of the appropriate CMYK choice for you. So if, for example, your output is for European, Japanese or U.S. printing presses, then choose the appropriate Settings default and the correct CMYK space will be automatically chosen. However it is also possible to make these choices individually, particularly if specific output for particular known printers is required, (see discussion on 'Advanced CMYK' in **'Printing and pre-press'**).

## A word about consumer inkjet printers

As discussed earlier, an RGB defined space is created using light and a CMYK space is created using inks or dyes. Why is it then that many consumer inkjet printers label themselves as RGB devices and require RGB files for output to achieve the best results?

The answer to this question lies in the nature of the CMYK space. Since converting an RGB file to CMYK is device dependent and will depend on the set-up being used, to avoid complications, entry level, consumer inkjet printers - such as the Epson series - allow the inbuilt printer driver to convert the file to CMYK. That way, the printer is always using the greatest possible information (via the larger RGB space) to output the image. The result is that these relatively low cost desktop printers can produce extremely high quality 'photographic' output, without the user needing to possess sophisticated colour knowledge.

*Epson 1290 inkjet printer*

**Note. Because most inkjet printers have this characteristic, the particular choice of CMYK working space selected is of no real consequence  - since the printer requires RGB data files anyway.  CMYK working spaces are only relevant when files are sent to a CMYK device, such as a printing press.**

## Colour management policies

Within this section choices are made which determine how Photoshop behaves when images are brought into the system from external sources. This is a complicated aspect of Photoshop, and the way versions prior to Photoshop 6.0 dealt with it were fundamentally different and significantly inferior, so to avoid confusion this discussion will focus only on Photoshop 6.0 /7.0. Three alternative 'Policies' are offered by Photoshop:

~  **'Off'**  Use this option only if the intention is not to use any colour management with Photoshop. This is not a recommended setting, unless you have a particular, closed-loop, 'by the numbers' workflow. Even then, the minute a file is moved to another system, the image will look different. The numerical values of the colours will remain unaltered, but they will mean different things within different set-ups.

~  **'Preserve Embedded Profiles'**  This setting provides the most flexibility when dealing with files from various sources. An image with a tagged profile opens in its own working space regardless of the working space set on your machine. The display of the image will be adjusted by the monitor profile in use, so it will look as it was intended, and after editing it will be saved with its original profile. If the file has no tagged profile, it will be saved without one. All of these options can however be altered on a case by case basis if the 'Ask When Opening' and 'Ask When Pasting' checkboxes are ticked. This is highly recommended as it enables choices to be made where the default option set by the 'policy' chosen may not be appropriate. For example, if the original file does not have a profile embedded, it can be opened with the working space profile tagged to the file.

~  **'Convert to Working Space'** This setting automatically gives preference to your selected working space and converts all incoming files to be tagged with that profile. This is not necessary to view the file correctly on your monitor and would only be the preferred workflow if you were part of a controlled work situation where your files rarely move to other systems. In particular, it is unlikely you would want an incoming CMYK file profile converted, as it would most likely be defined specifically for the device on which it is intended to be printed.

## Step three: calibrate the scanner

As for any hardware device, a scanner will function within its own colour space. Therefore within a managed workflow it will be necessary to tag the scanner colour space to the image, so that the image can display correctly on the system into which it is imported. When this occurs the image should appear on the monitor as close as possible to the original. If however the scanner is not properly calibrated, the profile tagged to the image will not provide accurate information to the system and the image will not appear correct. This is why it is essential to calibrate the scanner properly. Numerous third party software applications (e.g. EZColor, GretagMacbeth, X-Rite) are available to help with this task.

Usually supplied with the software or the scanner, a reference target (often called an IT8) is scanned with all settings set to their default. This reference target is available in both a print and a transparency version, each with a corresponding reference file of expected values. The scanned version is compared through the calibration software with this reference file and a profile is created.

**Note. Ensure the profile has been saved in the correct folder so that Photoshop can make use of it. For Windows, it should be in Windows\System\Color Folder and for the Mac in the ColorSync Profiles folder, within the System Folder.**

## Step four: calibrate the printer

The production of the printer profile is once again created by software specifically designed for the purpose, and can often be part of the calibration suite used to calibrate the scanner or indeed the monitor. There are two methods that can be used:

~    Using a '**spectrophotometer**' - an instrument that will directly measure the printed colours - to determine the values of a known target, printed on the device to be calibrated. These values are then compared with the original expected values, similarly to the scanner calibration, and a corresponding profile built.
~    Using the scanner to scan in the printed output of the target and then making the comparisons with the known values through the calibration software.

**Note. Remember to disable any printer colour management during this procedure.**

The latter method, although cheaper - in that it does not use any expensive hardware - is less accurate since it relies on the calibration of the scanner and its associated profile. Other limiting factors include the texture and reflectivity of the test target paper. Once again the profile is stored in the required folder for access by Photoshop, or other imaging software.

# Assignment - creating a target image

The aim of this assignment is for you to create a test image for printing and viewing purposes. This image should be saved as a reference target for calibrating any devices within your workflow.

1. Choose four images that contain a good range of colours and tones. Highlights having detail as well as shadows with detail are essential in at least one image. In addition one image should contain skin tones. If these images are not already available as digital files scan them at 300 ppi to about A5 size.

2. Use the step wedge from Activity 2 ('**Scanning and Image Adjustment**', page 64) and save with a suitable file name. Create another step wedge as previously, but this time posterise with 12 steps.

3. Select the entire file (Select >All) and copy it to another layer five times. The end result will be six layers each containing the same grey step wedge.

4. Go to Image > Adjust > Hue /Saturation and click the Colorize button. Then drag the saturation slider to approximately 75. The active layer should now be red.

5. Repeat this process for each layer. Making each layer active in turn, move the Hue slider until green, blue, yellow, magenta and cyan step wedges are created, in addition to the red. The Hue values to use are: green - 100, blue - 225, yellow - 55, magenta - 315, and cyan - 200. (For yellow, magenta and cyan a saturation value of 90 works best.)

6. Make each layer active in turn and using the Move tool, drag until the layer underneath is exposed. When all layers have a strip exposed the result should be a six colour step wedge. Rotate the canvas if desired to fit better into your composite image, flatten the layers and save.

7. Add this coloured step wedge to the four images together with the black and white step wedge created earlier. Using the Type Tool add the letters' CMYBGR' to the top and bottom of the step wedge for identification purposes onto the relevant bars. (Choose either black or white for the type colour as required.)

8. Make sure the final composite image is scaled to fit onto an A4 size piece of paper and save after flattening the layers. Save the file onto a disk and record any colour space and profile details. This should remain the master copy of the file. This composite image can now be used for all future colour test outputs.

9. Create a folder to file each test printout using this target image. On the reverse of each print be sure to record all details of colour space, profile, paper stock and workflow. This folder should become your colour management work book and should build up over time with a library of test results.

# Revision exercise

**The following exercise refers to both 'Colour Management' and 'Managed Workflows' study guides.**

Q1.    What is a CMS or Colour Management System?
(a)  A means by which colours unable to be printed are eliminated from an image.
(b)  A system of colour control based on the viewable colours of a 15" monitor.
(c)  A system of colour management based on calibrating and profiling devices.

Q2.    A colour space is:
(a)  A mathematically defined map of colours.
(b)  The difference between colours we can see and the colours we cannot see.
(c)  The relationship between hardware and software definitions of colour.

Q3.    A colour gamut is:
(a)  A group of colours defined by the particular operating system.
(b)  The range of colours possible within a particular colour space.
(c)  The colours that are unable to be reproduced within a particular colour space.

Q4.    Which of the following is **not** a device dependent colour space?
(a)  US Web Coated (SWOP)      (b)  Epson Stylus Photo 1290
(c)  ColorMatch RGB                  (d)  Flextight Scanner II

Q5.    What is the role of a profile within colour management?
(a)  It enables the translation of an image from one colour space to another.
(b)  It defines the colours that will not reproduce via the printing process.
(c)  It enables only those colours viewable to the eye to be shown on a monitor.

Q6.    A monitor needs to be calibrated because:
(a)  Without calibration it will consume more electricity.
(b)  An uncalibrated monitor will only show those colours that can be printed.
(c)  Subjective judgements relating to the displayed image will be inaccurate.

Q7.    Hardware monitor calibration using a colorimeter measures:
(a)  The speed at which each colour is rendered on the monitor.
(b)  The red, green and blue light emitted by the phosphors of the monitor.
(c)  The amount of red, green and blue light reflected off the screen when white light falls upon its surface.

Q8.    A closed loop in colour management is useful because:
(a)  It enables images to be printed without any loss of colour.
(b)  The devices within the loop can be matched to give predictable results.
(c)  If the devices are from the same manufacturer the colour will be predictable.

# Gallery

*Les Horvat*                                        *Justin Ridler*

*Lizette Bell*

# digital

# printing and pre-press

*Les Horvat*

## aims

~ To offer a resource of technical information regarding pre-press and printing.
~ To develop an understanding of procedures involved in printing a digital image.
~ To develop knowledge and understanding about the control that can be exercised over how an image is translated onto a paper surface.

## objectives

~ **Print** digital image files using knowledge concerning:
   - ICC profiles
   - rendering intent
   - device independent colour spaces
   - printing previews using soft proofing

# Introduction

For many purposes, even with today's electronic modes of displaying images gaining in prominence, the final output of the photographic image will still be printed onto paper or similar substrate. Whether this is achieved via the press using mechanical reproduction techniques, or using direct printing devices for short run or single output, the final result should conform to expectations - which means a colour managed workflow needs to be in place. Unless a closed-loop system is employed, the use of ICC profiles tagged within the image file, utilized by the CMS of the computer system and recognised by the editing and printing software, is necessary.

**Note. It is better to archive all image files in a device independent space i.e. RGB, even if a subsequent conversion for printing purposes takes place. This will ensure maximum flexibility for future uses.**

## Soft proofing outputs

One of the advances in Photoshop since version 6 is the ability to easily 'soft proof' the output expected from a particular device. Because Photoshop 5.5 did not function in a document specific colour space, it was unable to soft proof an RGB file at all and also had problems even soft proofing CMYK files.

**Note. A soft proof is a simulation of the output in the form of a preview on screen.**

One of the very convenient ways it can be used is to see how an image will display on either a Mac or a Windows monitor. Since each uses different gamma settings, the image will appear with different densities and contrast. This facility is of particular use when creating images to be viewed on the web, which need to look right no matter what system is used for display. (See **'Images for the web'**).

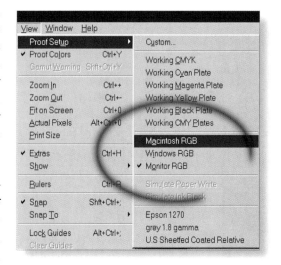

When preparing an image for output, rather than actually printing the file, the soft proof option enables it to be displayed similarly to how it will look when printed. If changes need to be made it is more convenient, and less time consuming to determine this from the preview, rather than the print itself.

**Note. Soft proofing is only as good as the profile for that device and relies heavily on the accuracy of the monitor calibration.**

## Using soft proofs

Soft proofs can be useful in both ICC profile managed workflows and in closed loop workflows.

~ **Where a profile based workflow is being used**, going to View > Proof Setup enables the profile that represents the printer to be also used for the proofing process. This can then give an indication of where any colour problems may arise when outputting to that particular device. Suitable localised or even global adjustments can be made to the original file (via an adjustment layer), until the preview closely matches the original image.

~ **Where a closed loop workflow is being used,** choosing a monitor space that has been set up specifically to match a unique printed output within the loop enables a preview of how the image will look when printed to that printer. This is an extension of 'Using a closed loop system workflow', page 89.

## Closed loop printing to an RGB device

This method of printing relies on the adapted monitor profile created in 'Using a closed loop system workflow' page 89, being used as a preview of the print.

1. Open the image intended for printing. Go to View > Proof Setup and choose the adapted monitor profile that was created to best match the printed output of the target print in **'Managed Workflows'.** This profile should appear at the bottom of the list if it was saved previously, but if not, go to View > Proof Setup> Custom and select it from the drop-down menu.

2. Go to View > Proof Colors to alter the view of the image to replicate (via a soft proof) how the printed result will look. This does not tag the file with a new profile, it merely changes the way the file is displayed.

3. Now create an adjustment layer by selecting Layer > New Adjustment Layer. Choose any of the methods available (curves, levels, hue/saturation, etc.) depending on the changes that you require. Apply an appropriate adjustment to the file so that it matches as closely as possible the intended appearance of the print. Do not flatten this adjustment layer, rather save it with a name that suggest it is required just for the printed output. In fact you could have more than one Adjustment layer - or layer set - relating to more than one printer.

**Note. The image, with the Adjustment layer active and the view set to Proof Colors, should look as close as possible to the image without adjustments active and the view set to the normal monitor profile.**

4. Send the file to the printer with the Adjustment layer active and print without altering any printer colour settings. (Remember to disengage View > Proof Colors after printing is complete.)

# Colour managed printing to an RGB device

1. Select File > Print with Preview or File > Print Options in Photoshop 6 and tick 'Show More Options'.

2. Click 'Output', which controls some of the organizational attributes of the printout, and choose 'Color Management' from the drop-down menu.

3. The 'Source Space' gives us a choice between the profile tagged within the file or the ICC profile chosen in the CMYK set-up in 'Color Settings'. Since we are printing to a device which requires RGB data, we should use the RGB profile embedded within the document, so choose 'Document'.

4. The 'Print Space: Profile' allows us to choose how we actually apply colour management from Photoshop to the printer. Three choices are available:

~  If **'Same as Source'** is chosen, the data is simply sent to the printer without change, effectively telling Photoshop **not** to colour manage the document.

~  If **'Printer or Postscript Color Management'** is selected, the file along with the chosen 'Source Space' profile will be sent to the printer, allowing the printer to manage the colour. It is best to choose this option only if you do not have a profile for the printer, as the results are dependent on the printer's colour conversion capabilities.

~  If a **profile** is selected from the list that matches the profile of the printer, the file will be sent with the printer's colour space embedded, giving the most accurate result - as long as the printer profile itself is accurate. With this approach the file itself does not have any changes applied to it - the profile is applied '**on the fly**' by the printing set-up.

# Choosing a rendering intent

When colours are changed from one space to another, certain adjustments have to be made to accommodate for the different gamuts of the spaces in question. Just how these adjustments are defined is the basis of the rendering intent.

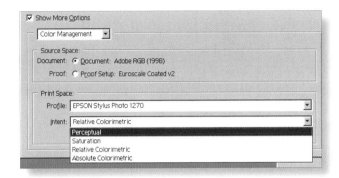

~ **Perceptual** - often the choice for photographic images, this intent maintains the relationship between colours as perceived by the human eye, but compresses the entire colour gamut so that it will fit into the target colour space.

~ **Saturation** - this intent creates vivid colours at the expense of accuracy. It is most suitable for business graphics.

~ **Relative Colorimetric** - this intent shifts those colours within the colour space that are out of gamut relative to the target colour space. For example, when the paper white is compared against the monitor white. The result is that only those source colours that are out of gamut are clipped in the target space. This intent is sometimes preferred for images (and is the default setting in Photoshop) however, extreme RGB colours can be dramatically changed when converted to CMYK and may need to be adjusted manually.

~ **Absolute Colorimetric** - this intent maintains colour accuracy, but does not change the relationship between colours if any fall outside the gamut of the destination space. Specific colours will map very precisely as long as they fall within the target gamut and therefore this intent is particularly useful where spot colours within a design are required to reproduce accurately.

## Conversion options

**Black Point Compensation** ensures that the darkest shadow points on the source space are mapped to the darkest shadow points on the target space, thereby using the largest possible dynamic range. As a result, it is best left on.

**Use Dither** enables Photoshop to mix colours in an attempt to reduce the banding that sometimes occurs after conversions - particularly when the target space is CMYK.

# Colour managed printing to a CMYK device

Most of what has been discussed in the previous sections concerning an RGB printing set-up is equally valid for CMYK printing and press outputs. However, many of the settings chosen are even more critical and need to be addressed separately within the workflow.

**Note. As the boundaries and demarcations become more and more fuzzy between what was once the role of a Pre-Press House or printer, and the role of the photographer, it is essential that photographers have a clearer understanding of decisions they may make which have a major affect on the final printed output.**

## A closed loop CMYK workflow

Printing to a CMYK printer requires a CMYK file, which as we know is device specific. For this reason it is recommended that the original RGB file should be retained as a 'master' file and the required CMYK version created from it as necessary, (see 'CMYK conversions', page 109). However, one way to avoid the entire conversion process is to work with a CMYK file supplied by the Pre-Press House or printer themselves. Even though all scanning devices are RGB in nature (as they work with light, not inks), most high-end drum scanners convert the file 'on the fly' to CMYK. The settings used in this process have already been optimized for the printer that is to be used for output, so further adjustment is not required.

**Note. Any editing to be done on the file should occur in the file's native CMYK format and not in RGB, so that it is not altered and compromised in its press optimization.**

It is therefore very important that as the file is brought into the system, it is not converted to another colour space, i.e. tagged with a new profile, as this will alter the colour values. The safest way to make sure that this is not happening is to tick the checkboxes in the 'Colour Management Policies' window in Photoshop 6.0/7.0 that indicate 'Ask When Opening', (see **'Managed Workflows'**, page 87).

**Note. This option is unfortunately not available to users of earlier versions of Photoshop, as pre-Photoshop 6.0 versions worked without document specific colour.**

When the required editing and manipulation of this file is complete, it is automatically saved with its own original profile, ready for print output. At this point the file is most probably sent back to the printer who will then control that process, knowing that the device specific, optimized file that was sent out of their 'closed loop' environment has not been inadvertently altered.

## Managing a CMYK workflow

In many cases the image file a photographer will be working with has not been drum scanned, or indeed scanned at all in the case of files from digital cameras. As a result the file in its original form will be an RGB file, which will require conversion to CMYK for printing. This process can be carried out by choosing 'Image > Mode > CMYK Color' from the drop-down menu. However, this simple menu step hides what is a very powerful and crucially important stage in the creation of a press ready image file. Although Photoshop performs this conversion very well, the nature of the information necessary for the result to be meaningful can often be difficult to obtain.

It may necessitate contact with the printer to determine the exact press conditions the image will be printed under and some printers may not be keen to provide this information as a misguided way of protecting their 'turf'. Or perhaps the printer has not yet been chosen for the job, or perhaps the one file will be sent to many printers for insertion into multiple magazines.

**Note. A growing view amongst many professionals within the reprographic industry is that for the above reasons, all files should be supplied in device independent RGB form, with the conversion being completed at pre-press stage by the printer.**

## Converting a file to CMYK

If you are required to create a CMYK file ready for printing, you need to revisit the 'Color Settings' dialogue box and choose 'Custom CMYK'. This is the 'engine room' of your CMYK conversion and enables entry of all the parameters that need to be controlled for the specific printing device. Once all the detail has been entered, simply save the file with a suitable name and description - Photoshop will automatically save it in the 'Settings' folder. Next time the 'Color Settings' window is opened, the saved setting will appear in the 'Settings' menu.

**Note. If the printing conditions are not available then choose from the pre-sets offered within Photoshop. For example, for European printing conditions choose 'Europe Pre Press Defaults'.**

## What press information is required?

To successfully customize the settings required for a high quality CMYK conversion, certain information is needed from the printer to determine the conditions under which the image file will be reproduced.

~ **Ink colours.** Inks will behave differently depending on the paper type they are to be applied upon - whether for example the stock is coated or uncoated will give different printed results and may require varying ink formulations. Find out which ink set is to be used on the presses and include that information by selecting 'Custom' from the 'Ink Colors' menu.

~ **Dot gain.** This is a measure of the amount of spread that occurs as the ink is applied to the paper. It is of course dependent on the particular paper stock to be used, so the choice of paper must also be considered.

~ **Separation options.** Included in this area is information about the limit to the total ink that will be applied, as well as how the black generation is to be controlled. Options to consider are whether GCR (Gray Component Replacement), UCR (Undercolour Removal), UCA (Undercolour Addition) or a combination of these is to be used. All of these techniques are methods employed by the printer to avoid too much ink being applied to the paper, which can result in muddy tones or smeared wet ink as it rolls through the high speed presses.

## Proofing with inkjet printers

Desktop inkjet printers such as the Epson 1290 use CMYK inks - or more accurately CMYK plus Light Cyan and Light Magenta. However, these printers are not ideal as proofing devices for press output - since translating the characteristics of a six colour printer to preview or proof a four colour printing process is somewhat problematic. Where these printers can be useful however, is in the production of a 'target' print - to help specify the final outcome required after CMYK separations have been created.

**Note. This print can be used as a guide to the 'pre-press house', when starting with an RGB file, to direct the operator as to how the final printed result should look.**

## Activity 1    www.photoeducationbooks.com/colour.html

Displaying a soft proof of an RGB file:

1. Open the image file 'onions.jpg.

2. From the View menu select Proof Setup > Custom. Make sure the Preview box is ticked so that the result can be seen immediately. This is also useful as a method of toggling backwards and forwards between the soft proof and the original file.

3. From the Profile menu select an output device profile from the available list. You can choose any RGB or CMYK profile related to a printer, monitor or working space - although make sure you do not choose a digital camera or scanner, as these are not output spaces.

4. Check and uncheck the preview box to see how the conversion to your chosen space has affected the file. If you have chosen a space in the same colour mode as the original (for example RGB to RGB), then the 'Preserve Color Numbers' checkbox will also be available. The purpose of this option is to indicate how the file would look if sent to the chosen device without any conversion - particularly useful to determine how a file with a particular CMYK conversion would print if sent unchanged to another CMYK setup. Toggle this checkbox to observe the way the image alters.

5. Select a rendering intent (see 'Choosing a rendering intent', page 107) that gives the most pleasing result. This will usually be either Perceptual or Relative. By changing from one to the other you can immediately see how each affects the image.

6. The 'Simulate' checkboxes indicate how the output device deals with the white of the paper and the black of the ink. Click 'Paper White' to preview how the paper shade itself will alter the appearance of the printed image.

7. Select Save and give the soft proof a suitable name.

## Activity 2    www.photoeducationbooks.com/colour.html

The ability to soft proof allows easy comparisons between profiles - either created or supplied by the manufacturers of hardware devices. Using an image that has a wide gamut, it is easy to see which colours will not translate readily to certain CMYK device spaces.

1. Open the image file ColourTest.jpg.

2. Choose Proof > Setup > Custom from the View menu.

3. Select the Euroscale Coated profile from the drop down list, choose 'Relative Colorimetric' and make sure that the 'Preview' box is checked. Observe how the colours displayed on screen change, particularly with regard to the blue and deep orange hues. Toggle the 'Preview' checkbox.

4. Now select 'Paper White'. Observe how there is a general fading of all the colours as the paper tone is allowed for in the soft proof.

5. Uncheck 'Paper White' and select Euroscale Uncoated. This is simulating an uncoated paper stock which by its nature absorbs more ink and has a matt appearance. Notice how the colours change even further from the original.

6. Now select 'Paper White' once again. With an uncoated stock it is quite clear that the colours will not be reproduced with anything like the intensity of the original.

*Original image (above) with soft proof on uncoated paper with 'Paper White' selected (top) and not selected.*

7. Uncheck 'Paper White' once again. This time toggle between the various 'Intent' settings to observe how the representation of the original changes as it is mapped to the CMYK space with the different renderings. In particular, note how the 'Absolute' intent completely loses many of the dark colours.

**Note. Soft proofing is a very powerful way to determine the accuracy of a particular colour space associated with a device - or at least the profile created for that device.**

# Revision exercise

Q1.    It is not a good idea to archive a file after conversion to a CMYK space because:
(a) The CMYK space is device specific and the file may be needed for a different device at a later stage.
(b) The CMYK space has a larger gamut than RGB, so the file will be larger.
(c) A CMYK space cannot be viewed on a monitor.

Q2.    A 'Rendering Intent' determines:
(a) How heavily drawn are the lines within an image.
(b) What is the original relationship between the colours of an image and its brightness.
(c) How colours are dealt with during the transformation from one colour space to another.

Q3.    'Black Point Compensation':
(a) Ensures that the darkest shadow points of a source space are mapped to the darkest shadow points on a target space.
(b) Ensures that the darkest shadow points of a target space are eliminated to compensate for the space's deficiencies.
(c) Enables shadows from one space to be mapped to the mid-tones of another.

Q4.    Which of these devices does not operate in a CMYK colour space?
(a) Heidelberg printing press    (b) Kodak SWOP proofer
(c) Nikon D1x Camera    (d) Hewlett-Packard Deskjet

Q5.    Document specific colour refers to:
(a) The particular colours that are important in a document.
(b) A document having its own colour space regardless of the colour space chosen for the system on which it is displayed.
(c) A document having a specific colour space which is converted to the best possible CMYK space for display.

Q6.    Which of these colour spaces should be used when sending a file to a desktop inkjet printer?
(a) Euroscale Coated    (b) Japan Standard
(c) US Web Coated (SWOP)    (d) Adobe RGB (1998)

Q7.    'Dot Gain' is:
(a) A measure of the amount of spread that occurs as ink is applied to paper.
(b) The number of extra dots required to render smooth tones
(c) A measure of the increased size of ink dot necessary for correct conversion of one colour space to another.

# Gallery

*Les Horvat*

*Les Horvat*

*Rhiannon Slatter*

*Rhiannon Slatter*

# digital

## retouching and image enhancement

*digital imaging digital imaging digital imaging digital imaging digital in*

*Mark Galer*

*igital imaging digital imaging digital imaging digital imaging digital i*

## *aims*

~ To develop an awareness of how a digital image can be enhanced and optimized
   for the intended output.
~ To develop an understanding of how different techniques can be employed to
   modify pixel values.

## *objectives*

~ **Research** the different features of the retouching tools and techniques available in
~ the image editing software.  Record your observations.
~ **Analyse and evaluate critically** - exchange your findings with others.
~ **Personal response** - produce and present digital prints that demonstrate how retouching
   tools and techniques can be employed to enhance the quality of a digital image.

# Introduction

An image must first be captured or scanned with the appropriate tonality and colour (see 'Scanning and Image Adjustment'). The digital file can then be prepared for the final output device so that it may be viewed in its optimum state. Whether images are destined to be viewed in print or via a monitor screen, the image usually needs to be sized, optimized, retouched and enhanced. The original scan or capture will usually possess pixel dimensions that do not exactly match the requirements of the output device. In order for this to be corrected the user must address the issues of '**Image Size**', '**Resampling**' and '**Cropping**'.

## Save, save and save

Before you start to edit your digital image it is well worth acquiring good working habits. Good working habits will prevent the frustration and the heartache that are often associated with inevitable '**crash**' (all computers crash or '**freeze**' periodically). As you work on an image file you should get into the habit of saving the work in progress and not wait until the image editing is complete. It is recommended that you use the 'Save As' command and continually rename the file as an updated version. Unless computer storage space is an issue the TIFF or PSD file formats should be used and not the JPEG file format for work in progress. Before the computer is closed down the files should be saved to a removable storage device such as Zip. In short, save often, save different versions and save back-ups.

## Histories

Digital image editing allows the user to make mistakes. There are several ways of undoing a mistake before resorting to the '**Revert to Saved**' command from the File menu or opening a previously saved version. Photoshop allows the user to jump to the previous state via the Edit > Undo command (Command + Z) whilst '**Histories**' allows access to any previous state in the histories palette without going through a linear sequence of undos.

## Image retouching and image adjustments

Most scans produce some unwanted non-image data such as dust and scratches. This can be removed using a number of different techniques. The term '**retouching**' refers to the process of removing or replacing unwanted image data, e.g. dust and scratches, lampposts growing out of peoples heads, etc. Retouching may use tools such as the rubber stamp tool or make use of a filter such as the dust and scratches filter in Photoshop.

'**Image adjustment**' on the other hand refers to the process of optimising the colour and tonal quality of the output image. The adjustments can be applied globally (to the whole image) or be localised (by selecting a portion of the image). Each time pixels are modified and adjusted the original data is weakened. Photoshop allows the adjustments to be recorded and stored on an '**adjustment layer**'. This means that the original pixels are changed only once when the image is flattened for output. Finally the image can be sharpened just prior to output using the '**Unsharp Mask**' or USM.

**Note.  Images to support the activities in this chapter can be found on the supporting web page: www.photoeducationbooks.com/retouching.html**

# Selection tools and techniques

One of the most skilled areas of digital retouching and manipulation is the ability to make accurate selections of pixels for repositioning, modifying or exporting to another image. This skill allows localised retouching and image enhancement. Obvious distortions of photographic originals are common in the media but so are images where the retouching and manipulations are subtle and not detectable. Nearly every image in the printed media is retouched to some extent. Selections are made for a number of reasons:

~ Making an adjustment or modification to a localised area, e.g. colour, contrast etc.
~ Defining a subject within the overall image to move or replicate.
~ Defining an area where an image or group of pixels will be inserted ('paste into').

Three categories of selection tools are available for selecting groups of pixels in very different ways. These categories are:

~ The '**marquee tools**' select pixels by drawing a rectangle or elliptical shape around an area within the image.
~ The '**lasso tools**' are used to draw a selection by defining the edge between a subject and its background.
~ The '**magic wand**' selects groups of pixels by evaluating the similarity of the neighbouring pixel values (hue, saturation and brightness) to the pixel that is selected.

## Tools, palettes and options

At the top of the tool palette in Photoshop are the selection, crop and move tools. Some tools in Photoshop are hidden.

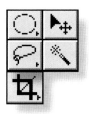

To select a tool you can:
1. Select the visible tool by clicking its icon.
2. Click on the small triangle and drag to highlight the tool you want.

## Photoshop 5 and 5.5

Double-clicking any tool in the tool-box brings up the tool options palette.
To display the palette menu move the pointer to the triangle in the top right-hand corner in the palette and hold down the mouse button.

## Photoshop 6 and 7

Click on a tool to display its options. Click on the tool icon in the options palette for the 'Reset Tool' and 'Reset All Tools' options.

**Note. Reset all tools before starting any new work when using a shared computer.**

## Marquee tools

The rectangular or elliptical marquee tools are used to define square, oblong, circle and oval selections by dragging a shape (indicated by a moving dotted line or '**marching ants**') over the area required. Holding down the shift key as you drag the selection will 'constrain' the selection to a square or circle rather than a rectangle or oval.

**Note. To locate the starting point for the selection of a circle use the rulers (View > Rules or Command/Ctrl + R). Click and drag from each rule to border the circle. This intersection of the rules indicates the starting point for dragging the circular selection.**

## Lasso tools

When using the lasso tools the selection is not complete until you have returned to the point where you started the selection. A large screen and a mouse in good condition (or a graphics tablet) are required to use the freehand lasso tool effectively. Double clicking the polygonal lasso tool or magnetic lasso tool automatically completes the selection using a straight line between the last selected point and the first.

**Note. The magnetic lasso tool requires a tonal or colour difference between the object and its background in order to work effectively.**

## The magic wand

The magic wand tool selects by relative pixel values (controlled by a tolerance box). The tool is placed on a specific area of the image and the mouse clicked. The magic wand selects adjacent pixels that are either the same or similar to the one specified by the click of the mouse. Increase the number in the tolerance box of the magic wand options palette to increase the selection. Decrease the number in the tolerance box to decrease the number of pixels selected. Uncheck the box marked contiguous in the magic wand options palette to select pixels of a similar value that are not adjacent to the area that is clicked.

## Moving a selection

If the selection is not accurate it is possible to move the selection without moving any pixels. Place the cursor inside your selection and drag the selection to reposition it. To move the pixels and the selection, use the move tool from the tools palette. The area where the selection was moved from is filled with the background colour (as prescribed by the Foreground and Background colours in the tools palette). If the selection is to be moved to another layer (see 'Layers'), the selection can be cut or copied and then pasted onto the new layer. A selection will automatically be pasted to a new layer. The new layer does not have to be created first.

## To remove a selection

Go to Select > Deselect or use the shortcut 'Command/Ctrl + D' to deselect a selection.

# Histories

Most adjustments or modifications can be undone quickly by using the Edit > Undo (Command + Z).  If the user needs to go further back than the last command however, Photoshop allows '**multiple undos**' via its history palette.  The user can quickly go back to a previous version of the image by clicking on the appropriate history in the history palette.  If the user needs to go further back in time than the history palette will allow the user may have to choose File > Revert to restore the image to its last saved version; choose a '**snapshot**' from the History palette or use the '**History brush**' to paint from a snapshot. It is recommended that different versions of the image be saved periodically using the 'Save As' command from the file menu so that in the event of a computer crash your recent work is not lost (alternatively choose save current state from the bottom of the history palette).  It is important to note that all snapshots and histories are lost when the file is closed.

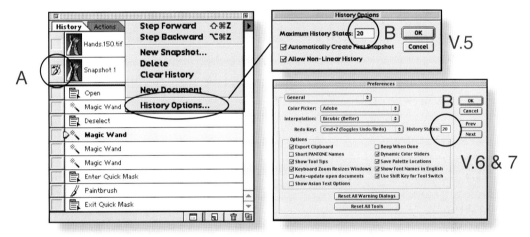

A.  *History brush set to paint from a snapshot.*
B.  *Reduce history states to free-up memory*

## Histories and RAM

The History palette lists the previous 20 states by default.  This may require a great deal of the available memory (computer RAM) if the image you are working on is large.  Choose Edit > Purge to delete all histories and free up the memory when Photoshop is unable to perform the next operation (a warning screen will indicate this).  If this continues to occur either increase the RAM assigned to Photoshop or decrease the number of histories using the history options (Photoshop 5) or General Preferences (Photoshop 6 and 7).

## Returning a part of the image to previous state

The history brush tool allows the user to paint with a previous state or snapshot on the History palette.  An appropriate brush size should be selected and the history being returned to should display the history brush icon.  The eraser tool can also be used to return to a selected state in the history palette ('Erase to History' option should be selected). Alternatively a single state or command in the history palette can be deleted by selecting 'Non-Linear' from the history options.

# Dust and scratches

## Clone stamp and healing brush

The primary tools for localised retouching are the 'Rubber Stamp Tool' and the 'Healing Brush Tool' (Photoshop 7). The  clone stamp or rubber stamp is able to paint with pixels selected or '**sampled**' from another part of the image. The healing brush also matches the texture and characteristics of the sampled pixels to those of the pixels surrounding the damage.  The healing brush tool (if available) allows for a more seamless repair where the damage is surrounded by pixels of a similar value. If the damage is close to pixels of a very different hue, saturation or brightness a selection of the damaged area should first be made that excludes the different pixels.

~    Choose a brush size from the brushes palette.
~    Select a sampling point by Option/Alt-clicking on a colour or tone (this sample point is the location from where the pixels are sampled).
~    Drag the tool over the area to be modified (a cross hair marks the sampling point).

**Note.  Deselect 'Aligned' to return to the initial sampling point each time you start to paint.  If a large area is to be repaired with the clone stamp tool it is advisable to take samples from a number of different points with a reduced opacity brush.**

*Master image*

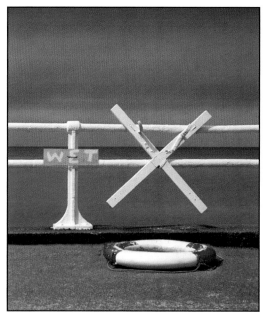

*Manipulated image*

## Cloning entire objects

With care it is possible to duplicate an entire subject within the image.  The image above demonstrates how a landscape composition has been manipulated to fit a portrait format. This has been achieved by cloning the sign and the life-ring and moving them to the right. The original life-ring is then removed.

## Dust and scratches filter

Ideally if the original image and scanning equipment are clean the scanning process introduces only the occasional dust mark or scratch.  If on closer inspection of the digital file it appears that the dust and/or scratches cover an extensive area of the image it is often quicker to resort to the dust and scratches filter rather than use the rubber stamp tool.  Choose Filters > Noise > Dust and Scratches.  Set the threshold to zero and choose the lowest pixel radius that eliminates the dust and scratches problem. Then increase the threshold gradually for optimum image quality.  The drawback to applying the dust and scratches filter to the entire digital image is that it also has the effect of blurring the image.

## Limitation of effect

The user can reduce or limit the filter to only the area of the image that does not have fine detail, e.g. areas of featureless or blurred background.  This can be achieved by using any of the selection tools as outlined in the following section.  Only those pixels that are part of a selection can be modified or adjusted using global actions such as the image adjust or filter commands.  This technique will reduce the amount of manual retouching (using the rubber stamp tool) to just those areas containing fine detail.

## Using the history brush to remove dust and scratches

The history brush can also be used to remove dust and scratches.  This technique is especially useful when removing dust and scratches from the more detailed areas of the image.  Pixels are painted over the damaged areas from an image state or '**snapshot**' that has had the dust and scratches filter applied.  The technique is as follows:

1.  Apply the dust and scratches filter to the entire image and create a snapshot.
2.  Click on the previous state or '**snapshot**' in the histories palette.
3.  Double-click on the histories brush in the tool box to select the tool and open the history brush options palette.
4.  Click in the small window on the dust and scratches state, or snapshot, in the history palette (a history brush icon will appear in the box).

5.  In the options bar or history brush palette set the '**blend mode**' to darken if the dust and scratches are lighter than the original image and lighten if the dust and scratches are darker than the original image.
6.  Proceed to paint with the history brush over the areas to be repaired using an appropriate sized brush selected from the brushes palette.

# Retouching tools

When printing in a traditional black and white darkroom it is possible to enhance the final print by changing the exposure or contrast to localised areas. Digital enhancement also allows localised modification. This is possible in two distinctly different ways. A selection can be made using the selection tools (see '**Selection tools**') and the pixels adjusted using the '**Adjust**' commands to be found in the Image menu. Alternatively the adjustments can be directly painted onto the pixels using the retouching tools. The tools include:

~    Dodge, burn and sponge
~    Smudge
~    Sharpen and blur

Double click any tool to bring up its options. Each of these tools requires a pressure, exposure or opacity to be set along with an appropriate brush size which is selected from the brushes palette. Start with a low exposure, opacity or pressure setting and paint with the tool several times to modify in stages rather than choosing a higher setting and trying to achieve a similar effect in one stroke. Great care needs to be taken not to make the retouching obvious when using these tools.

## Dodge, burn and sponge

The dodge and burn tools are used to lighten and darken pixels whilst the sponge tool increases or decreases saturation (RGB images) or contrast (Grayscale images). The dodge tool and burn tools can concentrate their effects to the Midtones, Shadows or Highlights by selecting them from the pull-down menu in the options palette. This same pull-down menu is used to select Saturate or Desaturate when the sponge tool is selected.

## Blur and sharpen

It is very easy to be a little 'heavy handed' when using this tool, especially with the sharpen option. Proceed with great care. Set a low opacity in conjunction with a soft brush and work the image gradually (in several repeated actions) to create the desired effect.

## Smudge

The only photographic equivalent for the smudge tool in analogue photography is some types of Polaroid film where the emulsion can be moved around whilst it is still soft.
The option 'Finger Painting' allows smudging using the foreground colour at the beginning of each stroke. If the option is deselected the colour underneath the brush is used at the beginning of each stroke.

# Layers

Layers allows increased flexibility whilst retouching and the ability to create complex digital photomontages. Layers are like a series of acetate sheets, each with a different part of the image, stacked on top of each other. The classic Walt Disney animations were created using this versatile imaging technique. Each character can be placed on their own acetate sheet so that when the character is moved the background does not have to be continuously redrawn.

Parts of a layer may be transparent allowing information on the layers underneath to be visible. At the bottom of the stack is the background layer which remains opaque. The layers can be rearranged so that pixels may be brought forward or concealed behind the pixels on the layers above. Layers are controlled via the layers palette and layers menu.

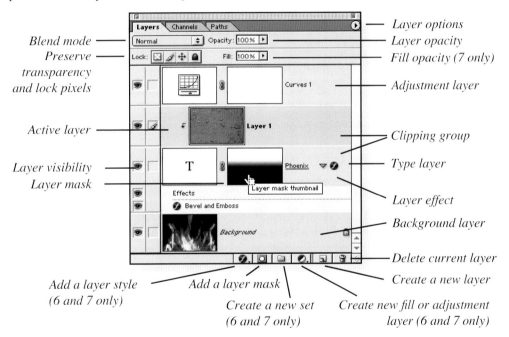

## Working with layers

Click on a layer in the layers palette to make it active (only one layer can be active at a time). Modifications usually only affect the active layer. It is common for new users to experience the problem of trying to edit pixels on a layer that has not been selected. Always check the correct layer has been selected prior to editing a multilayered image.

> **A selection is always pasted onto a new layer.**
> **All layers in the same image have the same resolution and image mode.**

Each layer in the same image must have the same resolution and image mode (a selection that is imported into another image will take on the host image's resolution and image mode). An RGB selection will be scaled down and reduced to grayscale if it is imported into a grayscale image with a higher resolution. Increasing the size of any selection will lead to 'Interpolation' which will degrade its quality.

## Layer visibility, active layer and linked layers

The eye icon indicates whether the layer is hidden or visible. Only the visible layers are printed. The paintbrush icon indicates the active layer. Links can be placed on other layers so they can be moved with the active layer as a group.

## Opacity, blend mode and preserve transparency

The opacity of a layer can be changed from nearly transparent (1%) to fully opaque (100%) whilst the blend modes determine how a layer is combined with the underlying layers. Checking the 'preserve transparency' box confines any painting or editing to the areas containing pixels (transparent areas remain unaffected).

## Layer masks

A '**layer mask**' is attached to a layer and controls which pixels are concealed or revealed on that layer. If the layer mask is discarded the original pixels are not affected.

## Adjustment layers and clipping groups

An '**adjustment layer**' allows image adjustments to be made without permanently modifying the original pixels (if the adjustment layer is removed the pixels revert to their original value). The effects of the adjustment layer appear on all layers below it, unless a '**clipping group**' is created. The thumbnails for the top layers of a clipping group are indented whilst the name of the base layer in the group is underlined.

## Type layer

It is possible to create '**editable text**' in Photoshop. If the text needs to be modified (font, style, spelling, colour etc.) the user can simply double-click the type layer.

## Layer effects

Layer effects are mainly used in conjunction with type layers but can be applied to any layer except the background layer. The effects such as 'drop shadow' and 'bevel and emboss' give a three-dimensional quality to flat shapes.

## Background layer

The background layer is the base layer in the stack. As such it cannot change its position or opacity unless it is renamed.

## Saving an image with layers

The file formats that support layers are Photoshop's native Photoshop document (PSD) format, and more recently with the release of Photoshop 6.0, PDF and TIFF. The layers must always be flattened if the file is to be saved as a JPEG or when saving as a TIFF image when using Photoshop 5. It is recommended that a PSD with its layers is always held as the master copy. It is possible to quickly flatten a multilayered image and save it as a JPEG or TIFF file by choosing '**Save a Copy**' from the 'File' menu (Photoshop 5) and 'Save As' dialogue box (Photoshop 6 - 7) and then selecting the required file format from the pull-down menu.

# Image adjustment

Prior to undertaking any image adjustments it is recommended that the optimum colour values are assigned to the pixels at the capture or scanning stage (see '**Scanning and Image Adjustment** > **Adjusting tonality and colour**'). Use 'Levels and Curves' in Photoshop to fine tune the tonality and colour values only.

> **The finest quality digital images are produced from digital files that have a broad range of levels present in the original scan.**

Repeated colour corrections using the adjust commands from the Image menu may result in a loss of pixel values and image quality. Use an '**adjustment layer**' for applying image adjustments if repeated corrections are required.

*Colour correction using Image > Adjust > Variations*

## Variations

The 'Variations' command allows the adjustment of colour balance, contrast and saturation to the whole image or just those pixels that are part of a selection. For those individuals that find the use of levels and curves intimidating, variations offers a user friendly interface. By simply clicking on the alternative thumbnail that looks better the changes are applied automatically. The adjustments can be concentrated on the highlights, midtones or shadows by checking the appropriate box. The degree of change can be controlled by the Fine/Coarse slider.

If the '**Show Clipping**' is checked a neon warning shows areas in the image that will be converted to 255 or 0. Clipping does not occur when the adjustment is restricted to the midtones only.

Variations is not available when using adjustment layers. If saturation requires modification when using adjustment layers the Hue/Saturation command should be used instead.

# Adjustment layers

Adjustment layers act as filters that modify the hue, saturation and brightness of the pixels on the layer or layers beneath. Using an adjustment layer instead of the 'Adjustments' from the 'Image' menu allows the user to make multiple and consecutive image adjustments without permanently modifying the original pixel values.

## Non-destructive image editing

The manipulation of image quality using '**adjustment layers**' and '**layer masks**' is often termed 'non-destructive'. Using adjustment layers to manipulate images is preferable to working directly and repeatedly on the pixels themselves. Using the 'Adjustments' from the 'Image' menu, or the manipulation tools from the toolbox (dodge, burn and sponge tools), directly on pixel layers can eventually lead to a degradation of image quality. If adjustment layers are used, together with '**layer masks**' to limit their effect, the pixel values are physically changed only once when the image is flattened or the layers are merged. Retaining the integrity of your original file is essential for high quality output.

*Creating a 'Curves' adjustment layer*

## Retaining quality

The evidence of a file that has been degraded can be observed by viewing its histogram. If the resulting histogram displays excessive spikes or missing levels there is a high risk that a smooth transition between tones and colour will not be possible in the resulting print. A telltale sign of poor scanning and image editing is the effect of '**banding**' that can be clearly observed in the final print. This is where the transition between colours or tones is no longer smooth, but can be observed as a series of steps, or bands, of tone and/or colour. To avoid this it is essential that you start with a good scan (a broad histogram without gaps) and limit the number of changes to the original pixel values.

# Layer masks

The use of 'layer masks' is an essential skill for professional image retouching. Together with the selection tools and 'adjustment layers' they form the key to effective and sophisticated image editing. A 'layer mask' can control which pixels are concealed or revealed on any image layer except the background layer. If the layer mask that has been used to conceal pixels is then discarded or switched off (shift + click the layer mask thumbnail) the original pixels reappear. This non-destructive approach to retouching and photographic montage allows the user to make frequent changes. To attach a layer mask to any layer (except the background layer) simply click on the layer and then click on the 'attach layer mask' icon at the base of the layers palette.

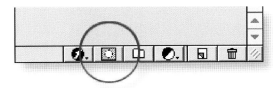

*The 'Add layer mask' icon in the layers palette*

A layer mask is automatically attached to every adjustment layer. The effects of an adjustment layer can be limited to a localized area of the image by simply clicking on the adjustment layer's associated mask thumbnail in the layers palette and then painting out the adjustment selectively using any of the painting tools whilst working in the main image window. The opacity and tone of the foreground colour in the toolbox will control whether the adjustment is reduced or eliminated in the localised area of the painting action. Painting with a darker tone will conceal more than when painting with a lighter tone or a dark tone with a reduced opacity.

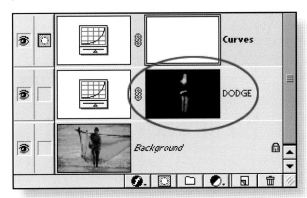

*Painting with white will reveal the adjustment*
*in the localized area of the painting action*

## Painting an adjustment

A layer mask can be filled with black to conceal the effects of the adjustment layer. Painting with white in the layer mask will then reveal the adjustment in the localized area of the painting action.

## Selections and layer masks

A localized adjustment can be created using the 'Fill' command. Selecting a layer mask and filling an active selection with either the foreground or background colour will create a mask that limits adjustments or visibility in a localized area of the image. This allows the selection tools to be used in addition to the paint tools for the creation of masks. The fill shortcuts 'Command/Ctrl+delete' (to fill with the foreground colour) and 'Option/Alt+delete' (to fill with the background colour) speed up the masking process.

*A layer mask created from a selection*

The Himalayas image demonstrates how an adjustment layer can be used to effect global changes to tonality and colour whilst a second adjustment layer affects only the foreground due to the presence of a layer mask limiting its effect.

## Activity 1    www.photoeducationbooks.com/retouching.htm

1. Open the image file '01.Himalayas.jpg'.

2. In the layers palette click on the 'New fill or adjustment layer' icon and select a 'Curves' adjustment layer from the fly-out menu.

3. From the 'Channel' menu select the 'Red' channel. Click on the line in the centre of the curves box. Drag upwards until the line becomes a curve. Observe the changes to the colour in the image window. Increase the level of the red in the image until you feel that the overall colour has been corrected.

4. Using the 'Lasso Tool' (with a 2-pixel feather entered in the options bar) select the fields in the foreground of the landscape.

**Note. Feather selections to soften the transition between the adjusted and non-adjusted pixels. If you create a mask with a hard edge it can be softened by applying a small amount of 'Gaussian Blur' (Filter > Blur > Gaussian Blur).**

5. Click on the 'Channels' palette (grouped with the 'Layers' palette) and then click on the 'Save selection as channel' icon to save the selection as an 'Alpha' channel. This will ensure the selection is saved when the file is closed.

6. Return to the 'Layers' palette. With the selection active create another new adjustment layer. Choose 'Curves' from the menu. The selection automatically limits the adjustment to the selected area by filling the rest of the layer mask with black.

7. In the curves dialogue box select the 'Green' channel. Pull the curve down to reduce the level of green in the foreground of the image and click OK to complete the tonal and colour adjustments. Double-click the thumbnail on either adjustment layer to reopen the curves dialogue box in order to further modify the colour or tonality.

**Note. Drag an adjustment layer to the 'Delete layer' icon (trash can) to discard the adjustment.**

8. To retain the adjustment layers when saving the image it is important to save the document as a Photoshop file (PSD).

# Target values

To optimize the quality of the final print it is possible to set the tonal value of specific highlight and shadow tones within the image. This can be achieved using a curves adjustment in conjunction with the eyedropper tool and information palette or by using the black and white eyedroppers to be found in the curves and levels dialogue boxes. The tones that should be targeted are the lightest and darkest areas with detail that can be seen in the image.
Adobe state in their user manual:

> "It's important to identify a truly representative highlight and shadow area. Otherwise the tonal range may be expanded unnecessarily to include extreme pixel values that don't give the image detail. A highlight area must be a printable highlight, not specular white. Specular white has no detail, and so no ink is printed on the paper. For example, a spot of glare is specular white, not a printable highlight."

## Setting a target value

Target values for highlight and shadow tones can be set either by using the white and black eyedropper tools to be found in the levels and curves dialogue boxes or by pegging the highlight and shadow tones on an adjustment curve.

To set the target values using the eyedroppers open the levels dialogue box or curves dialogue box, Image > Adjust > Levels/Curves.
Double-click the white eyedropper tool to display the colour picker.
Enter the value of 96% in the Brightness text box (part of the hue, saturation and brightness or 'HSB' controls).
Click OK when you have entered this value.
Double-click the black eyedropper tool in the Levels or Curves dialogue box, and enter a target shadow value by entering a value of 4% in the Brightness text box.
Click OK when you have entered this value.

*Entering a target value in the brightness box of the colour picker after double clicking the black or white eyedropper tool.*

Carefully view the image to locate the brightest highlight with detail. Be careful to select representative tones, e.g. for the target highlight do not select a specular highlight such as a light source or a reflection of the light source which should register a value of 255.
Using the black and white eyedropper tools, with the altered values, click on the appropriate image detail to assign their target values.

**Note. When setting the target values of a colour image it is very important to select neutral highlight or shadow tones, otherwise a colour cast may be introduced into the image. If no neutral highlight or shadow tones are present it is advised that the tones are targeted by pegging them on an adjustment curve, using the master RGB channel.**

# Unsharp mask - increasing image sharpness

It is common to increase the apparent sharpness of the image as the last step prior to output. Many images benefit from some sharpening even if they were photographed and scanned with sharp focus. The 'Unsharp Mask' filter is used to sharpen the edges and corrects any blurring introduced during the digital process. The unsharp mask increases sharpness by emphasising the edges between different tones within the image (chemical developers are used with film to create similar effects). If a light tone is next to a dark tone, the edge between the two can be emphasised by lightening the pixels along the edge of the light side and darkening the pixels along the edge of the dark side. The effects of the Unsharp Mask filter are more noticeable on-screen than in print. For final evaluation always check the final print and adjust if necessary. The three controls over sharpness are:

**Amount** - controls the increase in **contrast** between different tones or pixels at the edges. 80 to 180% is normal. The amount is usually low when sharpening images of people.

**Radius** - controls the **width** of the effect occurring at the edges. There is usually no need to exceed 1 pixel.

**Threshold** - controls **where** the effect takes place. A zero threshold affects all pixels whereas a high threshold affects only edges with a high tonal difference. The threshold is usually kept very low (0 to 2) for images from digital cameras, medium or large format film. The threshold is usually set at 3 for images from 35mm. Threshold is increased to avoid accentuating noise, especially in skin tones.

*Before the USM is applied*

*After USM is applied. Radius set high to exaggerate effect*

**Note. If the Unsharp Mask filter makes colours appear too saturated, the image can be converted to 'Lab mode' and the filter applied to the L channel only. This will sharpen the image without affecting the colour.**

## Targeting tones

In this activity specific highlight, shadow and mid-tone values are targeted on an adjustment curve. The colour cast is corrected using the 'Set Gray Point' eyedropper in the curves dialogue box and the colour of the man's turban is selectively altered.

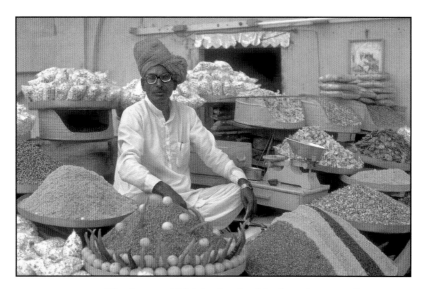

*The image '04.Market.jpg' before image adjustments*

### Activity 2    www.photoeducationbooks.com/retouching.htm

1. Open the file '**02.Market.jpg**' and select the 'Eyedropper Tool' in the 'Tools' palette. Set the sample size of the eyedropper to a 5 by 5 average in the options bar to ensure general tonal values are sampled rather than individual pixel values.

2. Create a curves adjustment layer by clicking on the 'Create new fill or adjustment layer' icon at the foot of the layers palette.

3. Move the mouse cursor outside of the curves dialogue box into the image window. The cursor will change to an eyedropper tool whatever tool was selected previously. Hold the mouse clicker down as you move around the image and note the 'Input' read-out in the curves dialogue box. Move to a bright highlight in the image (a bright section of the shirt).

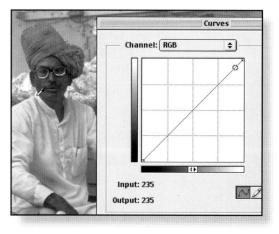

4. Select a tone that registers an input level that is approximately 235. Command/Ctrl click whilst the pointer is over the image area to set an adjustment point on the curve.

5. Move the cursor to an object with a dark tone (the rim of the man's glasses or spectacles). Select a tone that registers an input level that is approximately 15 to 20. Set an adjustment point as before.

6. Move the cursor to a part of the image that you would like to adjust to a midtone (the skin on the back of the man's hand would be ideal). Select a tone that registers an input level that is approximately 95. Set an adjustment point as before.

*The curve with modified output values*

7. In the curves dialogue box drag the highlight adjustment point until the output value reads 245. Select and drag the shadow adjustment point until the output value reads 10. Select and drag the midtone adjustment point until the output value reads 127.

8. Select the 'Set Gray Point' eyedropper in the curves dialogue box (between the black and white point eyedroppers). Click on a suitable tone you wish to desaturate in an attempt to remove the colour cast present in the image (the metal tray holding produce to the left of the man's shoulder would be ideal). The neutral tone selected to be the 'Gray Point' can be a dark or light tone within the image. If the tone selected is not representative of a neutral tone the colour cast cannot be rectified effectively.

*The 'Set Gray Point' eyedropper is used to correct the colour cast*

9. Fine-tune any colour correction by selecting an individual channel from the pull-down menu in the curves dialogue box. Create an adjustment point or use the adjustment point created by the Gray point eyedropper to perfect the colour adjustment. Select OK to apply the curves adjustment.

10. Create a 'Hue/Saturation' adjustment layer. Move the 'Hue' slider until the man's turban shifts to an orange/red hue. Decrease the saturation slightly.

**Note. All colours will be modified towards red as the adjustments are made at this stage.**

11. Fill the Layer mask that accompanies the Hue/Saturation adjustment layer with black (Edit > Fill).

**Note. If the default foreground and background colours are set in the 'Tools' palette the keyboard shortcuts 'Command/Ctrl + Delete' and 'Option/ Alt + Delete' can be used to fill or clear a layer mask quickly.**

12. Select the 'Brush Tool' and make the foreground colour white. In the options bar set the opacity to between 80 and 100%. Select an appropriate brush size and paint the turban in the image to reveal the hue adjustment. If you paint over the edge simply switch the foreground colour to black and paint to remove the previous adjustment.

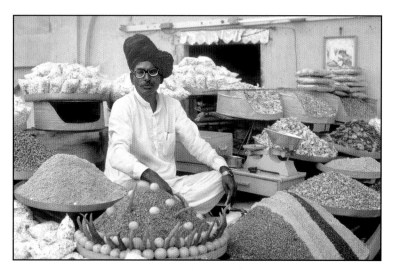

*The image '02.Market.jpg' after image adjustments*

13. Save the image as a PSD file.

## Preparing for print

This activity takes you through the complete series of steps required to retouch a digital file of poor quality. It is dirty, crooked and the colour and tone are a long way from being correct. The process includes sharpening, which is the last step prior to printing.

*Mark Galer*

## Activity 3  www.photoeducationbooks.com/retouching.html

1. Open the file '03.Temple.jpg'.

2. Select the 'Measure Tool' from the 'Tools' palette (behind the 'Eyedropper Tool'). Click and drag along the edge of the step beneath the mans feet to draw a line parallel with the step.

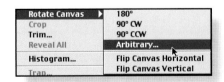

3. Go to Image > Rotate Canvas > Arbitary. The angle of rotation required to straighten the image will automatically be entered in the 'Angle' text field. Click OK to rotate the canvas.

4. Set the output dimensions and resolution in the 'Options' bar (7 in x 4.5 in @ 200 ppi). Drag the cropping marquee over the image to select an area that removes the black border and shaded lines at the base of the image. Press the tick or 'Commit current crop option' icon in the options bar to crop the image to the required specifications

**Note. The keyboard shortcuts for cropping are 'return/enter' to commit the crop and 'esc' to cancel the crop.**

5. In the 'History' palette create a new 'Snapshot' of the cropped image. This snapshot will enable the use of the history brush in the selective removal of the dust and scratches that cover much of the image.

**Note. The 'Dust & Scratches' filter cannot normally be applied globally to the whole image without removing excessive amounts of detail.**

6. From the 'Filters' menu apply the 'Dust & Scratches' filter ('Filters > Noise > Dust & Scratches'). Use the smallest 'Radius' and 'Threshold' settings possible to remove the large majority of the damage.

*Before and after using the 'Dust & Scratches' filter*

**Note. Do not worry if the Dust & Scratches filter removes important detail as well as the dust and scratches. You will revert to a previous 'History State' and use the 'History Brush' for selectively cleaning the image.**

7. Create another new snapshot and set the source for the history brush on this latest snapshot by clicking in the window next to the snapshot thumbnail. Snapshots can be named by double-clicking on the snapshot name and typing in something more memorable than the default name.

8. Change the current history state to the previous snapshot ('Snapshot 1') by clicking on it.

**Note. The history brush will be used to paint from the future state (minus dust and scratches) to the current state. The filter is limited to a localized adjustment.**

9. Select the 'History Brush' from the 'Tools' palette. Select the 'Lighten' paint mode in the history brush options.

**Note. Set the paint mode to darken if the marks or blemishes are lighter than the surrounding image.**

10. Paint out the damage using an appropriate brush size (just larger than the damage being retouched). Zoom in on the image when required and navigate by pressing the spacebar (to access the hand tool) and dragging to move the image within the window.

11.  Create a new adjustment layer and select 'Curves' from the menu. Use the RGB curve to adjust the tonality of the image.  Select a sample highlight from the sunlight striking the stonework to the right of the step and move it to a value of 245. Select a midtone from the shadow side of the man's forehead and move it to a value of 127. Select a dark tone above the man's head and move it to a value below 10. Remove the colour caste by moving the curves in the individual Red, Green and Blue channels. Alternatively use the 'Set Gray Point' eyedropper and select the neutral grey from the man's hair.

12. Create a 'Hue/Saturation' adjustment layer. Select 'Reds' from the pull-down menu. Increase the saturation by dragging the 'Saturation' slider to the right. As the warm tones in the image are restricted to the red scarves emerging from the temple and the man's skin, the rest of the image remains relatively unaffected. Click OK to apply the adjustment.

13. To limit the adjustment to just the scarves, paint into the adjustment layer's layer mask with black (set to 100% opacity) to conceal the increase in saturation to the man's skin. Alternatively fill the mask with black and paint with white to reveal the saturation adjustment to the scarves.

14. Prior to sharpening the image duplicate the file (Image > Duplicate).

15. View image at 100% (View > Actual Pixels). From the 'Filters' menu select 'Sharpen > Unsharp Mask'. Average settings are Amount: 180, Radius: 1.0, Threshold 3 for a scan destined for print from 35mm film. Select OK to apply sharpening.

16. Save the duplicate image as a TIFF file for printing. Save the master file with adjustment layers as a Photoshop file (PSD). If minor adjustments are required they should be made to the master file and a new duplicate created before printing a second time.

# 16 bit image editing

In order to produce the best quality digital image, it is essential that we capture, retain and preserve as much information about the tonality and colour of the subject as possible. This information is stored in the channels and the confirmation of 'quality' information is evident in the histogram of a flattened image.

The more we are forced to edit the pixel values of a digital image to compensate for poor light quality in the original scene, or poor scanning, the more information/quality we must sacrifice. If the subject is well lit and exposed, and the quality of the scanning or capture is good, minimal editing is usually required. This type of file can be edited in 8 bit mode with no apparent loss in quality. 16 bit editing is invaluable if maximum quality is required from an original image file that requires extensive editing.

## The problem with 8 bit editing

As an image file is edited extensively in 8 bit per channel mode (24 bit RGB) the histogram starts to 'break-up', or become weaker. 'Spikes' or 'comb lines' may become evident in the resulting histogram after the file has been flattened.

*Final histograms after editing the same image in 8 and 16 Bit/Channel mode*

**Note. The least destructive 8 bit editing techniques make use of adjustment layers so that pixel values are altered only once, when the layers are flattened prior to printing.**

The problem with editing extensively in 8 bit mode (the standard editing mode in Photoshop) is that a 24-bit image (8 bit per channel) has only 256 levels or tones per channel to describe the full colour range of the image. This is usually sufficient if the histogram looks healthy (few gaps) when we begin the editing process and the amount of editing required is limited. If many gaps start to appear in the histogram as a result of extensive adjustment of pixel values this can result in 'banding'. The smooth change between dark and light, or one colour and another, may no longer be possible with the data supplied from a weak histogram. The result is a transition between colour or tone that is visible as a series of steps in the final image.

## Advantages and disadvantages of 16 bit editing

When major colour corrections are required, and/or the highest quality, there are major advantages to be gained by using 'Adobe Photoshop' to edit an image file using '16 Bit/ Channel' mode (48 bit RGB). In 16 bits per channel there are trillions, instead of millions, of possible values for each pixel. Spikes or comb lines, that are quick to occur whilst editing in 8 bit per channel, rarely occur when editing in 16 bit per channel mode. There is however a catch. Photoshop has limited functionality when an image is opened or converted to 16 bit per channel mode.  The disadvantages of editing in 16 bits per channel are:

~    Not all scanning devices are capable of scanning in 16 bit per channel mode.
~    The size of file is doubled when compared to an 8 bit per channel image of the same output size and resolution.
~    No support for the use of Layers (including text and vector shape layers).
~    16 bit image editing does not support the use of the 'Quick Mask Mode'.
~    Many tools and filters do not work in 16 bit per channel mode, e.g. Magic Wand, Gradient, Dodge and Burn tools.
~    Only 3 file formats support the use of 16 bits per channel (PSD, Raw and TIFF).

*Adjustment layers and layer masks are not available in 16 bit mode*

Although Photoshop has limited functionality when an image is opened or converted to 16 bit per channel mode, it is still preferable to make the major changes in 16 bit mode before converting the file to 8 bit mode in order to access the full range of Photoshop features. Many editing techniques exist to help the user stay in 16 bit mode for much of the time. These include using the adjustments from the Image menu together with the history brush to apply localised or selective adjustments. Selections that would ordinarily require the use of the 'Quick Mask Mode' or the 'Magic Wand' can first be created by working in an 8 bit duplicate of the 16 bit file and then moving the resulting selection to the 16 bit file. These techniques are the focus of '**Activity 4**'.

**Note. Images can be converted from 8 bit to 16 bit prior to any adjustments required (Image > Mode > 16 Bit/Channel) or captured in 16 bit at the scanning stage (the preferred choice). Most of the better scanners that are now available (flatbed and film) now support 16 bit per channel (48 bit RGB) image capture.**

## Activity 4  www.photoeducationbooks.com/retouching.html

The image used in this tutorial was taken in the lowlands of Nepal as the light was fading. The distant Himalayas are still illuminated but the lighting conditions created a flat and desaturated image. Because of the extensive editing required to restore contrast and saturation, editing the image in 16 bit mode is preferable for a high quality final image.

*Before and after editing in 16 bit mode*

The aim of this activity is to:

~    Selectively increase the saturation of the yellow crop in the field.
~    Selectively increase the brightness of the figure in the foreground.
~    Selectively darken the sky whilst increasing its saturation.

1.  Open the image '**04.Nepal.jpg**' and convert to 16 bits per channel (Image > Mode > 16 Bit/Channel).

**Note. Many scanners refer to 16 bits per channel scanning as 48 bit RGB scanning. Some scanners offer 14 bits per channel scanning but deliver a 48 bit image to Photoshop. If you are unable to capture an image in 16 bit per channel you can capture an image in 8 bit mode and convert it to 16 Bits/Channel mode (Image > Mode > 16 Bit/Channel). Remember, you need twice as many megabytes as the equivalent 8 bit image, e.g. if you typically capture 11 Megabytes for an A4 image (A4 @ 200 ppi) you will require 22 Megabytes when scanning in 16 bits per channel.**

2. Image adjustments in 16 bit mode can be made from the Image > Adjustments menu only. As Photoshop does not allow the creation of selections using the 'Magic Wand Tool' or by 'Color Range', the whole image often has to be adjusted prior to limiting the effect of the adjustment to a more localised area. In the example the first adjustment is to increase the saturation by +20 (Image > Adjustments > Hue/Saturation). Create a new snapshot in the histories palette by clicking on the 'Create new snapshot' icon. This is by default called 'Snapshot 1'.

**Note. Snapshots are history states that have been preserved for future reference. It is important to note that all history states are lost when the file is closed.**

3. Click on the opening snapshot and make a 'Curves' adjustment to brighten some of the dark areas of the image, e.g. the foreground figure. A new snapshot is again created ('Snapshot 2').

**Note. The history brush can be used to paint from future or past states to the current state. In this way a global adjustment can be limited to a localized adjustment. We can take modified pixel values from a future or past state and paint them into the current history state. Confusing as it may be, it is currently the best technique available for editing in 16 bit mode.**

4. Snapshots can be renamed by double-clicking on the name of the snapshot, e.g. 'Snapshot 1' can be renamed 'Saturation' after its adjustment and 'Snapshot 2' can be renamed 'Brighten'. It is not essential that you rename snapshots but it can help to organise the future editing process.

5. Select the opening snapshot (created automatically when a file is opened) and set the source for the history brush to Snapshot 1 ('Saturation') by clicking on the small window to the left of the Snapshot 1 thumbnail. Select the history brush from the 'Tools Palette'. Paint the increased saturation from snapshot 1 to the opening snapshot.

**Note. Set a lower opacity from the options bar if you would like to implement the adjustments gradually.**

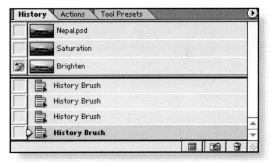

6. Reset the source of the history brush to the 'Brighten' snapshot. Ensure the 'Current State' is the last state in the history palette. Selecting the opening state as the 'Current State' would go back in time and remove the localized saturation adjustments you just made. If you now decide to make new adjustments (that are not available from the first series of snapshots created), first preserve the changes already made as a new snapshot.

**Note. Snapshots are not a replacement for saving work in progress. If you have been working for some time click on the 'Create new document from current state' icon and save the work in progress.**

7. The next step involves gradually darkening the sky towards the top of the image whilst increasing the saturation. As the 'Magic Wand Tool', 'Quick mask Mode' and 'Gradient Tool' are all unavailable in 16 bit mode we must first make a selection from an 8 bit duplicate file and import the selection into the file that is in 16 bit mode. Go to 'Image > Duplicate', click OK (naming the duplicate file is optional) and then convert this duplicate file to 8 Bit/Channel mode (Image > Mode > 8 Bit/Channel).

8. Make a selection of the sky and feather the selection. The 'Contiguous' box in the options bar was unchecked in the example so that the sky would be selected between the foliage of the trees.

9. Switch to 'Quick Mask Mode' (press Q on the keyboard) and add a gradient (foreground to transparent) in 'Multiply' blend mode. Drag the gradient from the horizon line to the top of the image whilst holding the shift key to constrain the gradient. Try lowering the opacity slightly if you wish to darken the sky at the horizon line a little.

10. Exit the Quick Mask Mode (press Q on the keyboard again). Make visible both the 16 bit file and the duplicate file on your screen and position them side by side. Make active the duplicate file. Click on any selection tool in the Tool Box and click and drag the selection into the 16 bit file. Before letting go of the selection press the shift key so the selection lines up exactly inside the 16 bit file.

11. With the selection still active go to Image > Adjustments > Hue/Saturation. Slide the Lightness slider to a negative value to darken the sky to your personal preference. Click OK and deselect the active selection (Select > Deselect).

*The final image and its histogram*

12.  With the major adjustments now complete you can convert to 8 Bit/Channel mode safe in the knowledge that these adjustments will not have compromised the image histogram and resulting image quality. All that remains is to fine tune your image and apply the required amount of Unsharp Mask prior to printing.

**Note. If you are used to editing with adjustment layers and layer masks, 16 bit editing may feel like editing without a safety net (the snapshots are not saved with the document). The goal however is only to make the 'major' changes before switching to 8 bit mode. Editing in 16 bit mode may seem unduly complex but the benefit is optimum quality.**

# Assignment 1

## Image reproduction

The aim of this assignment is to duplicate (as closely as possible) a photographic image. This will help you to understand the translation of tonality and colour between an original photographic image, a preview of the image on a monitor, and its digital reproduction from a print output device.

1. Scan a personal colour photographic print (no larger than A4) that has a broad tonal and colour range. Scan the image to give a file size and output resolution necessary to give a high quality digital print (a scanning resolution of at least 200 ppi is required).
2. Adjust digital file to replicate, as near as possible, the original. Use adjustment layers wherever possible.
3. Print (in colour) the digital image on a similar paper surface (gloss, matt etc.) to the original photograph.
4. Compare the digital print to its monitor preview (return to the same monitor you used to correct the image originally). Adjust the digital file if required and print again.
5. Prepare a 300 word report (in point or list form) on the methods and procedures used. Briefly describe the highlight and shadow detail, the overall contrast and the hue, saturation and brightness of the colours reproduced.

 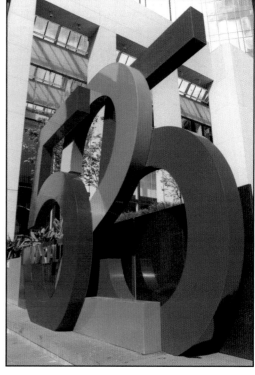

*Assignment work by James Cowie*

# Assignment 2

## Advanced retouching

The aim of this assignment is to modify an original image to improve on its aesthetic qualities. Modifications should be subtle and the final image 'believable' or realistic in appearance.

1. Select a personal colour image that demonstrates both a high degree of technical competence and aesthetic quality.
2. Scan the image to obtain an optimum tonal range and a file size of approximately 11MB (8 bit per channel scanning for an A4 print @ 200 ppi).
3. Selectively remove dust and scratches using the techniques learnt in this chapter.
4. Adjust the hue, saturation or lightness of a selected area within the image.
5. Adjust the contrast of a selected area within the image.
6. Remove or modify unwanted detail.
7. Print (in colour) the original scanned image and the modified image on the same paper surface using the same digital output device.
8. Save a master PSD file and a flattened Tiff file for printing
9. Prepare a 300 word report (in point or list form) on the methods and procedures used.

**Note. Scan to obtain a 22 MB file if scanning at 16 bits per channel.**

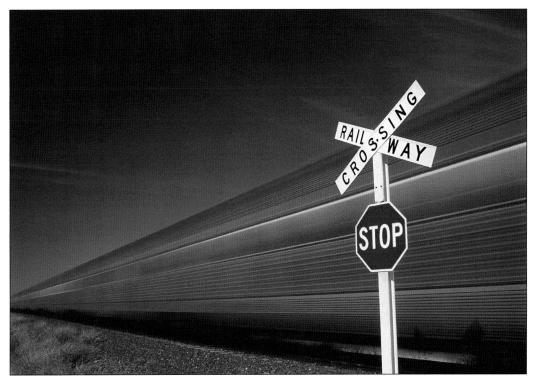

*Assignment work by James Cowie*

# Revision exercise

Q1. What is the advantage of using the 'Save As' command rather than the 'Save' command when you want to save your recent actions during image editing?
(a) Saves a smaller file size. (b) Saves quickly using the last save options.
(c) Preserves (does not save over) the current version if the file name is changed.
(d) No difference.

Q2. When increasing the output dimensions of the image (Image > Image Size), what happens if the 'Resample' box is checked before carrying out the process?
(a) Interpolation occurs during the resizing of the image.
(b) Pixel dimensions are protected. (c) The Resolution of the image is lowered. (d) Down sampling of the image occurs.

Q3. What is the aspect ratio of a 35mm full-frame negative?
(a) 3:4 (b) 35mm (c) 2:3 (d) 4:5

Q4. Which of the following actions will **not** free-up memory when working with Photoshop?
(a) Reduce the history states from their default of 20. (b) Merge layers.
(c) Choose Edit > Purge > All. (d) Switch to the Non-linear history option.

Q5. How can the blurring effects of the dust and scratches filter be limited to preserve important detail?
(a) Increase pixel radius in filter dialogue box.
(b) Reduce tolerance in dialogue box.
(c) Apply the dust and scratches filter globally to the whole image.
(d) Create a selection prior to applying the filter.

Q6. What effect does the sponge tool have when working on a Grayscale image?
(a) Has no effect. (b) Increases or decreases saturation. (c) Decreases contrast. (d) Increases or decreases contrast depending on selected option.

Q7. How does the Magic Wand tool select pixels?
(a) Shape (b) Contrast (c) Similar colour value (d) By dragging

Q8. How can the effects of an adjustment layer be restricted to one layer only?
(a) Position the adjustment layer below the target layer.
(b) Position the adjustment layer above the target layer.
(c) Create a clipping group between the target layer and the adjustment layer.
(d) Cannot be confined to one layer.

Q9. What do the neon colours indicate when adjusting the highlights or shadows of an RGB image when using the 'Variations' command?
(a) Colours are out of gamut. (b) An RGB channel is being set to 0 or 255.
(c) Colours are too saturated to print.
(d) Indicates the specific tones being adjusted.

# digital

## practical montage

*Mark Galer*

## aims _____

- ~ To offer an independent resource of technical information.
- ~ To develop knowledge and understanding about the processes and procedures involved with montaging photographic images.
- ~ To develop skills and experience in the control and construction of digital montages.

## objectives _____

- ~ **Create** digital montages using skills and knowledge concerning:
  - selection tools and techniques
  - layers and channels
  - quick mask mode and layer masks
  - adjustment layers and clipping groups
  - blend modes

# Introduction

The ability to create a composite image or '**photomontage**' that looks subtle, realistic and believable rests in whether or not the viewer is able to detect where one image starts and the other finishes. The edges of each selection can be modified so that it appears as if it belongs, or is related, to the surrounding pixels.

Options are available with most image processing software to alter the appearance of the edges of a selection. Edges can appear sharp or soft (a gradual transition between the selection and the background). The options to effect these changes are:

~    Feather
~    Anti-aliasing
~    Defringe and matting

## Feather

When this option is chosen the pixels at the edges of the selection are blurred. The edges are softer and less harsh. This blurring may either create a more realistic montage or cause loss of detail at the edge of the selection.

You can choose feathering for the marquee or lasso tools as you use them by entering a value in the tool options box, or you can add feathering to an existing selection (Select > Feather). The feathering effect only becomes apparent when you move or paste the selection to a new area.

## Anti-aliasing

When this option is chosen the jagged edges of a selection are softened. A more gradual transition between the edge pixels and the background pixels is created. Only the edge pixels are changed so no detail is lost. Anti-aliasing must be chosen before the selection is made (it cannot be added afterwards). It is usual to have the anti-alias option selected for most selections. The anti-alias option also needs to be considered when using type in image editing software. The anti-alias option may be deselected to improve the appearance of small type to avoid the appearance of blurred text.

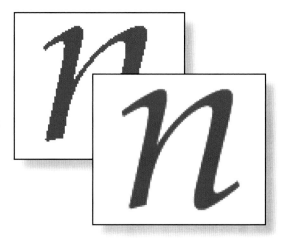

## Defringe and matting

When a selection has been made using the anti-alias option some of the pixels surrounding the selection are included. If these surrounding pixels are darker, lighter or a different colour to the selection a fringe or halo may be seen. From the Layers menu choose Matting > Defringe to replace the different fringe pixels with pixels of a similar hue, saturation or brightness found within the selection area.

*Fringe*

*Defringe*

The user may have to experiment with the most appropriate method of removing a fringe. The alternative options of remove white matte and remove black matte may provide the user with a better result. If a noticeable fringe still persists it is possible to contract the selection prior to moving it using the Modify > Contract option from the Select menu.

## Saving a selection as an alpha channel

Selections can be permanently stored as '**alpha channels**'. The saved selections can be reloaded and/or modified even after the image has been closed and reopened. To save a selection as an alpha channel simply click the '**Save selection as channel**' icon at the base of the channels palette. To load a selection either drag the alpha channel to the '**Load channel as selection**' icon in the channels palette or Command/Ctrl click the alpha channel.

It is possible to edit an alpha channel (and the resulting selection) by using the painting and editing tools. Painting with black will add to the alpha channel whilst painting with white will remove information. Painting with shades of grey will lower or increase the opacity of the alpha channel. The user can selectively soften a channel and resulting selection by applying a gaussian blur filter. Choose Blur > Gaussian Blur from the filters menu.

An image with saved selections cannot be saved as a JPEG.

# Replacing a background

Perhaps one of the most common montage techniques is the process of replacing the background of one image with the background from another. The effectiveness of such a montage is often determined by whether the image looks authentic (not manipulated). In order to achieve this the digital photographer needs to modify the edge of any selection so that it is not obviously apparent when the selection is placed onto the new background. An inappropriate selection will make the subject appear as if it has been cut out with a pair of scissors and pasted onto the new background.

*Mark Galer*

In the practical activity that follows you will learn how to increase the accuracy of a selection, modify the selection and then store or save this selection. In the activity you will use the following techniques:

~   Add and subtract from a selection using a combination of selection tools.
~   Edit a selection using the quick mask mode.
~   Modify a selection using the feather, contract and/or defringe commands.
~   Save a selection as a channel.
~   Add a layer mask.

**Note. Images to support this activity can be found on the supporting website.**

## Activity 1  www.photoeducationbooks.com/montage.html

1. Open the images '01.sax.jpg' and '01.zoom.jpg' from the supporting website. As with any montage work it is advisable first to ensure that the resolution of each image is the same and that each image is of an appropriate size. For a quick check depress the option key and click the document size box at the base of the image window. The images should also be in the same mode, e.g. RGB or Grayscale.

If the resolutions of the images do not match they need to be adjusted. Choose Image > Image Size and adjust the resolution and pixel dimensions until the images are of a similar size. If this action is not taken imported images of a different resolution will be automatically adjusted to match the resolution of the background image. This will lead to changes in size of the imported image, e.g. imported images possessing a lower resolution than the host image will reduce in size. If increased to their original size using the 'transform' command the image will require '**Interpolation**' (see Digital Basics > Interpolation).

**Note.  Be careful when adjusting the pixel dimensions of an image not to use excessive interpolation.  It is better to 'downsample' the larger image (decrease the total number of pixels) rather than sample up the smaller one.  Exceptions can be made for background images where there is little fine detail, e.g. water, sky, fire etc.**

2. Reset the palette locations to their default location. Choose 'Window > Reset Palette Locations' or Command + K  - 'Reset Palettes Locations to Default' (Photoshop 5).

3. If you are using a shared computer select the magic wand in the tool palette and 'Reset all tools' (accessed via the tool options bar or palette).

4. Select the majority of the background using a combination of the magic wand and lasso tools. Keep the shift key depressed to build on, or add to, each successive selection. See 'Basic selection techniques'. Areas around the saxophone player's trousers will be difficult to select using these tools due to the tonal similarities. To complete the selection we will need to use the '**Quick Mask Mode**'.

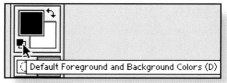

5. Switch to 'Quick Mask Mode'.

6. Click on the default colours in the tools palette.

7. Select the paintbrush tool from the tools palette and an appropriate hard-edged brush from the options bar or brushes palette (V.5).

8. Double click the Quick Mask icon in the tools palette to open the Quick Mask Options box. Click the colour swatch to open the 'Color Picker' and select a contrasting colour to the image you are working on (in this case a bright green would be appropriate). Click OK and set the opacity to 50% in the Quick Mask Options box.

9. Painting or removing a mask with the brush will result in a modified selection when the edit mode is returned to normal (the icon next to the Quick Mask Mode). The foreground and background colours can be switched when painting to subtract or add to the mask and the resulting selection. Click on Edit in Standard Mode to see the changes to your selection. Zoom in on localised areas of the image to check the accuracy of your selection and reduce the size of the brush for correcting fine details. Click the standard editing mode when you have finished.
The illustration to the right shows editing in Standard Mode (left) and Quick Mask Mode (right).

10. After successfully separating the saxophone player from the background you will need to 'Inverse' the selection (Select > Inverse) so the saxophone player rather than the background is selected.

11. Select the 'Move' tool in the tool palette and drag the saxophone player a short distance. You will notice that the selection has a fringe of dark pixels surrounding it (part of the original background image). The edge of the selection also possesses a sharp well-defined edge that is not consistent with the edge quality in the original image. This can be modified so that the edge quality does not stand out when the saxophone player is moved to a lighter background. Undo the move (Command/Ctrl + Z) or go back in the '**Histories**' (not available in Photoshop LE) to the point prior to the move.

*Selection before modifications*            *Selection after modifications*

12. The selection can be contracted or shrunk by two pixels to remove this telltale dark fringe (Select > Modify > Contract).

13. The edge can be softened using the feather command in the select menu (Select > Feather). Type 2 pixels in the feather dialogue box and click OK. Move the saxophone player to see the changes in the edge quality of your selection.

14. Save the selection by clicking the '**Save selection as a channel**' icon at the base of the channels palette. An 'Alpha' channel appears below the RGB channels.

Save your image by using File > Save As. Change the name of the original file and save the file as a TIFF or PSD file (the JPEG file format does not support additional channels). The alpha channel contains a record of your selection. This selection can be recalled if the selection is lost or the file is closed and reopened.

15. Go to Select > Deselect (Command/Ctrl +D). To reload your selection go to the alpha channel in the channels palette. Drag the channel to the 'load channel as selection' icon at the base of the channels palette or Command/Ctrl click the Alpha channel. Clicking on the alpha channel will view the channel. After viewing an alpha channel simply click on the RGB channel to return the view to normal. Return to the layers palette and select the layer before proceeding.

16. Locate the zoom image and position it alongside the saxophone player image. Click on the zoom image to make this the active window. Select the 'Move Tool' and drag the zoom image onto the saxophone image. A border will appear momentarily around the saxophone image to indicate when the zoom image has been placed into the new image.

17. Check the layers palette and observe that the image now comprises two individual layers. The saxophone player is concealed by the zoom layer. Select the top layer (the zoom image) and then Edit > Free Transform (Command/Ctrl + T). Drag on a corner handle to resize the zoom image to fit the saxophone image or background image. Drag inside the image to reposition it.

18. Load the alpha channel created earlier from the channels palette (see step 15) and select the zoom layer in the layers palette to make this the active layer.

19. From the layer menu go to 'Add Layer Mask > Hide Selection' or simply click on the layer Add a mask icon at the bottom of the layers palette whilst holding down the Option/Alt key. A section of the zoom image will be masked to reveal the saxophone player beneath it. It is important to note that the section of the zoom image that is no longer visible has been masked and not removed permanently.

20. Any imperfections still evident can be corrected by clicking on the mask thumbnail in the layers palette and then painting with black to increase the mask or painting with white to remove sections of the mask.

21. Save the completed montage as a PSD image (complete with all layers).

# Blending images

Blending two images in the computer is similar to creating a double exposure in the camera or sandwiching negatives in the darkroom. Using image processing software the individual can exercise a greater degree of control over the final outcome. This is achieved by controlling not only the position and opacity of each layer but also which areas of the image will be blended and which will remain untouched, using a technique called '**layer masking**'. The blending technique enables the texture or pattern from one image to be modelled by the form of a selected subject in another image.

*Mark Galer*

*The 'layer mask' is created automatically when the image of the water drops is copied and pasted into a selection. This selection is made to separate the subject from its background and define the area that will be blended.*

In the montage above the image of the body has been blended with an image of raindrops on a car bonnet. A '**layer mask**' is created by pasting the drops of water into the selection of the body. This layer mask limits the visibility of the raindrops to the area of the body only.

# Activity 2   www.photoeducationbooks.com/montage.html

The following operations were performed in 'Adobe Photoshop' to achieve the blended image on the previous page.  This is a suggestion only to indicate the type of effects that can be achieved using a variety of software packages designed for image processing.

1. Select or create one image where a three-dimensional subject is modelled by light. Try photographing a part of the human body using a large or diffused light source at right-angles to the camera.  The image should ideally contain bright highlights, midtones and dark shadows.   Scan the image and save as 'Form'.  Alternatively use the image titled '02.form.jpg' provided on the web site to support this study guide.

2. Select or create another image where the subject has an interesting texture or pattern. Scan the image and save as 'Texture'. Try using a bold texture with an irregular pattern. The texture should ideally have a full tonal range with good contrast. A subtle or low contrast texture may not be obvious when blended.  Alternatively use the image provided to support this study guide that is titled '02.texture.jpg'.

3. Go to 'Image > Image Size', and check that the image pixel dimensions (width and height) are similar.  It is possible to blend a coloured texture with a grayscale image. If the colour is to be protected the grayscale image must first be converted to RGB in 'Image > Mode'.

4. Open the image labelled "form" and make a selection of the subject using the magic wand, marquee and lasso tools. Save this selection as a channel (see Activity 1). Do not deselect.

5. Open the image labelled 'Texture', choose 'select all' (from the select menu) and 'copy' (from edit menu).  This action saves the image to a 'clipboard'.

6. Make active (click on the window) the image 'form' and from the edit menu choose '**Paste Into**'. This allows the saved image in the clipboard to be pasted into the active selection. The texture will appear only in the selection and is controlled by the '**layer mask**'. The layer mask icon appears alongside the icon of the texture in the layers palette. Click on the texture icon and select the move tool in the tools palette. Click and drag the texture in the large image window. Observe from this action that the texture image has not been cropped but masked.

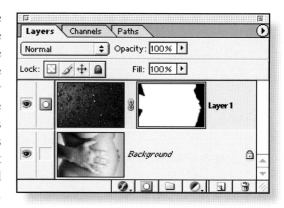

7. As the top layer is set at 100% opacity none of the information on the layer below is visible. Experiment with adjusting the opacity of the top layer using the opacity slider in the layers palette. Observe the effects created by allowing the information on the layer below to show through. Set the opacity between 50 and 75%.

8. With the top layer active click on the blend mode menu in the layers palette and scroll down to the option '**Multiply**'. Observe the changes that take place in the image and pay particular attention to the information that can be seen in the shadows and highlights. Now change the blend mode to '**Screen**' and then '**Overlay**' to observe the differences that these blend modes have on the interaction between the two layers. Choose the most appropriate one and readjust the opacity of the layer.

9. The blend is now complete. Save a copy of the finished image as a TIFF by choosing Save As from the File menu and TIFF from the Format menu in the Save As dialogue box (Photoshop 6 - 7 only). For Photoshop 5 choose '**Save a Copy**' from File menu and select TIFF from the pop-up menu. It is advisable to save a master version as a PSD (Photoshop document) if you need to save an image which requires the image to be flattened.

# Incorporating typography into a montage

An important element of many photomontages is the use of text to extend the communication. Image processing software, such as Photoshop, allows for the full integration of typography and photographic imagery. In the image below the typography is stretched and then filled with the same imagery that was used in the blend with the figure (Activity 2).

*Mark Galer*

## Activity 3    www.photoeducationbooks.com/montage.html

This activity revisits the use of a layer mask that was introduced in Activity 2. The layer mask in this activity is created using the '**Add Layer Mask**' command and then filled using the gradient tool rather than created using a selection and the 'Paste Into' command. This graduated layer mask allows the typography to appear gradually as if from the fire. Because a layer mask is already in place on the typography layer the alternative technique of creating a '**clipping group**' is used to assign the texture 'raindrops' to the typographic form (creating a layer mask would have given the same effect). The three-dimensional look of the typography is created by applying a layer effect called '**Bevel and Emboss**' to the typographic layer. The finishing touches were created by using an adjustment layer clipped to the texture to increase its contrast.

1. Open the image '**03.fire.jpg**'. Select the type tool in the tools palette and open the character palette (Photoshop 6 - 7) or double click to open the dialogue box (Photoshop 5). Click on the left side of the image. Specify the text, style, size of the text (with the characters selected typing minus or plus values in the tracking box will move letters closer or further apart).

**Note. Colour is normally selected by clicking the colour swatch. Colour is not important for this exercise as the type will be filled with another image. Ensure that anti-alias is selected (crisp, strong or smooth) and then click OK.**

2. Stretch or distort the type layer by applying the '**Free Transform**' command (Command/Ctrl + T). The type in the example has been stretched vertically by dragging the top-centre handle upwards. Press the Return/Enter key to apply the transformation.

**Note. Transform alters the shape and/or size of the subject matter on a single selected layer. Holding the shift key down whilst dragging a corner handle will constrain the proportions.**

3. Apply an effect or '**Layer Style**' to this typographic layer, 'Layer > Layer Style > Bevel and Emboss' or 'Layer > Effects > Bevel and Emboss'(Photoshop 5).

Ensure that an 'Inner Bevel' is selected from the style menu, adjust the look of the bevel and click OK. The effect can be adjusted later by double-clicking on the effects layer (Photoshop 6 - 7) or the effects icon that appears on the typographic layer (V. 5).

4. With the type layer still selected add a layer mask by clicking the '**Add a mask**' icon at the foot of the layers palette. An empty layer mask will appear in the layers palette beside the typography thumbnail. With this thumbnail selected you can use any of the paint tools to paint a layer mask. A layer mask will conceal information on its own layer. The darker the colour that you use to paint with, the more information on this layer will be concealed. If black is selected, the pixels in the location of the mask will be completely concealed. If a middle tone is used the opacity of the information will be reduced.

*The example above illustrates how a soft-edged brush used to paint black in the layer mask affects the typography on the same layer.*

5. Set the default foreground and background colours in the tool box (black and white). Click on the layer mask in the layers palette to select it rather than the type. Select the linear gradient tool in the tools palette. Select foreground to background or foreground to transparent and 100% opacity. Move the cursor to the bottom of the typography in the main image window. Click and drag the gradient cursor from the base of the letters to the top of the letters. A linear gradient will appear in the layer mask and the typography should be half hidden behind this layer mask. Experiment with dragging shorter and longer gradients.

6. The layer mask can be moved by selecting the move tool and dragging inside the main image window. To move the typography and not the mask you must first click on the typography thumbnail in the layers palette. To move both the layer mask and the typography at the same time you must first click between the layer mask and typography windows in the layer palette. This action creates a link between both elements. The link can be broken by clicking on the icon.

7. Select the type tool again and click beneath the word you have just created. Select a smaller point size and type the additional copy. Highlight the text and adjust the size if necessary. Reposition the copy by dragging the type and then click OK.

8. Click the 'Color Swatch' in the type options or dialogue box (V. 5) to open the colour picker. To choose a colour from the image move the cursor onto the image window. The cursor appears as an eyedropper and can sample a colour by clicking on it. This colour will then be assigned to the typography.

9. Apply an 'Outer Glow' layer style (layer effect in Photoshop 5) to this typographic layer. Adjust the opacity, spread and size (blur and intensity in Photoshop 5) to create the desired effect surrounding the typography. Click the colour box to open the color picker and choose a colour.

10. Open the image containing the texture you wish to paste into the typographic form (the image '**02.texture.jpg**' from Activity 2 was used in this example). Ensure the image is of a similar size and resolution to that required. The size can be modified later using the 'free transform' command but the digital photographer must be careful not to increase the size of any image excessively ('interpolation' will lower the overall quality). Select all (Command/Ctrl + A). Select the move tool and drag the selection into the background image with the typography. The texture will be placed on a layer above the other layers completely concealing both the typography and the background.

11. A clipping group is required in order to fill the typography with the image of the raindrops. This is achieved by moving the cursor to the line that divides the two layers in the layers palette. By holding down the Option/Alt key the clipping icon should appear (two overlapping circles). Clicking whilst holding down the Option/Alt key will clip the layers together. The layer thumbnail is indented and the name of the base layer in the clipping group is underlined. The typography acts as a mask.

12. Finally an adjustment layer is applied to the top layer. Increase the contrast and/or change the colour of the raindrops. It too is clipped to the typography layer to limit its effects to the raindrops only. Adjustment layers will affect all layers beneath them unless clipped.

# Advanced montage techniques

This activity utilises most of the techniques covered already (including the use of type layers and layer effects, the creation of a clipping group to mask the imagery and confine the effects of an image adjustment layer). These techniques are revisited to reinforce the learning process. The new techniques applied to this montage activity include:

~  Selective blending (via the blending or layer options dialogue box).
~  The use of filters to create special effects.
~  Transform commands to modify layer content.

*Mark Galer*

## Activity 4    www.photoeducationbooks.com/montage.html

The technique of making the typography disappear amongst the cloud cover is created by a sandwiching technique and a selective blend mode applied to the top layer.

The sky is duplicated and the copy moved to the top of the layers stack. The darker levels (the blue sky) are blended or made transparent whilst the lighter levels (the clouds) are kept opaque. The typography now appears where the sky is darker and is obscured by the lighter clouds.

1. Open the image '**04.sky.jpg**'. Click on the type tool in the tool palette and create the desired typography. The example uses a Charcoal font, '**Faux Bold**' and '**Faux Italic**' (a Photoshop feature that allows any font to be made italic or bold). Any bold italic font would be suitable for this activity.

2. The layer effect 'Bevel and Emboss' is applied to this type layer. Select 'Inner Bevel' from the style menu and select an appropriate 'Angle' that is consistent with the light source in the rest of the image. Apply an appropriate blend mode, opacity and colour to both the highlights and shadows. In the example both the highlight and shadow were set to 100% and the angle was set to 120°.

3. Duplicate the background layer 'Sky' by dragging the layer in the layers palette to the 'New Layers icon' at the base of the layers palette. Move the background copy to the top of the layers stack above the type layer (this action will temporarily obscure the type layer).

4. Double-click the background copy layer. The 'Blending Options' or 'Layer Options' (V. 5) dialogue box will be opened. This dialogue box allows the user to change the opacity and blend mode of the layer. The bottom half of the box allows the user to control the range of levels that may be blended. Dragging the left-hand slider on the top ramp to a position of 150 allows all of the darker tones, or levels, to be made transparent. The typography on the layer below is now visible in all areas where the pixels are 0 to 150.

5. The effect at present is abrupt. The type disappears suddenly into the clouds rather than gradually. A more gradual transition can be achieved by fading the effect over a range of pixels rather than selecting a single layer value at which 100% transparency takes place. By holding down the Option/ Alt key and dragging the slider it is possible to split the black slider. Drag the right half of the slider to a value of around 200. This action creates the desired effect of the type fading slowly into the cloud cover.

6. Apply a fill to the typography using the technique used in the last activity. The image used to fill the type in this activity is called '**04.storm_clouds.jpg**'. The image is opened and selected (Select > All) and is dragged (using the move tool) or copied and pasted into the sky image. The image is moved to a position directly above the type layer in the layers palette and is '**clipped**' to the type layer (see 'Activity 3').

7. An adjustment layer is then added and clipped with the storm clouds and typography (see 'Activity 3').
The adjustment layer is used to shift the colours of the storm cloud towards blue. This can be achieved by using either a colour balance or a curves adjustment.

8. Open the image '**04.jet.jpg**'. Isolate the aircraft from the surrounding blue sky using the selection tools and techniques of your choice. Be sure to feather your selection by one pixel. Move or copy and paste the selection into the sky image. From the Layers menu choose Matting > Defringe (one or two pixels) or 'Remove White Matte' to remove any sky blue pixels from around the jet aircraft that will not match the new sky that it is placed against.

9. From the Edit menu choose Transform > Scale to reduce the size of the aircraft. Drag a corner handle to reduce the size and press return/enter when this is achieved. Again from the Edit > Transform choose 'Flip Horizontal' to turn the aircraft facing right.

**Note. The flip command in the transform menu will flip only the contents of the selected layer whilst the 'Flip Horizontal' command in the 'Image > Rotate Canvas' menu affects the whole image (all layers).**

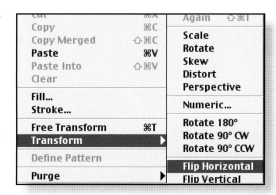

10. To create the movement effect duplicate the aircraft layer twice (drag the layer to the 'Create new layer' icon). Choose Blur > Motion Blur from the filters menu to apply a 10 pixel blur to one of the two duplicate layers. Apply a 300 pixel motion blur to the second duplicate layer. Ensure that the 'Angle' is appropriate for the direction of travel or movement. If you need to see a preview of the effect drag inside the preview window until part of the aircraft appears.

11. Position the 10 pixel blur above the original and the 300 pixel blur beneath the original. Create a layer mask on the 10 pixel blur layer and use a linear gradient tool to conceal the front half of the blurred aircraft. With the 300 pixel blur layer selected choose Transform > Rotate from the Image menu and move the streak into position.

12. The additional typography 'Red' is created using an additional type layer. First select a colour red from the aircraft using the eye-dropper tool. This colour will be placed in the foreground colour swatch in the tools palette and become the default colour for the typography. Click and drag the new type layer into position. From the edit menu choose Transform > Skew to increase the angle of lean of the typography. From the Filters menu choose Stylize > Wind and select 'From the Right' to give the appropriate direction of travel.

**Note. To apply a filter to a type layer the type must first be rendered (into pixels). If type is rendered it is no longer editable.**

The montage is now complete. Save a PSD version of the image. Choose 'Save a Copy' from the 'Save As' dialogue box or directly from the File menu (Photoshop 5). Select Photoshop from the pull-down menu.

# Advanced blending techniques

The layer '**blend**' modes are an effective, but limited, way of merging or blending a pattern or graphic with a three-dimensional form. By using the blend modes the pattern or graphic can be modified to respect the colour and tonality of the 3-D form beneath it. The highlights and shadows that give the 3-D form its shape can, however, be further utilised to wrap or bend the pattern or graphic so that it obeys the forms' perspective and sense of volume. This can be achieved by using the 'Displace' filter in conjunction with a 'Displacement map'. The 'map' defines the contours to which the graphic or pattern must conform. The final effect can be likened to 'shrink-wrapping' the graphic or pattern to the 3-D form.

*Mark Galer*

Displacement requires the use of a PSD image file or 'displacement map' created from the layer containing the 3-D form. This is used as the contour map to displace pixels of another layer (the pattern or graphic). The brightness level of each pixel in the map directs the filter to shift the corresponding pixel of the selected layer in a horizontal or vertical plane. The principle that this technique works on is that of 'mountains and valleys'. Dark pixels in the map shift the graphic pixels down into the shaded valleys of the 3-D form whilst the light pixels of the map raise the graphic pixels onto the illuminated peaks of the 3-D form.

Note how the straight lines of the Union Jack are distorted after the displace filter has been applied. The first image looks as though the flag has been projected onto the rock surface, whilst in the second image it appears as though it has been painted or shrink-wrapped onto the rock surface.

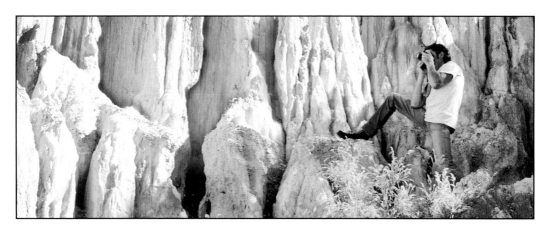

*Mark Galer*

## Activity 5  www.photoeducationbooks.com/montage.html

The limitation of the displacement technique is that the filter reads dark pixels in the image as being shaded and light pixels as being illuminated. This of course is not always the case. With this in mind the range of images that lend themselves to this technique is limited. A zebra would be a poor choice on which to wrap a flag whilst a nude illuminated with soft directional lighting would be a good choice. The image chosen for this activity lends itself to the displacement technique. Directional light models the rock face. Tonal differences due to hue are limited.

1. In order to apply the displace filter you must first create a grayscale image to become the displacement map. Open the image 05.Rockface.jpg. In the channels palette locate the channel with the best tonal contrast between the shadows and the highlights. Duplicate this channel by dragging it to the new layer icon at the base of the palette.

2. Apply a small amount of 'Gaussian blur' from the filters menu and adjust the levels to modify the contrast range if necessary.

3. Export this channel to become the displacement map by choosing '**duplicate channel**' from the channels menu and then '**Document > New**' from the Destination menu. Save the exported PSD file. This will be your displacement map.

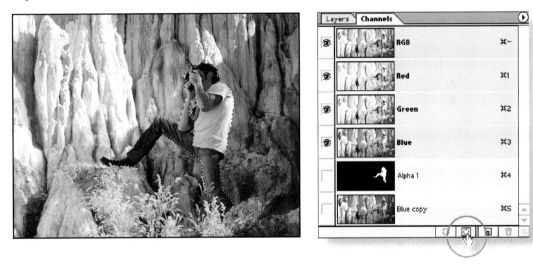

4. Select the parts of the image you do not wish to shrink-wrap with the imported graphic or pattern. Save your selection as an 'Alpha' channel by clicking on the 'Save selection as channel' button at the base of the channels palette.

5. A small paper flag was scanned so that it could be used as a flat two-dimensional graphic or pattern (image 05.flag.jpg). Select, copy and paste the flag in the rockface image. Apply the 'Free Transform' from the Edit menu to obtain a 'good fit' if necessary. From the blend modes choose an appropriate blend mode and layer opacity for the desired effect you would like to achieve. The 'Overlay' or 'Soft Light' blend modes are a good place to start, although 'Colour Burn' proved effective in this instance.

6. Choose 'Filter > Distort > Displace' and enter the amount of the displacement. As the displacement map is the same size as your final image you can ignore everything in the displace dialogue box except the amount. Select OK and then select the displacement PSD file you created earlier. The distortion is applied to the layer. The Displace filter shifts the pixels on the selected layer using a pixel value from the displacement map. Levels 0 and 255 are the maximum negative and positive shifts whilst level 128 produces no displacement.

**Note. If an RGB map is used the red channel controls the horizontal displacement and the green channel controls the vertical displacement.**

7. To complete the wrap load the selection you created earlier by dragging the alpha channel to the 'Load channel as selection' icon. Select the map layer in the layers palette and with the Option/Alt key depressed click on the 'Add a mask' icon in the layers palette. The blend is now complete.

## Alternative approach using the 'Liquify' filter

An alternative approach to distorting the graphic using the displacement filter in '**Activity 5**' would be to use the 'Liquify' filter. Instead of using the '**blue copy**' channel to create a displacement map it can be used to '**freeze**' an area of the image prior to selectively displacing the unfrozen pixels using the '**Warp Tool**'. This alternative method of displacing pixels on one layer, to reflect the contours of another layer, is most suited to the improved features to be found in Photoshop 7 which allow for the visibility of additional layers.

To try this alternative approach complete the first five steps of 'Activity 5', skipping step 3. When you reach step 6, instead of creating a displacement map, click on the graphic layer and launch the Liquify filter. Check the backdrop option in the dialogue box and select 'background layer' from the menu.

To selectively freeze the darker pixels in the image load the 'Blue copy' channel in the 'Freeze Area'. Check 'Mesh' in the view options and uncheck 'Frozen Areas'. Select a brush size and pressure and then stroke the graphic upwards whilst observing the contours of the rock wall to displace the lighter pixels. Invert the freeze area (which creates a custom channel) so that you can displace the darker pixels in the opposite direction.

# Extract filter

Photoshop's 'Extract Filter' can be an indispensable tool for montage work. With a suitable edge the extract filter works well, e.g. a sharp outline on a contrasting background. If the final montage is to be effective the new background also needs to complement the tone and colour of the subject's edge pixels. Many of the problems encountered when trying to achieve effective and sophisticated extractions usually lie with the images chosen and not with the extract filter itself. As soon as the edge is difficult for the filter to detect the results are often less than convincing. If unsuitable images are chosen a lot of patching, rebuilding or manual removal of the unwanted background pixels may follow.

*The filter has difficulty extracting a background where the edge contrast is low*

*Simple and challenging images for extraction*

A studio backdrop that is lit independently of the subject will make extraction easier. You may however not have access to a studio where the background illumination and content can be controlled so effectively. When on location the photographer can choose the least busy background and use shallow depth of field (wide aperture on a telephoto lens) to help delineate the edge of the subject clearly to help the extract filter perform its task.

## Matching the edge to the new background

The extract filter can effectively work with a soft or blurred edge, but when this edge is viewed against a very different tone – the edge looks out of place. These 'soft edges' can however be 'worked' so that they can be blended into the new background.

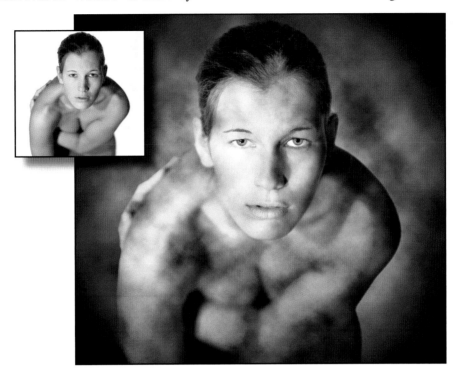

*Photography by Benedikt Partenheimer*

**Activity 6** www.photoeducationbooks.com/montage.html

1. If you are starting with a Grayscale image and would like to introduce colour you must first convert the image mode to RGB (Image > Mode > RGB). The next step is to import or create a new background. It is possible to create a background using the 'clouds' filter that resembles the brushed canvas backdrops used by many portrait photographers. To achieve this effect click on the 'New Layer' icon in the layers palette. In the tools palette set the foreground colour to black and the background colour to a light shade of grey (double-click the colour swatch and then choose a colour from the 'Color Picker'). To apply the clouds effect go to 'Filter > Render > Clouds'.

2. To create the illusion of an effects light on the backdrop the 'Lighting Effects Filter' was used (Filters > Render > Lighting Effects). By clicking and dragging on the handles in the preview box the circle, or spread, of light can be controlled. Select an intensity value that keeps the highlights from 'blowing out' or becoming white and the shadows from 'filling in' or becoming black.

3. Create a curves adjustment layer to colour the clouds layer by clicking on the 'Create New Fill or Adjustment Layer' icon. From the pull down menu in the curves dialogue box select a colour channel and create a curve to colour the layers beneath.

4. Duplicate the background layer containing the subject to be extracted (Layer > Duplicate Layer) and move it to the top of the layers stack (Layer > Arrange > Bring to Front).

5. The following steps in the process prepare the way for, and speed up the selection process when using, the extract filter. The 'magic wand' is used to make a rough selection of the white background on the background copy layer. This initial selection may fall short of some of the 'soft edges' because of the slow transition between dark and light, which may repel the wand's attempts to make an effective selection. The magic wand selection by itself is usually imprecise at selecting a typical background. This can be rectified in a controlled way by first feathering the selection and then using a levels adjustment in 'Quick Mask Mode'. Slide either the highlight slider or the shadow slider to expand or contract the selection so that it falls closer to the edge of the figure. Zoom in on a soft edge to get a clear idea of the effects of moving the sliders. Once the edge of the mask has been modified exit the quick mask mode (press Q) to return to a selection.

**Note. It is important to feather the selection (Select > Feather) for this technique to work. The precise amount of feathering is however dependent on both the resolution of the image and the edge quality of the subject being extracted.**

6. With the selection active click on the 'Create new channel' icon to create a new empty alpha channel (filled with black).

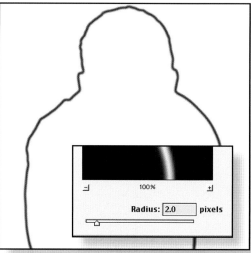

7.  Stroke the selection (Edit > Stroke). Click on the 'Color' swatch and choose white from the color picker. The stroke width you choose should cover the soft edges of the subject you are extracting. Deselect to remove the selection.

8.  Apply a small amount of Gaussian Blur (Filter > Blur > Gaussian Blur) to the channel and then invert the channel (Image > Adjustments > Invert). Return to the layers palette and ensure the background copy layer is selected.

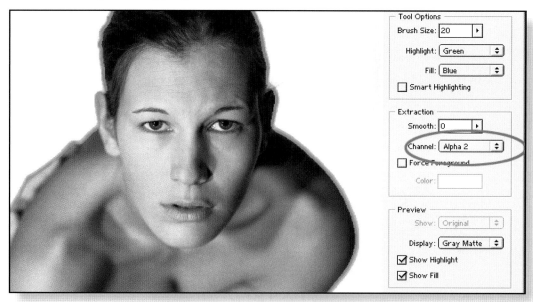

9. Select 'Extract' from the menu (moved to the filters menu in Photoshop 7) and Alpha 1 from the channel pull-down menu. The outline of the subject will be automatically loaded for you, thus saving a lot of painstaking work with the highlighter tool.

10. Use the 'Edge Highlighter Tool' to include any areas missed by the alpha channel selection. This may include fine detail that extends out from the border or very soft edges that exceed the width of the edge highlight. Zoom in to get a close look at the edge and avoid painting too deeply into the subject itself. Use the spacebar to access the hand tool so that you can drag the magnified edge through the preview window.

**Note. When using the 'Edge Highlighter Tool' you can paint generously into the background but care must be taken not to paint too deeply into the subject as this may result in a loss of subject detail.**

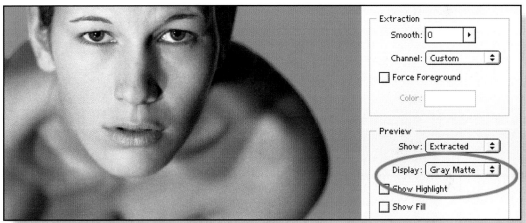

11. Fill the area you wish to retain using the 'Fill Tool' or bucket. The fill colour denotes the area to be retained by the extraction process.

12. Select a 'Matte' colour from the 'Display' pull-down menu that is closer in tone to the new background. This will help you identify any unwanted edge detail left over from the old background.

13. Use the 'Cleanup Tool' to remove any unwanted pixels. Select a low pressure (by pressing a lower number key on your keyboard) to reduce the opacity of the edge pixels gradually. Pressing the Option/Alt key on the keyboard can restore full opacity to the edge pixels. Any ragged edges produced by the extraction process (usually created where edge contrast is low) can be smoothed out or made sharper using the 'Edge Touchup Tool'. Click 'OK' when the edge has been modified to look good against the preview Matte.

**Note. Many find the 'Edge Touchup Tool' a little unwieldy to use, as it is able to move the location of the edge as well as replace and remove pixels in its attempt to smooth the edge. It takes a lot of practice to use effectively. If your subject/background contrast is sufficient you can often avoid using this tool altogether. A little extra time spent when capturing the image to ensure sufficient contrast will save time during this stage of the process.**

14. The edge pixels that were modified in the last step using the 'Cleanup Tool' were adjusted to look good against a matte colour. The edge pixels may not look so good against the exact tone and colour of the new background now that the extraction has been performed. If the edge pixels are now too dark or too light, burning or dodging selectively can modify them further.

15.  It is possible to burn or dodge the offending pixels on the background copy layer itself (choose a low brush pressure and set the 'Range' of the burn and dodge tools, located in the options bar, to highlight or shadow to limit the effects). An alternative option is to burn or dodge the pixels on a '50% gray' layer set to 'Overlay' blend mode that has been grouped with the background copy layer. Adjustments made to this layer modify the pixel values on the layer below, whilst areas that are left as 50% grey leave the pixels below unaffected.

**Note. The advantage of working on a separate layer is that it offers an extremely flexible way of editing an image. Working on a separate layer allows you to repeatedly change your mind regarding the level of adjustment required. 50% grey overlay layers, together with adjustment layers and layer masks, offer the least destructive method of image editing. Pixel values, rather than being changed repeatedly, are changed only once when the image is flattened prior to printing.**

16.  Once the pixels have been modified to a more suitable tone for the new background, the edge can be softened further if required. A softer edge can be achieved by using a layer mask.  Make a selection by holding down the 'Command/Ctrl key when clicking the 'background copy' thumbnail.

**Note. The completed layers that form the new background have been placed in a 'Layer Set' to help prevent the layers palette becoming unduly crowded.**

17.  Click on the 'Add layer mask' icon to create a layer mask using the selection.

18.  Apply a small amount of 'Gaussian Blur' to this mask (Filters > Blur > Gaussian Blur). This will soften any hard edges remaining from the extraction process. The edges should now look very comfortable against the new background.

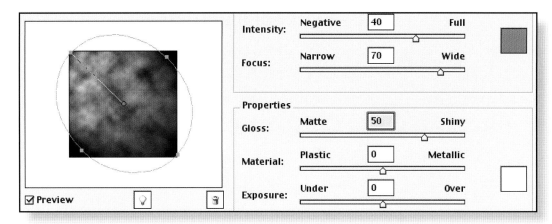

19.  Create a new layer and apply the clouds filter again. A 'Spotlight' lighting effect is used to reflect the lighting used on the model. Click on the top colour swatch to pick an appropriate colour for the effect.

20.  Assign an overlay blend mode to the new layer. Add a layer mask to protect the whites of the eyes from being coloured. Finally the layer is grouped with the background copy layer by holding down the 'Option/Alt' key and clicking on the dividing line between this layer and the previous layer (alternatively choose 'Layer > Group with Previous' from the menu).  Use adjustment layers with layer masks to colour and brighten the eyes (the focal point of the image) and refine the overall image.

## Assignment 1 - Editorial illustration

A magazine requires a photographic illustration for an article about cosmetic surgery.  The editor requires a digital montage to illustrate the double-page spread.

## Text

**Headline:**    The Cutting Edge

**Subheading**:    Is cosmetic surgery creating a better quality of life or just operating under the cover of 'good medicine'.  Mark Davis separates the facts from the fantasy.

*Zarah Ellis*

## Image

**Mode**:           RGB

**Resolution**:     150 ppi (the commercial resolution would be approximately 300 ppi and require a file size exceeding 50 Megabytes).

**Dimensions**:     Width: 460mm          Height: 276mm

**Text**:           Size of text optional.

**Design**:         Landscape/horizontal image to cover both pages ('full bleed').
Avoid splitting the text or the focal point of the image by the 'gutter' (the centre fold of the magazine).
Create an area within the image where the text (especially the subheading) can easily be read.

**Submission**:     Print a scaled-down version of the final image on A4 coated paper (File > Page Setup > 60%).

# Assignment 2 - Book cover design

Illustrate the cover of a photography book to be published by 'Focal Press'.  Create a photographic montage using image editing software for the cover illustration.  The montage should illustrate the following title:

## "Seeing is believing"

'This book deals with the perceptions and misconceptions of photographic evidence.  Problems are often encountered in the interpretation of the image.  Technically speaking all photographs "lie"; sometimes by accident and sometimes by deliberate misrepresentation.  This book covers areas of difficulty in extracting facts from photographs and what photographs can and cannot reveal.'                                                                      Gale E. Spring

## Inspiration

The publisher has expressed a desire for the illustration to be inspired by the visual ambiguity found in the surrealistic work of Magritte.

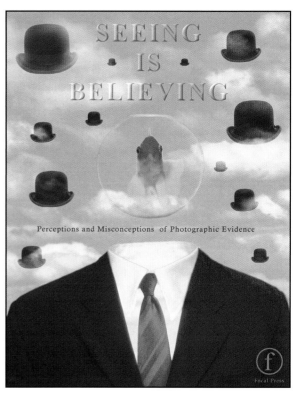

> "The effect of strangeness derived from the juxtaposition in one and the same space of several elements, none of which causes any surprise, since they all belong to everyday reality.  The visualisation of the impossible which questions ordinary perception."

Combine visual elements and/or concepts from two or more of Magritte's paintings.  Include copies of these images with your final submission.

*Guy Israeli*

## Specifications
Dimensions: 189 x 246mm.
Title: Seeing is believing
Subtitle: Perceptions and Misconceptions of Photographic Evidence.
Image Mode and Resolution: Colour (RGB)  200ppi
Artwork: A4 paper.

*Assignment 2, Practical Montage - Paul Allister*

# Gallery

*Catherine Dorsen*

# digital manipulation

*Les Horvat*

## aims

- ~ To offer a resource of information regarding manipulation techniques.
- ~ To develop skills required to manipulate images successfully.
- ~ To create a knowledge base that facilitates the successful enhancement of images without degrading quality.

## objectives

- ~ **Create** digitally manipulated images using the skills and knowledge acquired, with particular reference to the use of:
  - history brush
  - layer masks
  - adjustment layers
  - textures

# Introduction

The term image manipulation covers almost the entire spectrum of change that can be applied to photographs using software such as Adobe Photoshop. In the previous two chapters we looked at applying that change in the form of:

~    Making adjustments and optimising the original image.
~    Creating and applying montage - both with text and with the images themselves.

This chapter will further examine ways that new images can be created using 'raw material' in the form of textures, shapes and images specifically taken (or simply selected) for use as image building blocks. As well as looking at constructing images in this way, we will also extend the concept of the computer as your 'digital darkroom' and look at advanced colour and tonal effects on existing images.

## Ways of working that don't destroy the original

In **'Retouching and Image Enhancement'** (pages 115-148), Photoshop adjustments layers were demonstrated as a way of applying a change to a file without permanently affecting the pixel values of the image. This notion of retaining the integrity of your original file is one that needs to be emphasised further. It is quite self defeating to go to great lengths to achieve the best possible scan, one with the largest range of tones achievable (see 'Scanning and Image Adjustments) only to destroy much of that tonal and colour information by constantly altering and changing the image. These sort of changes must always be kept to a minimum so that the end result has lost none of the quality of the original. What is being discussed here is not simply the correction of mistakes that might occur during image editing - this can be achieved with the use of the history palette - but the ability to creatively change one's mind as part of the overall manipulation process.

## Activity 1

1.  Choose a photograph that you have already scanned and have achieved a tonal range that is an accurate representation of that image.
2.  Using 'Levels', examine the histogram representing the tones you have captured in your scan. The histogram should be quite solid and not contain any spikes or gaps.
3.  Save the file under a different file name, e.g. myshotTest.tif
4.  Choose 'Curves' and apply a major shift in colour and density to the file.
5.  Choose Filter > Noise > Add Noise to add an amount of grain to the image.
6.  Choose 'Unsharp Mask' and apply a sharpening effect to the image.
7.  Choose 'Hue /Saturation' and increase the colour saturation of the image.
8.  Choose 'Color Balance' and alter the dominant colour of the image.
9.  Now using 'Levels' once again, examine the histogram of your manipulated file.

Depending on the degree of change given to your image, the histogram is likely to be much less dense, with gaps and spikes throughout. It is therefore easy to identify that applying commonly used manipulations to an image will result in a loss of tonal information.

# How to apply selective effects to images

Programs such as Photoshop often enable the user to achieve a similar end result in a number of ways. If as stated previously our goal is to retain as much of the integrity of the original image as possible, the main tools we can use for this purpose are the '**History brush**', '**Layer masks**' and '**Adjustment layers**'. Each of these can be used effectively to enable us to 'undo' any manipulation steps we might take.

## Selective effects using the history brush

The history brush can be used to 'paint' with various states of the image. This is a very useful approach if you define a 'before' and 'after' state which you can then use to paint from one to the other.

## Activity 2  www.photoeducationbooks.com/manipulation.html

In this activity we will use the history brush to paint pre-defined areas onto our image, using a separate layer so that our original image is not altered.

1. Open the file '**Figs.jpg**' (available from supporting web site). Select the Elliptical Marqee tool from the tools palette and make a selection of the area which includes the figs on the plate. Copy the selection and paste onto a new layer using the Edit > Paste command, thereby allowing work on this region without affecting the original.

2. Using 'Free Transform' from the Edit menu, increase the size of the figs by dragging any corner slider of the bounding box outward. Make sure you also hold the shift key as you slide, to restrain the proportions of the figs so they do not become distorted.

3. Now go to the History palette and by clicking on the top right hand arrow of the palette, save this stage as a new snapshot and call it 'figs_large'. Observe how by clicking next to the layer in the History palette, we can toggle between states.

4. Choose History Brush from the tools palette and the figs.jpg snapshot. Use the brush to paint out the areas of plate that are intruding around the figs.

5. Make sure a soft edged brush of suitable size is used, so the edge transition can be worked carefully. Observe how by changing the brush opacity as well as brush size, more control can be achieved.

6. If too much of the image is accidentally removed, click on the figs_large snapshot and paint the areas back with the history brush.

With careful selection of opacity, brush size and shape, the larger figs image can be successfully merged with the plate. This can be repeated as often as necessary without degrading the underlying pixels. The final result with the larger figs on the plate is shown at left.

**Note. The manipulation has only been applied to the layer containing a copy of the selected figs area - giving further opportunity to revert later to the original image if desired.**

## Selective effects using layer masks

Whilst using the history brush allows for a great deal of flexibility, once the image is saved and closed the history states are lost. A method that achieves similar results but with the advantage of being retained even after the image is closed, involves the use of layer masks (see 'Practical Montage', pages 149-186). This method has the great advantage of allowing adjustments to be made to an image at any time - even in the future should the need arise, without degrading any underlying pixels.

## Activity 3 www.photoeducationbooks.com/manipulation.html

1. Open the file '**Figs.jpg**' (available from the supporting web site) and once again use the elliptical marquee to make a selection of the area around the figs. Copy and paste this selection onto a new layer as for Activity 2.

2. Click the 'Add layer mask' icon located at the bottom of the layers palette to create a layer mask for that layer. Notice how the foreground and background colour boxes become black and white.

3. Any of the paint tools, as described within Activity 3 in '**Practical Montage**', can be used to add or remove parts of the mask. Remember, the mask icon is visible in the layers palette when you are painting a mask, rather than the paintbrush icon when you are painting onto the image itself.

4. Select the airbrush tool from the tools palette with an appropriate brush size and opacity. Now carefully paint over the unwanted areas of the plate, using black in the foreground palette, to apply a mask onto these areas. This results in the image on the layer underneath showing through.

5. Painting with the foreground colour changed to white results in the mask being removed. This allows the current (large figs) layer to show through. Therefore, simply by painting the mask carefully in or out, the larger figs can be merged effectively onto the existing plate.

## Selective effects using adjustment layers

In the previous activity, since the original pixels have not been touched, the image is not degraded in any way. If the image is then saved with the layers intact, further adjustments can be made to the image at any time. Remember, it is only when the image is flattened that the alterations are applied to the underlying image. A further technique for retaining the integrity of our image is the use of adjustment layers, which when combined with layer masks give powerful options for image manipulation.

## Activity 4 www.photoeducationbooks.com/manipulation.html

1. Open the file '**Artichoke.jpg**' (available from the supporting web site). Click on the 'Create new fill or adjustment layer' icon at the bottom of the layers palette and choose 'levels'. Drag the midtone slider to the right so that the tones become significantly darker. The shadow slider can also be dragged slightly. Click OK.

2. Choose the airbrush tool and by painting black onto the mask of the adjustment layer, remove some of the darker areas of tone on the image. This prevents the deepest shadow tones from blocking up and losing too much detail.

3. Click on the new adjustment layer icon again and this time choose 'posterize' and set the levels to 4. Select an appropriate brush size and opacity. Then, by using the black foreground colour to paint with, thereby masking the layer, remove the posterisation from the artichoke itself.

4. Select white as the foreground colour and once again click to make another adjustment layer. This time choose 'gradient layer'. A white, linear gradient should appear over the bottom of the image, fading out towards the top. Accept all the defaults and click OK.

5. Change the foreground colour to black and once again paint mask over the image to remove the white gradient from the artichokes and from around the edges of the frame. If areas have been masked that do not look quite correct, simply change the foreground colour to white and proceed to remove the mask.

6. Click the right hand top arrow on the layers palette to create a new layer set. The adjustment layers can be grouped into this folder by dragging them within the palette. This grouping is not only a convenient way to organise the various layers of the image, it also enables their actions to be grouped as one layer. Changing the opacity slider of this layer set will for example affect all layers in the folder. (This feature only available in Photoshop 6 or later.)

**All of the manipulations used to arrive at the above image have been applied through masks and adjustment layers, so subsequent alterations can still be made without any loss of image quality.**

# Selectively applying filters with masks

Throughout this chapter, emphasis has been given to the notion of applying minimal change to original pixels via the use of adjustment layers and masks. This not only retains quality but also allows for maximum creative flexibility. It is also worth examining ways that this flexible approach can be used to create unique effects with various filters. A note of caution though, when using filters such as the ones supplied in Photoshop. If they are merely applied without any further adaptation, they may result in a look that is quite appealing (due mainly to their novelty value), but as these types of images become more familiar, since the filter effects themselves have a very strong 'signature', the result is often more about the filter than any creative intent. As a consequence, they can soon become boring and tired. It is important therefore to think of these filters as tools, which selectively or even sequentially applied, can produce interesting and meaningful results.

### Activity 5 www.photoeducationbooks.com/manipulation.html

In this activity, we will examine how various filters were applied to an image in order to achieve the effect illustrated on the previous page. This is purely by way of example, as the results achievable are restricted only by the creativity of the photographer - the outcome should always reflect a unique, personal vision. However the general ideas used can be readily adapted. The important thing is always to be prepared to experiment.

1. Open the image labelled '**Pearls.jpg**' (available from the supporting web site). Click the right hand top arrow in the layers palette and select duplicate layer. Click OK and rename this layer 'watercolour'. At this stage there would be no difference in the appearance of the image as both layers still hold exactly the same pixel values.

This step involves creating a copy of the image onto another layer so that any applied effects will not change the original image, continuing the philosophy detailed in the earlier sections of the chapter. However, in this case a downside does exist as the file will grow appreciably with each duplicate layer created. Large file sizes can cause problems if the hardware is not able to cope adequately and may preclude this method being used at all times. As an alternative, experiment with smaller, low resolution files making notes on the final processes applied. Then create totally new files instead of duplicate layers, applying the effect to the file and only combining them at the final stage. Be careful to realize however that the filter values chosen will vary with the file size.

2. Go to 'Filters' on the menu bar and select Artistic > Watercolor and move the sliders as indicated. Experiment further with the sliders to observe the effect. Click OK to accept your final settings.

You can see the result in the small window by placing the cursor there and clicking. The scale of this view can also be altered by clicking on the + and - buttons which control zooming in and out, whilst dragging with the mouse within the window locates it over a different part of the image.

3. Click on the background layer once more and again duplicate the layer, this time naming it 'rough pastels'. Go to Filters and choose Artistic > Rough Pastels and again experiment with the sliders. You can also apply the filter twice to build up the effect. At this stage to be able to see any effect from the 'rough pastels' filter it is necessary to make sure the layer is above the watercolour layer. Remember that a lower layer is only visible if there are transparent areas created by a mask, or reductions in opacity in the layer above. Without this, the top layer will completely block the view of the layers underneath.

4. Once again duplicate the background layer and this time label the layer 'accented edges'. Allow this layer to sit above the background layer. Click the eye in the other layers so that you can see the effect of the filter in the next step.

*Ice and pearls with added texture*

5. Go to Filters and this time choose Brush Strokes > Accented Edged. After experimenting with the sliders as before, apply the filter twice to enhance the effect. Don't worry if the result appears too strong as it can be reduced later by adjusting the opacity of the entire layer.

6. Create a layer mask by clicking the icon at the bottom of the layers palette for each layer in turn and taking one layer at a time, paint a mask over those areas of the image where you do not wish to see the effect.

It is at this stage of the process that the most interpretation is brought into play. As much or as little of each layer's appearance can be retained or removed. By simply painting with any paint tool set to either black or white (depending whether the mask is being added or removed) the final result can become an amalgam of all three layers. As a starting point, try masking out the shadow and highlight areas as you work from one layer to another. If you change your mind remember that the mask can always be added to or removed from all three layers without any loss of image quality - and the original is still untouched as the background layer at the bottom!

7. Create a new layer set, call it 'texture effect' and being careful to retain the same layer order place all three layers inside. If the order of the layers is changed, the effect will alter - experiment with this as sometimes interesting effects can occur.

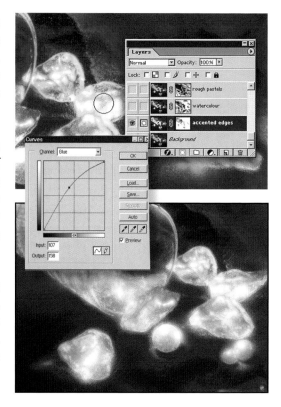

8. As a final step, create a new adjustment layer by clicking the icon at the bottom of the layers palette, choosing curves. Go to the blue channel and click a point on the middle of the curve, dragging it slightly upward. This will have the effect of making the overall colour of the image more blue.

9. So that only the ice and not the entire image is affected by the colour change, create a layer mask and using a large brush mask out most of the background area. The end result should be of bluish ice in a textural background of warm tones.

# Using the blur tool

Being able to blur an image in a controlled way is one of the most important tools in image editing programs. Photoshop gives us a number of blur options, but one of the most useful is the '**Gaussian Blur**'. This tool allows us not only to adjust the extent or degree of its application, but afterwards with some clever use of layers and masks to select how and where the effect should be applied.

This image has skin texture that distracts from the dramatic intent of the photograph. If this texture were eliminated or even reduced, more emphasis would be placed on the eye - thus creating a stronger graphic element that would draw you into the image. The following activity indicates a solution to this problem by using the blur tool in a selective fashion. This is achieved with the use of a layer mask, which allows 'painting in' of the areas where the blur is to apply.

## Activity 6 www.photoeducationbooks.com/manipulation.html

1. Open the file entitled '**Portrait1.jpg**' (available from the supporting web site) and duplicate the background layer. Apply a Gaussian blur to this layer, experimenting with the sliders to see the degree of blur possible. Notice that if the blur is too large, the image is impossible to make out, simply becoming a smooth mix of tones. If a large blur effect is required, applying the tool twice is often more controllable.

2. On the menu bar, choose Layer > Add Layer Mask > Hide All. This enables a mask to be made that will completely hide the effect of the layer. Although this at first might seem self-defeating, it enables the mask to be selectively removed in those areas we wish to apply the blur. If too much blur is applied to a particular area, as in previous activities, change the foreground colour to black and paint 'in' the mask to remove the effect. Since the background layer is not affected, this can be altered as much as desired throughout the process.

3. Choosing an appropriate brush size and pressure, whilst making sure that white is the foreground colour and the mask is active, carefully paint 'out' those areas where the excessive skin texture occurs. Be careful to leave enough detail, particularly around the eyes, as this is the area that needs to become more prominent. (Applying the brush with a very low pressure will allow much greater control, particularly towards the final stages.) Now that the texture has been subdued, it is also evident that the blur has eliminated the natural grain of the image. Hence in these areas, it is important that this grain is replaced or it will look rather false.

4. Photoshop has a filter called Film Grain, under Artistic in the Filter menu. However, in this situation a more varied grain effect is called for, since the image also has a 'digital' type grain evident within it - view this by zooming in to a high degree of magnification. For this reason, the addition of Noise is more appropriate. Choose Noise > Add Noise from the Filter menu.

5. Notice that the noise can be added as monochromatic or coloured noise. In this instance a coloured noise is more appropriate, however this will vary according to the image itself, so it is important to try all options. When using this filter always use a high zoom ratio to view the effect, so that its application is not stronger than desired.

# Working with textures

Textures of various types can be readily incorporated into images to give interesting effects, as well as creating diversity and depth.  There are many ways to create these textures:

~   Using filters available in image editing programs such as Photoshop, as described in Activity 5.
~   Photographing surfaces directly or even sandwiching two such images together.
~   Scanning surfaces directly with a flatbed scanner.

This last method is perhaps the easiest way that textures can be introduced into the visual effects library of any image creator.  Almost any type of surface (as long as it fits onto the plate of the scanner) can be used in this way - from readily found papers and (relatively) flat objects to any piece of artwork that has been made especially for the purpose.  These 'works of art' need not be anything too elaborate as the simplest things will sometimes surprise when scanned and manipulated.

## Activity 7

1.   Taking any of the following - film wrap, tissue paper, scratched acetate, wrapping paper,  leather, lace, aluminium foil or felt; scan them to produce image files.

2.   As this exercise is not about producing faithful, well rendered scans, experiment with levels and curves to produce interesting textural effects.  In addition, invert some of the texture files, or even apply filters to extend the possibilities further.

This texture image was created by scratching a piece of acetate, adding strips of adhesive tape, placing a sheet of black behind and then scanning.  The image file was then inverted and the levels were adjusted to achieve the desired effect.  However, any number of variations could be produced from this one combination of elements.  In this way a library of unique textures can be easily built up for later use.

3.   Finally, using sheets of clear and coloured acetate, apply paint using various applicators such as brushes, rollers and sponges.  Sandwich these sheets with other surfaces that have been previously made or select from a range of commercially available art papers - or even wrapping papers!  Scan these multi-layered works of art to create more textural images.

## Using edge effects

Edges or frames around images can at times give a signature or style that may be quite appropriate for the end result. Whilst commercially available disks can be purchased which contain a myriad of frames and edges for use in photographs, it can be quite fun to produce unique frames that no one else can have access to and apply to their images. These edges can simply be a variation of some of the results gained from Activity 7, or various borders that occur naturally can be scanned directly. For example, Polaroid instant films often produce a particular edge around the image - these can be separated from the emulsion and scanned, to produce an extremely popular frame device.

This Polaroid edge has been removed from the film surface after exposure and processing. It was then scanned and manipulated further to produce this end result. Applying various filters and effects to this base image can result in a large variety of frames.

## Combining edges and textures to produce new images

It is when combined creatively together with photographic images that textures and edges become powerful aspects of the visual content in the final image.

*The above four images have been used in the production of the final 'Pear' image.*

# Digital darkroom effects

One of the main advantages of using digital manipulation software such as Photoshop as an effects platform (aside from not having to spend time in the dark) is the control that is possible. Pretty well anything that could previously have been carried out as a darkroom manipulation is achievable digitally. It is true to say, some practitioners maintain that fine darkroom work has a certain 'syntax' that cannot be achieved on computer. This may or may not be so - different people will always prefer different methods of achieving a similar result. However, in this section we will examine how certain popular effects can be achieved.

## Toning

To tone an image, we can begin with either a full coloured original or a B&W original.

~ If the original image is Grayscale (B&W) then the first step is to change it to an RGB image by selecting Image > Mode > RGB. The appearance of the image will not alter - as no new colour information has been added - but it will be three times the size of the original due to the creation of two new channels.

~ If the original is a coloured image then go to Image > Adjust > Desaturate to remove the colour.

The end result of either approach should be a Grayscale image created with the three colour channels Red, Green and Blue. The next step is simply to create a new adjustment layer, selecting the Color Balance Layer option. Dragging the sliders for each channel will create an image toned to the exact colour desired. Remember also to select the Highlight, Midtone and Shadow radio buttons in turn to fine tune the colour and the exact hue of the various tones in the image.

## Split toning

One of the techniques that is very hard to control in the darkroom is that of split toning or assigning different colours to different groups of tones. This is however quite readily achievable and, more importantly, quite controllable in the digital environment. Before we look at how to achieve this result, let us consider this question - is there a difference between split toning and duotones?

Duotones are created when the printed output relies on two colour inks rather than the usual four colour process (see 'Colour Management'). The only reason why this is done is to reduce the cost of production - two inks on the press are cheaper than four inks. If the output is to be printed on an inkjet or similar printer there is no reason to create a duotone. The end result should be in RGB, i.e. full colour. Where the confusion arises is when the effect of a duotone is required - the result is rather like that of split toning - and an expectation exists that a special type of two channel file is necessary.

**Note. In all cases other than press output, a duotone effect should be created using RGB mode.**

## Activity 8

1.  Take a coloured image or a B&W image as for the toning example previously. Change it to a B&W, RGB file.
2.  Create an Adjustment layer choosing Color Balance Layer and move the sliders to create a toned image.
3.  Repeat Step 2 to create a second adjustment layer and create a new colour tone.
4.  Go to Blending Option in the Layers palette and hold down the Option/Alt key whilst sliding one half of the shadow slider towards the centre. You will notice the tones begin to merge between the layers. Adjust these sliders to explore the effects. Variations can be achieved by beginning with different colours in the layers.

# Cross processing effects

To cross process film simply means the processing of transparency film in colour negative developer (C41) or processing colour negative film in transparency developer (E6). In other words, the processing of film in a development process for which it was not designed. This of course leads to colour aberrations that in themselves have become quite fashionable as a particular 'look' - especially in fashion photography circles. The problem with cross processing is that it varies quite considerably with the type of film used and it is very difficult to control. The digital darkroom provides a solution.

## 'Neg as tranny' cross processing

The colour signature of this process is that highlights become somewhat magenta/orange and the shadows become rather cyan/blue.

## Activity 9

1. Begin with a full coloured RGB image, preferably with skin tones.
2. Create an Adjustment Layer choosing Curves Layer.
3. In the Curves Layer dialogue box choose the blue channel and alter the highlight point as shown to create a yellow highlight tone. Then choose the green channel and move the highlight point as indicated to create a more 'peachy' colour. Finally in the red channel move the shadow point on the curve to create a cyan hue in the deeper tones.

4. Now create a new Adjustment Layer but this time choose Hue/Saturation Layer. By moving the Hue slider the exact colour combination can be altered to suit the desired result. Further fine tuning can be performed by altering the shape of the curves themselves in the Curves Adjustment Layer, rather than simply moving the highlight and shadow points. Remember that all of these changes are performed in adjustment layers so that the integrity of the original image is retained until it is flattened.

## 'Tranny as neg' cross processing

This reverse processing has a less definite signature than neg as tranny. Generally the result is one where the contrast is increased, the highlights are a little lacking in detail and sometimes appear somewhat yellow, and the mid tones are highly saturated in colour.

## Activity 10

1. Begin with a full coloured RGB image as for Activity 9.

2. Create an Adjustment Layer choosing curves as for the previous activity. This time however, choose the RGB channel and move the shadow point as shown below to darken the deeper tones. Then choose the red channel and move the highlight and shadow points as indicated. Finally, choose the green channel and move the highlight point to give the highlights a slight green tone.

*The image above shows the 'tranny as neg' look on the left side and the original on the right hand side.*

3. Create another Adjustment Layer, choosing Hue/Saturation Layer and move the Saturation slider to +25, to increase the overall colour saturation of the image.

4. As for Activity 9, further fine tuning can be accomplished by varying the settings as well as changing the shape of the curves - instead of simply setting new shadow and highlight points.

Shifting colour values in this manner can result in big gaps within the tones in the image. This can lead to banding and slight posterisation, especially in smooth untextured areas. Therefore it is important only to flatten the image when you are happy with the result and always save the layered version in case further change is necessary.

# Depth of field effect

There are times when the focus achieved in an image is greater than what is required.  For example, if the background is distracting or intrusive to the subject matter.  At other times, it is desirable to blur the background for purely creative reasons.  This can be readily achieved using the Gaussian Blur filter in Photoshop.

## Activity 11

1. Select an image that has significant detail in the background and duplicate the image onto two new layers.
2. On the first layer apply a moderate amount of Guassian Blur.  Remember the blur effect and the corresponding value in the slider control will vary with resolution.

3. On the second layer apply a larger degree of blur.  Deselect the eye icon to make this layer invisible.
4. Click the first layer active and create a layer mask.  At this stage the visible image will be blurred.  Remove parts of the blur effect by painting in the mask.  Concentrate on the main subject and remove the blur effect from those areas that you require to be sharp.
5. Once an amount of sharp image has been restored, repeat the process for the  above, more blurred layer.

6. Selectively remove most of this layer via a layer mask, allowing it to be visible only in the edges of the image.  In this way a greater depth can be created through the blur transition between layers.

As an alternative to this method, if a more precise outline of the subject is required, it can be selected carefully and placed on its own layer before any blurring of the background takes place.

## A strategy for saving images

As long as the layers in an image are retained and history brushes, adjustment layers and layer masks are fully utilised in an overall approach that does not degrade the underlying image, total creative flexibility is retained. It is clear therefore that an important aspect of any serious image manipulation is always to save a version of the file with all the layers intact. The latest version of Photoshop allows layers to be retained in some formats and not others. Therefore it is important to understand just when a particular file format is best used.

~    **Photoshop Format (PSD):** This is the native format for photoshop files and allows the greatest flexibility and scope for saving all image information during the editing process. As PSD files take less time to save than equivalent file sizes in other formats, this is the preferred format for all work in progress - especially when frequent saves are necessary.

~    **Portable Document Format (PDF):** This is a universal, cross platform format created by Adobe for transporting documents both on the web and in print. Photoshop now supports this format with the ability to retain layers. Because of its transportability and its growing acceptance as a commonly available and easily read format (due in no small part to the free distribution of Acrobat reader), it is very useful for transferring files. Also in its favour is the ability to compress PDFs using ZIP compression, which reduces the file size without any loss of quality - a point particularly important for electronic transfers.

~    **Tagged Image File Format (TIFF):** This is the format of choice for the exchange of files across computer platforms and for most output devices. Although it is now possible to save layers with this format, at present most devices and available software will not recognise the layers, so it is still most useful as a format for flattened, archived images or as an output file.

~    **Joint Photographic Experts Group (JPEG):** This is the most commonly used format for the display of images on the web since it retains all colour information and can be quite small due to its inbuilt compression algorithm. Be aware however that JPEG is a 'lossy' format that discards information as part of its compression process and as such should not be used for the final archive of images. Should the need to re-size or further manipulate the image arise, it is far better to have a format available which contains all the information of the original, such as PDF, PSD or TIFF.

Whilst many other formats exist and can be read by programs such as Photoshop, in most instances it is the above four formats that will be used. Deciding which to utilise should be based on its end use, the file size required and the information that needs to be retained. In most instances, multiple copies of a finished file should be archived - often in more than one format and size.

# Revision exercise

Q1.    Adjustment layers are a useful way of working with Photoshop because:
(a) They enable the effect to be removed.
(b) They allow the effect to be applied incrementally.
(c) They allow the effect to be applied selectively.
(d) All of the above.

Q2.    To selectively paint in or out a layer mask, after the mask is activated, we use:
(a) Any paint tool set to default black or white. (b) Any paint tool and the eraser.
(c) The airbrush with the eyedropper set to the colour of the subject matter.
(d) The paintbrush set to either 100% or 0% opacity.

Q3.    A layer mask will affect:
(a) All layers in the layers palette. (b) All layers below the layer mask.
(c) The layer to which it is attached. (d) All layers linked with the chain icon.

Q4.    An adjustment layer will affect:
(a) All layers in the layers palette. (b) All layers below the layer mask.
(c) The layer to which it is attached. (d) All layers linked with the chain icon.

Q5.    A filter can be applied selectively onto a region of a layer by:
(a) Applying the filter and then reducing the opacity of the layer.
(b) Applying an adjustment layer over the application of the filter.
(c) Using the navigator tool to show where the filter is to apply.
(d) Painting on to a layer mask attached to the layer, after the filter has been applied.

Q6.    It is a good idea to duplicate onto another layer, the section of an image that will be worked on, because:
(a) The file does not keep getting larger with a buildup of pixel detail.
(b) Working on the duplicate layer means the original pixels are not altered.
(c) Working on a duplicate layer means that Photoshop works much faster.
(d) It is easier to keep track of histories when they apply to one layer only.

Q7.    If an adjustment layer is turned off in the layers palette, the result is the same as:
(a) Removing the layer beneath it from the palette.
(b) Adding the inverse of the layer effect to the image.
(c) Viewing the image in its original state before having applied the adjustment.
(d) Applying the adjustment to the image.

Q8.    Which of the following file formats utilises a 'lossy' compression?
(a) TIFF    (b) PSD    (c) PDF    (d) JPEG

# Assignment

The aim of this assignment is to produce three versions of an image without affecting the original. The strategy undertaken will allow for the fact that at any time either of the three 'final' versions could be preferred and hence can be retrieved if required.

> You are required to produce an image for a cookbook, entitled:
> **'The Green Wedge' A vegetarian cookbook for life**

However, the commissioning editor is uncertain as to the overall cover design and how it relates to texture and colour. In fact, the editor wants you to produce three versions of the cover image so that he can produce mock-up covers and take it to market research.

Produce a file which contains the master image and suitable adjustment layers to create the three variations. (You could revisit the use of filters and textures from Activity 5, page 194 and Activity 7, page 199 .)

## Specifications
Cover Dimensions: 246 x 204 mm
Image Mode: Colour (RGB)
Image Resolution: 200 ppi
Text: Include title and subtitle.

## Submission
Print out the three cover versions on A4 paper
Include on disk the master file showing the relevant layers.

# Gallery

Paul Allister

Raphael Ruz

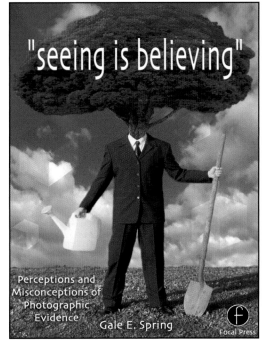

Susanna Check

Nick Richards

# Gallery

*Les Horvat*

*Seok-Jin Lee*

# digital
## images for the web

*digital imaging digital imaging digital imaging digital imaging digital in*

*Itti Karuson*

*digital imaging digital imaging digital imaging digital imaging digital i*

## aims

~  To develop skills required to prepare images successfully for the World Wide Web.
~  To develop an understanding of the procedures involved in the preparation of interactive
   web pages with links and rollovers.

## objectives

~  **Create** images and graphics using knowledge relating to:
   - vector tools, custom shapes and layer styles
   - animation

~  **Construct** web galleries and web sites that demonstrate skills relating to:
   - automated Adobe Photoshop features
   - slices, rollovers, links and optimization in Adobe ImageReady

# Introduction

ImageReady was bundled with Photoshop with the release of version 5.5. This move by Adobe was to recognise the growing significance of the Internet as a medium for visual communication using digital images. Adobe continues to retain the two separate interfaces rather than rolling them into one at this present time, to reduce the overall complexity and the number of tools visible at any one time. Although many specialised web features are now starting to appear in Photoshop itself (slicing, weighted optimisation, etc.), the bulk of the web tools remain in its 'sister' software ImageReady. ImageReady's primary strength is in its ability to 'Slice', 'Animate' and 'Optimize' images. In addition ImageReady is able to create 'Rollovers' and 'Links' (the two primary interactive features on a web page) together with the supporting 'HTML' or web code to enable them to be read by a web browser. Individuals whose primary task is to create sophisticated web sites would normally use the information and images created by ImageReady to load into specialised web-building software such as 'Adobe GoLive' or 'Macromedia Dreamweaver'. Using these software packages the web builders are able to fine-tune the HTML, load in additional imagery created by software such as 'Macromedia Flash' or 'Adobe LiveMotion' and exercise a degree of file management not supported by ImageReady.

## Working with Photoshop and ImageReady

Photoshop and ImageReady are intelligently interlinked so that a digital file can be 'jumped' from one software to the other, any changes being made to the file in one software package being automatically updated as it becomes active in the other software package. Each software package has its own specialised strengths but the creator of the file can make use of these by 'jumping' the file between the two software packages. An example of this may be an image file that starts life in Photoshop and is then jumped into ImageReady so that it can be modified to become interactive for the web. ImageReady is able to support the pixel, vector and adjustment layers in the file that has been created by Photoshop, but its ability to modify or create these layers is limited. If for instance one of the adjustment layers in a file required extensive modification, the image file would have to be jumped back into Photoshop for this work to be performed before being returned or jumped back into ImageReady.

## Creating a personal web site

Photoshop and ImageReady can supply all the features required to prepare the simple home page linked to web galleries for uploading straight to an 'Internet Service Provider' (ISP). The activities that follow will take you through this process and cover the major features of ImageReady. The activities will also introduce several features of Photoshop that have not already been covered to date, such as the 'Vector Tools', 'Custom Shapes' and 'Layer Styles' that are invaluable in the creation and management of web graphics.

# Web photo gallery

Photoshop 6 and 7 can create a 'Web Photo Gallery' of your images quickly and easily. All the additional software you may need to get your gallery online is available for free from the Internet. Apart from being exposed to a little jargon on the way the procedure is a remarkably painless process.

*A 'Simple' Web Photo Gallery*

Photoshop prepares all of your images and generates a homepage called an '**Index**' page, on which is displayed a sequence of thumbnails (small versions of your images). These thumbnails are linked to the larger images that are displayed individually on their own pages. When a thumbnail is clicked, the web browser (Explorer, Navigator, etc.) loads the full sized version of the image. Photoshop allows control over the size of the thumbnails, the size of the images, the amount of JPEG compression used and the appearance of the page itself. The resulting web gallery is quick and a very efficient use of valuable time.

## Uploading to the web

To place the gallery on the '**World Wide Web**' (www) you must either send (upload) the files to your own 'Internet Service Provider' (ISP), or use an Internet Service Provider that offers free hosting of your site, e.g. http://www.tripod.com. The activity that follows uses a '**Simple**' gallery style that does not require the more sophisticated use of '**Frames**'. Frames partition the page into separate sections. Old versions of the commonly used browsers and some free hosting sites may not support the use of these frames.

## Activity 1

1. Place a collection of your own images into a new folder (multiples of 3, 4 or 5 will make a neat arrangement). Photoshop will make copies of these images and resize them for the web gallery. Ensure that the largest dimension of each image is at least 500 pixels. Images prepared by Photoshop for a web gallery will be stripped of their embedded profiles and should therefore be prepared with this in mind. These master images can be in any file format. Photoshop will handle the conversion to JPEG and will sequence the images in the web gallery according to the numerical or alphabetical beginning of the file names. Files starting with numbers are placed before files starting with letters in the sequence. Images should be numbered with a zero preceding the first nine numbers, i.e. 01 to 09 to sequence them in a preferred order in the gallery, e.g. 01.Stone.jpg, 02.Slate.jpg, etc. Image 11 will come after 1 if the zero is not included.

**Note. Use short single-word file names with no spaces to avoid linking problems.**

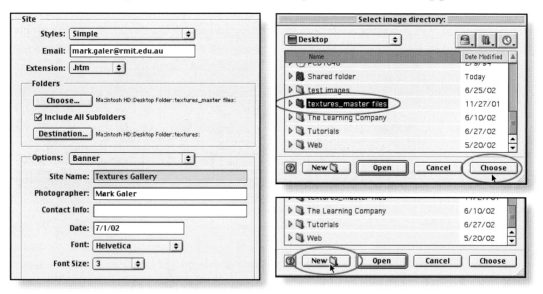

2. Launch Photoshop and choose 'File > Automate > Web Photo Gallery'. Choose 'Simple' from the 'Styles' menu. Enter your email address (Photoshop 7 only) and your preferred file extension (htm or html).

3. From the 'Folders' section of the dialogue box click on the 'Choose' button ('Source' in Photoshop 6) to select the image directory or folder in which you have placed your gallery images.

**Note. Do not open the image folder - 'choose' it (locate the folder, select it, and then click on the 'Choose' button).**

4. From the 'Options' menu select 'Banner'. Enter the gallery details that you would like to appear at the top of your gallery page. This will become your web page banner. You can enter alternative text in these boxes. Select a 'Font' and 'Font Size' to set the appearance of the text.

 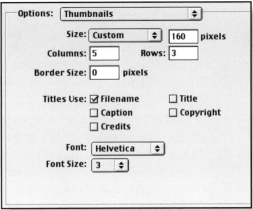

5. Select 'Large Images' from the 'Options' menu ('Gallery Images' in Photoshop 6). Select 'Resize Images' and choose 'Custom' from the menu and enter a size of 500 pixels in the box. Choose 'Constrain: Both' and 'Medium' from the JPEG quality menu. Choose whether your images will be displayed with or without a border (a one-pixel border was used in the example) and the source for the image title.

6. Choose ' Thumbnails' from the Options menu and select 'Use Filename' as your caption. If you think most of the people visiting your site will be using a high-resolution monitor (1024 x 768 or greater) you can choose quite large thumbnails, e.g. select 'Custom' from the 'Size' menu and enter 160 in the box. The gallery used in the example uses 5 columns and 3 rows. Anything greater would lead to excessive scrolling which many web designers try to avoid. Finally select a border if required. One-pixel borders if selected are enough to separate the images from the background.

7. Choose 'Custom Colors' from the Options menu and click on the colour swatches to change the colours. White text was used on a black background and black banner in the example. As the thumbnails will be links, the link colour will also become the border colour for the gallery thumbnails. Pick a contrasting colour or tone for the borders if you decide to use them.

8. Click OK to create the Web gallery. The web pages and images for the Web gallery are placed in the destination folder. Once finished, your web browser is automatically launched and your Web Photo Gallery is displayed. If the browser does not launch, simply open the destination folder and double-click the 'index.htm' file.

## Upload your web gallery to the 'World Wide Web'

To upload your files to the World Wide Web you may need to acquire 'FTP' software (file transfer protocol) that can be downloaded for free from the web, e.g. Fetch (http: //fetchsoftworks.com) for the Macintosh, and CuteFTP for Windows (http://cuteftp.com). Tripod.com allows the uploading of files directly via your web browser without the need to acquire FTP software.

## Using your own 'Internet Service Provider'

If you choose to use your own Internet Service Provider you will need to obtain some information from them in order to gain access to their server on which your files will be placed. You will need the address where your files will be uploaded (starting with the letters 'ftp'), your user name and your password that will ensure that you can gain access to this address. The address or 'URL' of your gallery will possibly be the address of the service provider, followed by your user name, followed by index.htm.

The web gallery should be placed in a folder (called a 'Directory' on the web) and so the URL may be as follows: http: //www.ozemail.com.au/~mgaler/textures/ index.html. The advantage of placing the web gallery in its own directory on the server is that it allows the file name 'index.htm' to be used again in a different folder or directory. This will allow you to have multiple galleries or link the gallery you have just created to a 'homepage', or master index.htm, that you may create in a future activity.

Once you have entered the FTP location (Host), your User ID and Password you will be presented with the option of selecting files and folders to upload. Modern FTP software such as Fetch demands no more than simply to drag your folders and files into the FTP window. If your FTP software seems unhappy with this procedure simply look for the command 'Put folders and files'.

## Using a free internet host

There are many providers offering a free hosting service using advertising to pay for the costs of hosting. If you pursue this route your gallery will be accompanied with a banner advertising somebody else's site. Although this takes up a little 'screen real-estate' there is still plenty of space left for the gallery. To upload to 'Tripod' follow the links 'Build' and 'File Manager' at their web site (http://www.tripod.lycos.com/).

You can upload your files to Tripod using either your own 'FTP' software to 'ftp.tripod.com', or the online service provided by their web site. This allows you to upload 8 files at any one time or your entire site if it has first been '**zipped**'. Loading the contents of your web gallery, 8 files at a time, is a little time-consuming considering you have to create a 'New Directory' or folder for each set of files (thumbnails, images and pages).

**Note. If you do decide to load the files, 8 at a time, make sure your folders are named exactly as they appear in your destination folder.**

## Your URL

As soon as you upload your files to the service provider the gallery will be 'Live' on the Internet. If you want to invite people to view your gallery type your gallery's URL into an email and they should be able to click on this link to be transported to your images. Be careful to type in the exact address. URLs are sometimes 'case sensitive', so be sure not to type in a capital 'I' at the beginning of 'index.htm'. Once you have established the correct URL it is often safer to copy and paste the URL when notifying someone of your site address.

## Getting found on the net

To enable people to find your site (if you have not first given them your URL personally), you must first list your site with the 'Search Engines' (Google, Alta Vista, etc.). Search engines examine listed sites to check for compatibility with the key words typed into the search field. The search engine then displays the most compatible sites in a 'ranked' order.

Most search engines focus their attention on your 'index' or homepage. Additional 'HTML' (hyper text mark-up language) can be inserted into your index page to increase the chances of being found. You can start with free html editing software such as 'Netscape Composer'. If you have Composer and your page is currently open in Navigator simply go to 'File > Edit Page' (your page will be jumped into Composer with its simple interface (few icons). Go to 'Format > Page Title and Properties' to start adding to your index page. Choose a title and description for your site that uses 'key words' that accurately describe the contents of your site and that may be used by the individual searching.

**Note. To get your site listed by a search engine in the top 10 sites it is usually necessary to edit the contents of the <head> region by editing the 'HTML Source'. For further information visit** http://www.genesiswebsitedesign.com

# Create a personal logo and style using Photoshop

Photographers displaying and distributing images to clients over the Internet, are wise to protect their images. By adding a small identifying logo to images or by adding a larger reduced opacity watermark over the entire image it makes the image more difficult to appropriate. The easiest and fastest way to apply either of these identifying graphics is to store the logo in Photoshop itself rather than as a separate image file. In Photoshop versions 6 and 7 the logo can be stored as a 'vector' shape that is 'resolution-independent' (it can be drawn any size without becoming pixellated).

**Note. Vector images are constructed from geographical markers (anchor points) connected by lines or curves, rather than pixels that are the basic building blocks of a digital photograph.**

Photoshop 6 and 7 is shipped with a small assortment of pre-drawn vector shapes called 'Custom Shapes'. Any vector shape created can be stored as a 'Custom Shape' adding your own shapes to Photoshop's selection - hence the name 'Custom Shapes'.

## Activity 2

In this activity you will create a custom shape from a simple combination of vector shapes and a letter. As you become confident with the tools you can begin to get more elaborate – but remember, the logos of the very powerful companies tend to be very simple.

1. Start by going to File > New File to create an empty canvas that is 320 x 320 pixels with a resolution of 160 ppi (a precise size and resolution is not important at this stage as a vector logo can be scaled later for the required output device without a problem). The resolution and pixel dimensions suggested create a file output size of 2 x 2 inches. The file can be resized later to create a larger graphic without any risk of pixellating because of the very nature of vector shapes that are 'resolution-independent' (not described by pixels).

2. Draw a series of guides similar to those in the illustration. The guides will help you create a symmetrical and uniform logo. To create guides go to the 'View' menu and select show rulers. Check the rulers are set to pixels. If they are not set to pixels you can quickly reset them by going to Edit > Preferences > Units & Rulers.

Click on a vertical or horizontal ruler and drag a guide into the image area using the ruler to guide you. The guides for this activity were placed in the following positions:

~ 20, 60 and 85 pixels from each side
~ 160 pixel centre position
~ 40 and 60 pixels from the top
~ 60 and 80 pixels from the bottom

*Drag in guides to help create a symmetrical and uniform logo and then type in a letter, or letters, of your choice*

3. Select the type tool and type the letter 'M' in the centre of the new canvas (in the illustration the font Arial Bold 72 pt. was used).

**Note. You can use any letter or letters to personalize the logo.**

The background in the illustration was filled with a light grey. The 1-pixel wide white lines were drawn over a grid and then blurred a little using the 'Gaussian Blur' filter. This background does not form part of the logo.

*Convert the type layer to a shape*

4. Select the type layer and go to Layer > Type > Convert to Shape.

5. From the edit menu select 'Define Custom Shape'. Name the shape layer. The shape is stored in the 'Custom Shapes' and will be used later in the activity.

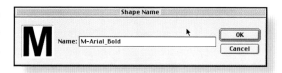

6. Delete the shape layer (the letter 'M') by dragging the layer to the trash in the layers palette.

7. Select the 'Ellipse Tool' (residing behind the rectangle tool) in the tool palette or on the 'Options bar'.

8. Starting in the top left hand corner (where the guides intersect) click and drag the cross-hair to the intersection of the guides in the bottom right hand corner of the canvas area.

Now select the 'Subtract from shape area' icon in the options bar and drag a second smaller ellipse that will cut out or subtract from the original ellipse. Use the guides to locate the starting and finishing points.

9. Select the 'Add to shape area' icon and your custom shape from the palette. Move the mouse cursor to your ellipse and add the custom shape (click and drag the mouse). If you need to resize the letter you can use the Free Transform command from the Edit menu. If you need to move the letter select the shape using the 'Path Selection Tool' (black arrow) and then click and drag the letter to a more suitable position.

10. The shape layer is now constructed from three separate 'paths' (the individual elements of the shape). The 'Path Selection Tool' (black arrow) can select multiple paths by dragging over one or more of these paths. The Direct selection tool (white arrow) can be used to select an individual anchor point on any of the paths to adjust the path's shape.

The 'active' adjustment point will be highlighted when selected and can be moved by dragging the point or using the arrow keys on the keyboard. Adjust the inner ellipse so that the width is even by selecting each of the side anchor points in turn and then tapping the left or right arrow key on your keyboard.

**Note. Each anchor point that is selected will display one or two 'direction lines' that end in 'direction points'. These can be moved to change the shape and size of the curve between the two anchor points.**

11. When all adjustments to your logo are complete ensure the vector thumbnail is selected and select 'Define Custom Shape' from the Edit menu again to add the combined shape to the custom shapes menu. It is now possible to throw away all the layers then select the custom shape from the custom shapes palette and draw another.

Vector mask thumbnail

Mark's Logos.csh

**Note. Custom shapes can be saved as a shapes file. The shapes file can be loaded into another copy of Photoshop on a different computer by clicking on 'Load Shapes' and browsing to the shapes file to be uploaded.**

## Alternative ways of acquiring a shape

An alternative to creating your shape in Photoshop is to Import a vector shape from Adobe Illustrator or by scanning a piece of artwork (a shape that exists on a piece of paper) using a flatbed scanner.

When Adobe Photoshop opens an Adobe Illustrator file it asks for the file to be assigned a size and resolution so that it can be 'rasterised' (converted to pixels). To protect the vector properties of the shape the file should first be opened in Illustrator, the path or paths selected and then copied to the clipboard (Edit > Copy). The vector file can then be pasted (Edit > Paste) as a vector shape in an open Photoshop file.

If a shape has been scanned and opened as a 'bitmap' file (a file constructed from pixels) in Photoshop you must first make a selection of the shape. With the selection active go to the 'Paths' palette and from the palette options select 'Make Work Path'. Select this path with the 'Path Selection Tool' and then proceed to the 'Edit' menu to save this active path as your custom shape.

## Applying a style

After dragging a logo to suit your needs the custom shape can then be quickly assigned a layer style. A layer style is a series of layer effect settings that has been saved (as a style) and can be a combination of layer effects such as 'drop shadow' and 'bevel and emboss'. To apply a layer style, click on the shape layer and then click on a style from the 'Styles' palette.

12. To create the 'Blue Glass' effect start with the one that comes shipped with Photoshop by clicking on the style with your shape layer selected.

**Note. Unlike the vector logo the styles are resolution dependent. The effects are described in pixels, e.g. a 3-pixel bevel, etc. A layer style that is suited to a high-resolution graphic will not be suitable for a low-resolution graphic destined for the Internet. Photoshop offers the option of scaling all of the layer effects at the same time. In this way a layer style that is suited for use with a high-resolution image can be quickly scaled to one suited for an image with a lower resolution.**

13. Scale the layer style by going to Layer > Layer Style > Scale Effects.

14. You can modify an existing style by adding a couple of your own layer effects. Click on the effects icon in the layers palette to add a 'Drop Shadow' and then an 'Outer Glow'. The additional effects used in the activity are outlined in the table.

## Specifications for the Drop Shadow

| Colour | | |
|---|---|---|
| Hue: 210 | Saturation: 80 | Brightness: 55 |
| **Structure** | | |
| Blend: Multiply | Opacity: 70% | Angle: 90° |
| Distance: 16 px | Spread: 0% | Size: 14 px |
| **Quality** | | |
| Contour: Linear | Noise: 0% | |

## Specifications for the 'Outer Glow'

| Colour | | |
|---|---|---|
| Hue: 195 | Saturation: 75 | Brightness: 100 |
| **Structure** | | |
| Blend: Screen | Opacity: 60% | Noise: 0% |
| **Elements** | | |
| Technique: Softer | Spread: 0% | Size: 23 px |
| **Quality** | | |
| Contour: Linear | Range: 50% | Jitter: 0% |

## Saving your style

15. With the graphics layer selected click on 'New Style' in the styles palette to add the modified style. You may choose to add the image resolution to the name of the style. Just as with the shape the style can be saved as a styles file.

*The logo with personalized style and used at a reduced opacity to act as a watermark*

## Scaling your logo

If the logo is destined for the Internet the file should be scaled using the Image size dialogue box (go to Image > Image Size). Make sure the 'Resample Image' box is checked and drop the resolution until the pixel dimensions required are achieved. If changes are made to either the 'Pixel Dimensions' or the 'Document Size' directly, the layer effects will require rescaling.

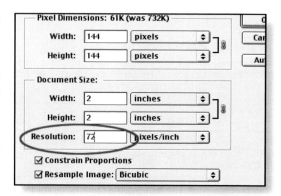

**Note. Once scaled you can 'Jump' the file into ImageReady to optimize or animate the file by clicking on the 'Jump' icon at the base of the Tools palette.**

# Creating an animated graphic for the web

We can use Adobe ImageReady, the companion software to Photoshop, to animate and optimise images destined for the 'World Wide Web'. If our animation plans include rotating a graphic in space we should first make some different viewpoints in Photoshop before jumping the multi-layered file into ImageReady, as the vector tools are not replicated in ImageReady.

*Animated frames in ImageReady*

Photoshop is not really designed as a cutting-edge 3D rendering program, but it is quite capable of creating a few alternative viewpoints of an image by using the transform command. Although capable of rendering a graphic to appear three-dimensional, Photoshop has no way of knowing or understanding the depth of the two-dimensional graphics that are created using the vector tools. The process of rendering alternative viewpoints in Photoshop is only a semi-automated feature, as we must instruct Photoshop how the graphic will look as it is turned in space.

## Activity 3

1. Start with the full size graphic created for 'Activity 2'. Add some additional guides to the canvas area, 20 pixels from the top and 40 pixels from the bottom. Drag the layer with the vector logo to the new layer icon in the layers palette to duplicate the layer.

2. Using the command 'Edit > Transform > Perspective' drag the corner handles to increase the height on the left-hand side and reduce the height on the right-hand side. By dragging the side handles of the bounding box, the width of the graphic can be reduced. Press the 'return/enter' key to apply the transformation.

3. Modify the appearance of the graphic using the 'Direct Selection' tool. The leading edge is made wider by clicking on the inner ellipse and then dragging (or by using the arrow keys on the keyboard) the anchor point to a new position.

4. Duplicate this modified layer in the layers palette before proceeding to alter the perspective a second time. The existing guides will help you to reposition the bounding box when using the transform command.

**Note. It is important to ensure the top of the ellipse remains in the same position as you create additional views of the logo, if the logo is later to appear to be spinning on the spot (use the intersection point of two guides to help you).**

5. It will be necessary to create a new shape layer for the side view rather than modify an existing layer. Use the 'rounded rectangle' shapes tool to draw a bar between the top and bottom guides. Alter the radius in the options bar to obtain an appropriate end-shape to this bar. A radius of 40 pixels was used in the example.

6. Apply the 'blue glass' layer style to the new shapes layer by dragging the layer effects from an existing layer to the new layer. Open the layer effects on an existing layer with the required style and click and drag the word 'effects' to the new layer. After completing the side view the logo has turned through 90 degrees. Duplicating and 'flipping' your existing layers can create the viewpoints of the remaining 270 degrees.

7. To create the additional views to complete the 360 degrees rotation duplicate a pre-existing layer and flip the logo if required.

**Note. To flip a vector shape select all the paths using the path selection tool and then go to Edit > Transform Path > Flip Horizontal.**

8. Your layers palette should look like the one opposite when you have completed a 180-degree turn.

**Note. As the demonstration graphic is symmetrical there is no need to create additional viewpoints.**

9. Save the file as a PSD file. Before jumping a Photoshop file with layer effects into ImageReady, scale the image in the 'Image Size' dialogue box using the resolution control to alter the pixel dimensions.

# ImageReady

The interface of ImageReady is similar to Photoshop. If you 'Jump' a file into ImageReady instead of opening a file in ImageReady (File > Open) the file also remains open in Photoshop. Any changes you now make to the file in ImageReady will be copied to the version open in Photoshop when you jump or switch back to Photoshop.

**Note. Some of the features available in Photoshop (e.g. adjustment layers and vector tools) are supported but cannot be edited in ImageReady. If at any time you need to access Photoshop's features simply switch or jump between the two.**

## The Interface

If you are new to ImageReady it is worth familiarising yourself with the interface and tools palette. At the top left corner of the image window there are the preview tabs 'original', 'optimized', '2-up' and '4-up'. It is usual to have the 'Show Original Image' displayed when creating an animation or working with type, etc. Prior to saving the image for the web you will need to 'Optimize' the image (choose a file format, compression setting and/or colour palette, etc.). The 'Show Optimized image' view displays a preview of the image as it will appear after saving the image with the settings chosen in the 'Optimize' palette.

## File quality, format and size

Creating images for the web is a trade-off between quality and speed of download. Choosing high quality over file size will increase the time taken to download the image for display in the web browser. Choosing speed at the expense of quality will lead to poor quality images. The final choice is a subjective one but can be influenced by considering the people most likely to be viewing the images (artist, photographer, general public, etc.), the type of connection they have to the Internet (modem, cable, etc.) and the resolution of the monitor being used to display the images (800 x 600, 1024 x 768, etc).

## Save and Save optimized

Files created or modified in ImageReady are saved as master PSD files using the 'Save' and 'Save As' options from the 'Edit' menu. Optimized GIF and JPEG files destined for the web are saved using the 'Save Optimized' and 'Save Optimized As' options from the Edit menu. Optimized file sizes and download times are displayed at the bottom of the image window (with the image in the 'Show Optimized' view). The choice of file format selected to save the image for the web is dependent on the type of image you are creating.

## JPEG file format

Photographic images requiring 24-bit colour quality (millions of colours) are usually saved as JPEG files. When choosing the JPEG file format a compression setting is applied that will balance quality with file size (download time). Excessive compression leads to image artifacts, lowering the overall quality of the image. The JPEG file format, although capable of saving 24-bit colour, does not support transparency or animations.

## GIF file format

A GIF (graphics interchange format) is an 8-bit format that supports both transparency and animated frames. A 'colour palette' determines the 256 possible colours supported by the 8-bit GIF file format. This colour palette can be a predetermined colour palette such as a 'web palette' or can be weighted towards the dominant colours present in the image being optimised (perceptual, selective and adaptive colour palettes).

The file size of a graphic image with a limited colour palette may be reduced further by choosing a more restrictive colour palette that uses fewer than 256 colours (128, 64, 32, etc.). Using a smaller colour palette can help to reduce the final file size but can have detrimental effects on quality, especially if smooth transitions of tone or colour are required. If photographic images are required for animation a larger colour palette is usually required to avoid the effects of 'banding' (steps in tone or colour).

**Note. The effects of banding can be minimised by selecting a 'dither algorithm' from the optimize palette (diffusion, noise or pattern). The process of dithering alternates the colours that meet in a pattern to create the perception of an intermediate colour.**

## Image resolution and the web

It is important to note that the pixel dimensions of the image and the resolution setting of the monitor control the size of an image displayed in a web browser. The web browser ignores the resolution and output dimensions (in inches or centimetres) that may have been specified in Photoshop.

**Note. The image size dialogue box in ImageReady has no options for resolution or output dimensions. The image being edited in ImageReady should normally be displayed at 100% magnification, as this is the size it will be viewed on the Internet by someone using a monitor with a similar resolution. Images will appear smaller when displayed on a higher resolution monitor and larger when displayed on a lower resolution monitor. Scrolling is required to view an image larger than the browser window.**

## Activity 4

Before you start to animate the logo make a decision as to whether you would like the logo spinning in front of the existing background or whether you would like to see the web page around and behind the cut-outs of the logo (the GIF file format is able to support transparency as well as animated frames). If you decide to opt for transparency, first switch off the visibility of the background in the layers palette (click on the eye icon).

**Note. If transparency is required it is advisable to switch off the outer glow and drop shadow components of each layer style as the limited colour palette has difficulty rendering gradual transitions of colour effectively when using transparency.**

1. Scale the multi-layered logo created in Activity 3 (using a resolution of 70 ppi will create a file size 140 pixels wide and 140 pixels high). First make visible the 'shape 1' layer in the layers palette. This should be the only layer with an eye icon visible. In the animation palette, set a time delay for this frame (0.2 seconds was set for this demonstration).

An animation frame can be constructed from the combined elements from single or multiple type, shape and image layers. To select the contents of each animated frame simply click on the visibility of one or more layers, layer effects or adjustment layers. As you create additional frames alter the visibility, opacity or position of the layers to alter the contents. Each frame can be assigned a 'frame delay time' or a period of time that the frame will be visible for before it is replaced by the next frame in the sequence. Actual timings should be previewed in a web browser.

2. Create a second frame by clicking on the 'Duplicates current frame' icon in the animation palette. This duplicate frame is exactly the same as the first frame until the visibility, position and opacity of the layers are altered. Make visible the 'shape 1 copy' layer and switch off the visibility of the 'shape 1' layer.

3. Continue to duplicate the last frame in the sequence and make visible the next layer in the stack until you have 6 frames, each reading from a different layer in the layers palette. Duplicate the first frame and then drag this frame to the end of the frames sequence so that it becomes frame 7.

4. In the illustration above the colour overlay component of the layer style has been switched off so that the reverse side of the logo appears different from the front surface. The new side view (half white and half blue) was created by first duplicating the side view layer. The colour overlay layer effect was then switched off on this duplicate layer. Layer masks were added to conceal a different half of each layer.

The animation palette should now resemble the one shown in the illustration. The logo will now turn 180 degrees. Because the logo is symmetrical and looks the same when turned 180 degrees there is no need to create any additional frames if the colour overlay is left switched on. The following steps however introduce a new feature to the animation.

## Tweening

If we want the opacity of a layer, layer effect or position of a layer to change gradually then we only need to create the first and last frame in the sequence. ImageReady is able to create the intermediate frames automatically without the need to create additional layers in a process called 'tweening'. ImageReady is not capable of 'tweening' or creating intermediate frames automatically when we wish to change the shape or size of a graphic. If we wish to zoom smoothly into a graphic or rotate the graphic in space we must first create the intermediate steps of the animation as additional layers that the animated frames can draw from.

5. Start by duplicating the seventh frame and make visible the colour overlay effect that had been previously turned off. With the eighth frame selected click on the 'Tweens animation frames' icon in the animation palette. Select the desired number of intermediate or 'in between' frames required and click OK.

The intermediate frames created by ImageReady 'fade in' the visibility of the color overlay effect. Adjust the time delay of each frame and set a longer time delay on the first or last frame if you want the graphic to pause before spinning again.

**Note. In the bottom left-hand corner of the animation palette you can set whether you want the animation to play just once, forever or a specified number of times.**

6. Play the animation by clicking on the 'Plays / stops animation' icon in the animation palette. Click on the 'Preview in Default Browser' icon to see the animation in 'real time'.

7. Click on the optimised view and set the required number of colours and the colour palette. Choose whichever colour palette gives the best visual result for your graphic. Select a dither algorithm if using only a few colours and check the transparency option if you have clicked off the background in the layers palette to create a logo that spins against the web page background.

8. Save the animation as a master PSD file (File > Save As) and an optimized GIF file (File > Save Optimized As). The optimized GIF file can launched by opening the accompanying HTML file (if saved) or can simply be dragged into a browser window. The animation may also play if the file is embedded into the body of an email.

**Note. If saving a HTML file with your animated GIF first create a new folder so that the GIF and HTML are in the same location. This will ensure the link between the two files is not broken when the files are moved to a different location or uploaded to a server.**

The creative possibilities for motion that ImageReady opens up are, of course, limitless. You may like to think about how the use of a motordrive or zoom lens can add to the potential for animation.  Think about creating sequential images over an extended period of time. Try mounting the camera on a sturdy tripod to create a professional result when the camera does not need to pan to follow the action.

# Web page construction

Photoshop and ImageReady can prepare photographic images, animations and graphics for assembly in 'web authoring' software such as 'Dreamweaver' and 'GoLive'. Everything can, however, be assembled and made interactive in ImageReady itself.

ImageReady has its limitations, but if something relatively simple is required there is no need to go to the expense of acquiring expensive web authoring software.

*A homepage created in ImageReady*

ImageReady is able to 'slice' an image canvas and save each slice as a separate image file suitable for use on the Internet. The slices can be saved in different file formats, each with its own optimisation setting. ImageReady can also write the supporting 'HTML' file so that a web browser can reassemble the slices. ImageReady can embed 'hyperlinks' in the image so that the user can jump to other web pages in the same web site or other web sites on the 'World Wide Web'. ImageReady can also export slices as GIF animations and create 'Rollovers' so that as the user moves the mouse cursor over a slice, changes will occur within the web page (a new image will be loaded into the same slice or a different slice somewhere else on the web page).

The following activity will guide you through the 'basic' steps in order to create a complete web page. All of the major features of ImageReady will be introduced as you assemble, slice, optimise and save a web page.  This 'index page, will serve as a 'homepage' to welcome and guide visitors to web galleries that you can create in Photoshop.

## Activity 5

1. Launch Adobe ImageReady. If working on a Macintosh computer increase the 'Preferred Size' in the 'Memory Requirements' to at least 48000 K (click once on the Adobe ImageReady icon in the 'Applications' folder and go to File > Get Info > Memory).

2. Reset palette locations ('Window > Workspace > Reset Palette Locations').

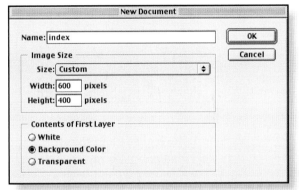

3. Click on the background colour swatch in the tools palette to open the 'Color Picker'. Select 'Only Web Colors'. Choose a colour value for the background colour of your web page by clicking on it. Select 'OK'.

4. Create a new document ('File > New'). Name the file 'index'. For the 'Image Size' specifications select 600 pixels for the width and 400 pixels for the height. Select 'Background Color' as the 'Contents of First Layer'. From the 'View' menu select 'Rulers'.

5. Click and hold on the vertical rule and drag a guide to the 40-pixel position as indicated on the horizontal rule. Repeat the process, adding guides to the 100, 160 and 200-pixel positions as indicated on the horizontal rule.

6. Drag guides from the horizontal rule to the 75, 150, 170 and 200-pixel positions as indicated on the vertical rule. Then add guides every 20 and 30 pixels until you reach the base of the canvas area. Save your work in progress (Image > Save As) as a PSD file.

## Create the web buttons

7. Select the 'Rounded Rectangle Tool' from the tools palette. From the options bar select a 'Corner Radius' of 20 pixels. Click and drag a vector shape starting 170 pixels from the top and 40 pixels from the left to a position, 200 pixels from the top and 160 pixels from the left (colour is not important at this stage). Create an additional three vector shapes, below the first, using the guides to help you position them in a neat vertical column.

8. In the 'Layers' palette link the four vector layers by clicking on the empty box next to the eye on each layer. From the layer palette options select 'New Layer Set From Linked'.

9. Double-click on the name 'Set 1' in the 'Layers' palette and rename the layer set 'buttons'.

## Prepare and import web-page components

### Logo

10. Open the 'Vector Logo PSD' created in 'Activity 4'. Link all layers except the background layer and create a layer set from the layer palette options as before ('New Layer Set From Linked'). Title this layer set 'logo'.

11. Select the 'Move Tool' in the 'Tools' palette and the 'logo' layer set in the layers palette. Click on either the layer set or the logo in the image window and drag the logo into the index.psd file window. The logo will appear in the index file and the layer set will appear in the layers palette. With the move tool still selected position the logo in the upper left-hand corner of the index file.

### Banner

12. Open or create a file that will act as the web banner for the web page. The text or image should be sized to 380 pixels wide by 110 pixels high (excluding layer effects such as drop shadows, etc.). Use the 'Transform' command to resize the banner if required. Place the layers of the banner in a layer set and name this set 'banner'. Import this layer set into the index file as before.

**Note. If a layer set containing an adjustment layer is imported into the index file, the blend mode of the layer set will need to be changed to 'Normal' from the default 'Pass Through'. This will prevent the adjustment layer from affecting the layers below.**

## Images

13.  Create a new file with the dimensions 380 pixels wide by 220 pixels high. Import and scale three different images and place the three images in a layer set as before. Each image will act as an example of the type of images that can be found in a gallery of images that will be linked to this homepage, e.g. a portrait linked to a gallery of portraits.

14.  Select the text tool in the 'Tools Palette' and select 'Center Text' from the options bar. Click in the centre of the image window and type your contact details such as your email address.

15.  Name the layer set 'images' and import the set into the 'index' file. Position the image set using the guides to align the images.

16.  Switch off the visibility of all layers in the 'images' layer set and save your work in progress as a PSD file (File > Save As). You can temporarily hide the guides now that all layers have been set in position by going to View > Show > Guides.

**Note. It is a good idea to ensure that every layer is in the correct position before proceeding with the creation of 'rollovers' and 'animations'. Moving the position of layers after animations and rollovers are in place can create major headaches for those inexperienced with ImageReady.**

## Creating the rollover buttons

17. In the 'Styles' palette there are rollovers available that can be applied to the vector shape layers in your 'buttons' layer set. These rollover styles (identified by a small black triangle in the upper left-hand corner of the style thumbnail) save a lot of time when creating a homepage.

To apply a rollover simply select a vector shape layer in the layers palette and click on the rollover style of your choice in the styles palette. As well as applying the styles for any additional states, such as 'Over' or 'Down', ImageReady also creates the layer-based 'slices' to support these rollovers. You can load additional rollover styles from the options fly-out menu in the styles palette.

18. Continue to apply the rollover style of your choice to all the vector shapes in the 'buttons' layer set. You will notice in the image window of the index file that 'slices' are created in addition to the layer styles being applied.

**Note. Layer styles used in the rollovers can be modified or replaced with alternative styles from the 'Styles' palette and then resaved as a 'New Style' complete with rollover states.**

## Slice

19. Select the slice tool in the 'Tools' palette. From the top left hand corner of the index file click and drag, to create a 'User Slice' around the logo, to a point that aligns with the top right-hand corner of the button slice.

20. Create a second user slice around the banner and a third user slice around the area that contain the images from the 'images' layer set.

**Note. When the web page is saved as the optimized version (as opposed to the master PSD file) each slice will become a separate image file. Each slice is numbered in the top left-hand corner. Slices can be further identified, by small icons, as 'User Slices' (those created using the 'Slice Tool'), 'Auto Slices' (those created by ImageReady) and 'Layer Based Slices' created automatically as part of a rollover or by the user from the 'Layer' menu. 'Layer Based Slices' are just large enough to contain the pixels on the layer from which they were created.**

21. Open the 'buttons' layer set and select the top vector layer. Select the 'Text Tool' and in the options bar set the font size to '14 px' and set the text alignment to 'Center Text'. Click on the colour swatch in the options bar to select a colour for the text. Click in the centre of the top button to add a text layer to name the button. Repeat the process to name the additional buttons.

**Note. Select the 'Toggle Slices Visibility' icon in the 'Tools Palette' to temporarily hide the slices.**

## Secondary rollovers

22. In the 'Rollovers' palette there will be listed 'Index_Layer 1' to 'Index_Layer 4'. These are the 'rollovers' that were created when the rollover layer style was applied to each of the vector layers. These are the 'Normal' states. Click on the small triangle to the left of the rollover thumbnail to view the other rollover states. Some styles have two states whilst others have three.

23. Click on the 'Over State' of one of the rollovers. Note the changes in the appearance to the button when the 'Over State' is selected. If the rollover style selected has a 'Down State' instead of an 'Over State' this can be changed by simply double-clicking on the state and changing it in the 'Rollover State Options' dialogue box that appears.

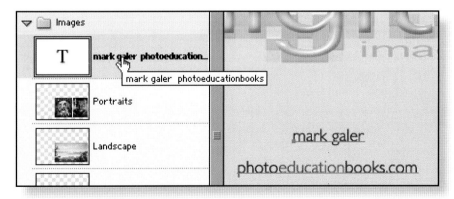

24. With the 'Over State' selected switch on the visibility of one of your images in the 'images' layer set. Switch between the 'Normal State' and the 'Over State' and notice how the image switches on and off. When an image appears in one slice as a result of rolling over another slice it is called a 'secondary rollover'.

25. Repeat the process to the other rollovers switching on a different image for each 'Over State' selected. With the 'Over State' of the last button switch on the 'contact' text layer.

26. Save your work in progress as a PSD file (File > Save As).

## Link

27. Select the 'Slice Select Tool' in the 'Tools' palette (behind the 'Slice Tool'). Click on a rollover slice to select it. Select the 'Slice' palette (grouped with the 'Animation' and 'Image Map' palettes).

28. Select the 'URL:' text field in the 'Slice' palette and type in the name (URL) of the web page you would like to link to. If you are linking to a web gallery created by Photoshop type in the directory name (the name of the 'destination' folder) followed by a forward slash, followed by 'index.htm', e.g. 'portraits/index.htm'. Choose a short name with no spaces or punctuation marks. Ensure the spelling is exactly the same, otherwise the link will not work.

29. Repeat the process and create links for all of the 'button' or layer based rollover slices. With the 'contact' slice selected, type 'mailto:' in the URL field followed by your email address. This link, when clicked, will generate an email window with your address already typed in the 'To:' field.

## Animate

30. If you wish to create an animation proceed as for the animated logo activity. You can if you wish create an animation in an 'Over State', so the animation is only activated by a mouse rolling over this slice.

**Note. You cannot import an animation that you have previously created in ImageReady into a new file and retain the animation frames. You must first import the component layers and start from scratch.**

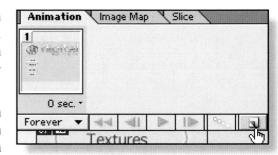

## Optimize

31. Click on the 'Show Optimized Image'
tag in the upper left-hand corner of the
image window.

32. Using the 'Slice Select Tool' select each slice and in the 'Optimize' palette choose
the appropriate optimisation settings. For a graphic with a limited colour palette the GIF
file format can be used effectively, whereas the 'images' slice and the 'banner' slices will
require the JPEG file format.

**Note. Shift-click to select multiple slices when you want to apply the same optimisation
setting to several slices at the same time.**

33. As changes are made to the optimisation settings preview the change in quality in
the image window. Also observe the change to the file size and the download time in the
'Image Information' data at the base of the main window. We are working in a 'what you
see is what you get' (WYSIWYG) mode, so the final choices are very subjective.

**Note. For photographic images and graphics with smooth gradations of tone and
colour choose the JPEG file format. Select 'Progressive' if you would like the image
to appear progressively when being downloaded by a web browser (the image will
gradually become clearer as more of the data is downloaded). JPEG file format does
not support animation frames or transparency.**

34. Save work in progress (File > Save As) as a PSD file.

## Preview and save

35.  Return to 'Show Original Image' mode. Click on the 'Preview Document' icon in the 'Tools' palette. Move the cursor over the buttons to check the rollovers are working. Then click on the 'Preview in Default Browser' icon to open your file in the web browser. Return to the open file in ImageReady and correct or modify any rollovers, animations or optimisation settings if required.

36.  Select the background colour used in the web page as the foreground or background colour swatch (use the 'Eyedropper Tool' or use the colour picker).

37.  Go to 'File > Output Settings > Background'. In the 'BG Color' pull-down menu select the background colour used in your web site. This will ensure that the colour surrounding the table of slices will be the same.

 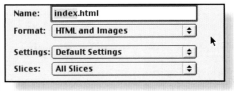

38.  From the 'File' menu choose 'Save Optimized As'. Create a new folder called 'mywebsite' and save the HTML and images into this folder. Save the ImageReady file as a PSD file in a separate folder.

39.  Drag any web gallery folders that are linked to your homepage into your 'mywebsite' folder. Launch the 'index.html' file to test the site and then upload to the Internet.

# Assignment

## Part A

Create a vector logo to promote your personal digital imaging work using Adobe Photoshop. Use a mixture of typographic form and drawn or modified shapes to create a vector based layer. The logo should be easily identifiable when viewed as small as 100 pixels square on a monitor or printed 1 inch (2.54 cm) square. The logo should be saved as a custom shape and exported as a 'chs' (custom shape) Adobe file.

## Part B

Create and apply a personal layer style to a large version of your logo (full-screen size). Scale the layer style so the style is the same when applied to a small thumbnail version of the logo. Save your layer styles as an Adobe 'asl' file.

## Part C

Construct an animation to promote your personal photographic work. The animation must be constructed using Adobe ImageReady from at least 3 frames (maximum 15). The animation may be constructed from image only, image and text, or text only.

## Part D

Create a minimum of three linked web pages using Adobe ImageReady.
The site is to be made available for viewing on the World Wide Web.
The content should promote your personal digital imaging.
The homepage is to include:

> ~ a web banner and logo.
> ~ links to two or more web photo galleries.
> ~ a contact email address that launches an email window.

The web site must be capable of being viewed on a monitor set to 800 x 600 resolution without the need for scrolling (approximately 410 x 650 pixels).

*Raphael Ruz*

*Paul Allister*

# Gallery

*Student Logos*

*Ari Hatzis*

*Amanda De Simone*                    *Nicole Stavrinidis*

*Paul Allister*                    *Raphael Ruz*

# Glossary

**Additive colour**    A colour system where the primaries of red, green and blue mix to form the other colours.

**Adjustment layers**    Image adjustment placed on a layer.

**Adobe gamma**    A calibration and profiling utility supplied with Photoshop.

**Algorithms**    A sequence of mathematical operations.

**Aliasing**    The display of a digital image where a curved line appears jagged due to the square pixels.

**Alpha channel**    Additional channel used for storing masks and selections.

**Analyse/Analysis**    To examine in detail.

**Anti-aliasing**    The process of smoothing the appearance of a curved line in a digital image.

**Aperture**    A circular opening in the lens that controls light reaching the film.

**Area arrays**    A rectangular pattern of light sensitive sensors alternately receptive to red, green or blue light.

**Artifacts**    Pixels that are significantly incorrect in their brightness or colour values.

**Aspect ratio**    The ratio of height to width. Usually in reference to the light sensitive area or format of the camera.

**Bit**    Short for binary digit, the basic unit of the binary language.

**Bit depth**    Number of bits (memory) assigned to recording colour or tonal information.

**Bitmap**    A one-bit image, i.e. black and white (no shades of grey).

**Blend mode**    The formula used for defining the mixing of a layer with those beneath it.

**Brightness**    The value assigned to a pixel in the HSB model to define the relative lightness of a pixel.

**Byte**    8 bits. The standard unit of binary data storage containing a value between 0 and 255.

**Captured**    A record of an image.

**CCD**    Charge coupled device. A solid state image pick-up device used in digital image capture.

**Channels**    The divisions of colour data within a digital image. Data is separated into primary or secondary colours.

**Charge coupled device**    See CCD.

**CIS**    Contact Image Sensor. A single row of sensors used in scanner mechanisms.

**Clipboard**    The temporary storage of something that has been cut or copied.

| | |
|---|---|
| **Clipping group** | Two or more layers that have been linked. The base layer acts as a mask limiting the effect or visibility of those layers clipped to it. |
| **Cloning tool** | A tool used for replicating pixels in digital photography. |
| **CMOS** | Complementary Metal Oxide Semiconductor. A chip used widely within the computer industry, now also frequently used as an image sensor in digital cameras. |
| **CMYK** | Cyan, magenta, yellow and black. The inks used in four colour printing. |
| **Color picker** | Dialogue box used for the selection of colours. |
| **ColorSync** | System level software developed by Apple, designed to work together with hardware devices to facilitate predictable colour. |
| **Colour fringes** | Bands of colour on the edges of lines within an image. |
| **Colour fringing** | See colour fringes. |
| **Colour gamut** | The range of colours provided by a hardware device, or a set of pigments. |
| **Colour space** | An accurately defined set of colours that can be translated for use as a profile. |
| **Complementary Metal Oxide Semiconductor** | See CMOS. |
| **Composition** | The arrangement of shape, tone, line and colour within the boundaries of the image area. |
| **Compression** | A method for reducing the file size of a digital image. |
| **Constrain proportions** | Retain the proportional dimensions of an image when changing the image size. |
| **Contact Image Sensor** | See CIS. |
| **Context** | The circumstances relevant to something under consideration. |
| **Continuous tone** | An image containing the illusion of smooth gradations between highlights and shadows. |
| **Contrast** | The difference in brightness between the darkest and lightest areas of the image or subject. |
| **CPU** | Central processing unit used to compute exposure. |
| **Crash** | The sudden operational failure of a computer. |
| **Crop** | Reduce image size to enhance composition or limit information. |
| **Curves** | Control for adjusting tonality and colour in a digital image. |
| | |
| **DAT** | Digital Audio Tape. Tape format used to store computer data. |
| **Default** | The settings of a device as chosen by the manufacturer. |
| **Defringe** | The action of removing the edge pixels of a selection. |
| **Density** | The measure of opacity of tone on a negative. |

| | |
|---|---|
| **Depth of field** | The zone of sharpness variable by aperture, focal length or subject distance. |
| **Descreen** | The removal of half-tone lines or patterns during scanning. |
| **Device dependent** | Dependent on a particular item of hardware. For example, referring to a colour result unique to a particular printer. |
| **Device independent** | Not dependent on a particular item of hardware. For example, a colour result that can be replicated on any hardware device. |
| **Device** | An item of computer hardware. |
| **Digital Audio Tape** | See DAT. |
| **Digital image** | A computer-generated photograph composed of pixels (picture elements) rather than film grain. |
| **Download** | To copy digital files (usually from the Internet). |
| **Dpi** | Dots per inch. A measurement of resolution. |
| **Dummy file** | To go through the motions of creating a new file in Photoshop for the purpose of determining the file size required during the scanning process. |
| **Dye sublimation print** | A high quality print created using thermal dyes. |
| **Dyes** | A type of pigment. |
| | |
| **Edit** | Select images from a larger collection to form a sequence or theme. |
| **Editable text** | Text that has not been rendered into pixels. |
| **Eight/8-bit image** | A single channel image capable of storing 256 different colours or levels. |
| **Evaluate** | Assess the value or quality of a piece of work. |
| **Exposure** | Combined effect of intensity and duration of light on a light sensitive material or device. |
| **Exposure compensation** | To increase or decrease the exposure from a meter-indicated exposure to obtain an appropriate exposure. |
| | |
| **Feather** | The action of softening the edge of a digital selection. |
| **File format** | The code used to store digital data, e.g. TIFF or JPEG. |
| **File size** | The memory required to store digital data in a file. |
| **Film grain** | See Grain. |
| **Film speed** | A precise number or ISO rating given to a film or device indicating its degree of light sensitivity. |
| **F-numbers** | A sequence of numbers given to the relative sizes of aperture opening. F-numbers are standard on all lenses. The largest number corresponds to the smallest aperture and vice versa. |
| **Format** | The size of the camera or the orientation/shape of the image. |
| **Frame** | The act of composing an image. See 'Composition'. |
| **Freeze** | Software that fails to interact with new information. |

**FTP software**    File Transfer Protocol software is used for uploading and downloading files over the Internet.

**Galleries**    A managed collection of images displayed in a conveniently accessible form.

**Gaussian Blur**    A filter used for defocusing a digital image.

**GIF**    Graphics Interchange Format. An 8-bit format (256 colours) that supports animation and partial transparency.

**Gigabyte**    A unit of measurement for digital files, 1024 megabytes.

**Grain**    Tiny particles of silver metal or dye that make up the final image. Fast films give larger grain than slow films. Focus finders are used to magnify the projected image so that the grain can be seen and an accurate focus obtained.

**Grayscale**    An 8-bit image with a single channel used to describe monochrome (black and white) images.

**Grey card**    Card that reflects 18% of incident light  The resulting tone is used by light meters as a standardised mid-tone.

**Half-tone**    A system of reproducing the continuous tone of a photographic print by a pattern of dots printed by offset litho.

**Hard copy**    A print.

**Hard drive**    Memory facility that is capable of retaining information after the computer is switched off.

**Highlight**    Area of subject receiving highest exposure value.

**Histogram**    A graphical representation of a digital image indicating the pixels allocated to each level.

**Histories**    The memory of previous image states in Photoshop.

**History brush**    A tool in Photoshop with which a previous state or history can be painted.

**HTML**    Hyper Text Markup Language. The code that is used to describe the contents and appearance of a web page.

**Hue**    The name of a colour, e.g. red, green or blue.

**Hyperlink**    A link that allows the viewer of a page to navigate or 'jump' to another location on the same page or on a different page.

**ICC**    International Color Consortium. A collection of manufacturers including Adobe, Microsoft, Agfa, Kodak, SGI, Fogra, Sun and Taligent who came together to create an open, cross platform standard for colour management.

**ICM**    Image Color Management. Windows based software designed to work together with hardware devices to facilitate predictable colour.

| | |
|---|---|
| **Image Colour Management** | See ICM. |
| **Image setter** | A device used to print CMYK film separations used in the printing industry. |
| **Image size** | The pixel dimensions, output dimensions and resolution used to define a digital image. |
| **Infrared film** | A film that is sensitive to the wavelengths of light longer than 720nm, which are invisible to the human eye. |
| **Instant capture** | An exposure that is fast enough to result in a relatively sharp image free of significant blur. |
| **International Color Consortium** | See ICC. |
| **Interpolated resolution** | Final resolution of an image arrived at by means of interpolation. |
| **Interpolation** | Increasing the pixel dimensions of an image by inserting new pixels between existing pixels within the image. |
| **ISO** | International Standards Organisation. A numerical system for rating the speed or relative light sensitivity of a film or device. |
| **ISP** | Internet Service Provider allows individuals access to a Web server. |
| **Jaz** | A storage disk capable of storing slightly less than 2 GB manufactured by Iomega. |
| **JPEG (.jpg)** | Joint Photographic Experts Group. Popular image compression file format. |
| **Jump** | To open a file in another application. |
| **Juxtapose** | Placing objects or subjects within a frame to allow comparison. |
| **Kilobyte** | 1024 bytes. |
| **Lab mode** | A device independent colour model created in 1931 as an international standard for measuring colour. |
| **Lasso tool** | Selection tool used in digital editing. |
| **Latent image** | An image created by exposure onto light sensitive silver halide ions, which until amplified by chemical development is invisible to the eye. |
| **Latitude** | Ability of the film or device to record the brightness range of the subject. |
| **Layer mask** | A mask attached to a layer that is used to define the visibility of pixels on that layer. |

| | |
|---|---|
| **Layers** | A feature in digital editing software that allows a composite digital image where each element is on a separate layer or level. |
| **LCD** | Liquid crystal display. |
| **LED** | Light-emitting diode.  Used in the viewfinder to inform the photographer of exposure settings. |
| **Lens** | An optical device usually made from glass that focuses light rays to form an image on a surface. |
| **Levels** | Shades of lightness or brightness assigned to pixels. |
| **Light cyan** | A pale shade of the subtractive colour cyan. |
| **Light magenta** | A pale shade of the subtractive colour magenta. |
| **LiOn** | Lithium Ion.  Rechargeable battery type. |
| **Lithium Ion** | See LiOn. |
| **LZW compression** | A lossless form of image compression used in the TIFF format. |
| | |
| **Magic wand tool** | Selection tool used in digital editing. |
| **Magnesium Lithium** | See MnLi. |
| **Marching ants** | A moving broken line indicating a digital selection of pixels. |
| **Marquee tool** | Selection tool used in digital editing. |
| **Maximum aperture** | Largest lens opening. |
| **Megabyte** | A unit of measurement for digital files, 1024 kilobytes. |
| **Mega-pixels** | More than a million pixels. |
| **Memory card** | A removable storage device about the size of a small card. Many technologies available resulting in various sizes and formats.  Often found in digital cameras. |
| **Metallic silver** | Metal created during the development of film, giving rise to the appearance of grain.  See grain. |
| **Minimum aperture** | Smallest lens opening. |
| **MnLi** | Magnesium Lithium.  Rechargeable battery type. |
| **Mode   (digital image)** | RGB, CMYK, etc. The mode describes the tonal and colour range of the captured or scanned image. |
| **Moiré** | A repetitive pattern usually caused by interference of overlapping symmetrical dots or lines. |
| **Motherboard** | An electronic board containing the main functional elements of a computer upon which other components can be connected. |
| **Multiple exposure** | Several exposures made onto the same frame of film or piece of paper. |
| | |
| **Negative** | An image on film or paper where the tones are reversed, e.g. dark tones are recorded as light tones and vice versa. |
| **NiCd** | Nickel Cadmium.  Rechargeable battery type. |

| | |
|---|---|
| **Nickel Cadmium** | See NiCd. |
| **Nickel Metal Hydride** | See NiMH. |
| **NiMH** | Nickel Metal Hydride.  Rechargeable battery type. |
| **Noise** | Electronic interference producing white speckles in the image. |
| **Non-imaging** | To not assist in the formation of an image.  When related to light it is often known as flare. |
| **Objective** | A factual and non-subjective analysis of information. |
| **ODR** | Output device resolution.  The number of ink dots per inch of paper produced by the printer. |
| **Opacity** | The degree of non-transparency. |
| **Opaque** | Not transmitting light. |
| **Optimize** | The process of fine-tuning the file size and display quality of an image or image slice destined for the Web. |
| **Out of gamut** | Beyond the scope of colours that a particular device can create. |
| **Output device resolution** | See ODR. |
| **Path** | The outline of a vector shape. |
| **PDF** | Portable Document Format.  Data format created using Adobe software. |
| **Pegging** | The action of fixing tonal or colour values to prevent them from being altered when using curves image adjustment. |
| **Photo Multiplier Tube** | See PMT. |
| **Piezoelectric** | Crystal that will accurately change dimension with a change of applied voltage.  Often used in inkjet printers to supply microscopic dots of ink. |
| **Pixel** | The smallest square picture element in a digital image. |
| **Pixellated** | An image where the pixels are visible to the human eye and curved lines appear jagged or stepped. |
| **PMT** | Photo Multiplier Tube.  Light sensing device generally used in drum scanners. |
| **Portable Document Format** | See PDF. |
| **Pre-press** | Stage where digital information is translated into output suitable for the printing process. |
| **Primary colours** | The three colours of light (red, green and blue) from which all other colours can be created. |
| **Processor speed** | The capability of the computer's CPU measured in megahertz. |

| | |
|---|---|
| **Quick mask mode** | Temporary alpha channel used for refining or making selections. |
| **RAID** | Redundant Array of Independent Disks. A type of hard disk assembly that allows data to be simultaneously written. |
| **RAM** | Random access memory. The computer's short-term or working memory. |
| **Redundant Array of Independent Disks** | See RAID. |
| **Reflector** | A surface used to reflect light in order to fill shadows. |
| **Refraction** | The change in direction of light as it passes through a transparent surface at an angle. |
| **Resample** | To alter the total number of pixels describing a digital image. |
| **Resolution** | A measure of the degree of definition, also called sharpness. |
| **RGB** | Red, green and blue. The three primary colours used to display images on a colour monitor. |
| **Rollover** | A Web effect in which a different image state appears when the viewer performs a mouse action. |
| **Rubber stamp** | A tool used for replicating pixels in digital imaging. |
| **Sample** | To select a colour value for analysis or use. |
| **Saturation (colour)** | Intensity or richness of colour hue. |
| **Save a Copy** | An option that allows the user to create a digital replica of an image file but without layers or additional channels. |
| **Save As** | An option that allows the user to create a duplicate of a digital file but with an alternative name, thereby protecting the original document from any changes that have been made since it was opened. |
| **Scale** | A ratio of size. |
| **Scratch disk memory** | Portion of hard disk allocated to software such as Photoshop to be used as a working space. |
| **Screen real estate** | Area of monitor available for image display that is not taken up by palettes and toolbars. |
| **Screen re-draws** | Time taken to render information being depicted on the monitor as changes are being made through the application software. |
| **Secondary colours** | The colours Cyan, Magenta and Yellow, created when two primary colours are mixed. |
| **Sharp** | In focus. Not blurred. |
| **Silver halide** | Compound of silver often used as a light sensitive speck on film. |
| **Single Lens Reflex** | See SLR camera. |
| **Slice** | Divide an image into rectangular areas for selective optimization or to create functional areas for a web page. |

| | |
|---|---|
| **Sliders** | A sliding control in digital editing software used to adjust colour, tone, opacity, etc. |
| **SLR camera** | Single Lens Reflex camera. The image in the viewfinder is essentially the same image that the film will see. This image, prior to taking the shot, is viewed via a mirror that moves out of the way when the shutter release is pressed. |
| **Snapshot** | A record of a history state that is held until the file is closed. |
| **Soft proof** | The depiction of a digital image on a computer monitor used to check output accuracy. |
| **Software** | A computer program. |
| **Subjective analysis** | Personal opinions or views concerning the perceived communication and aesthetic value of an image. |
| **Subtractive colour** | A colour system where the primaries of Yellow, Magenta and Cyan mix to form all other colours. |
| **System software** | Computer operating program, e.g. Windows or Mac OS. |
| | |
| **Tagging** | System whereby a profile is included within the image data of a file for the purpose of helping describe its particular colour characteristics. |
| **Thematic images** | A set of images with a unifying idea or concept. |
| **TIFF** | Tagged Image File Format. Popular image file format for desktop publishing applications. |
| **Tone** | A tint of colour or shade of grey. |
| **Transparent** | Allowing light to pass through. |
| **Tri-colour** | A filter taking the hue of either one of the additive primaries, Red, Green or Blue. |
| **True resolution** | The resolution of an image file created by the hardware device, either camera or scanner, without any interpolation. |
| **TTL meter** | Through-the-lens reflective light meter. This is a convenient way to measure the brightness of a scene as the meter is behind the camera lens. |
| **Tweening** | Derived from the words "in betweening" - an automated process of creating additional frames between two existing frames in an animation. |
| | |
| **UCR** | Under Colour Removal. A method of replacing a portion of the yellow, magenta and cyan ink, within the shadows and neutral areas of an image, with black ink. |
| **Under Colour Removal** | See UCR. |
| **Unsharp mask filter** | A filter for increasing apparent sharpness of a digital image. |
| **Unsharp Mask** | See USM. |
| **URL** | Uniform Resource Locator. The unique Web address given to every web page. |

| | |
|---|---|
| **USM** | Unsharp Mask. A process used to sharpen images. |
| **Vector graphic** | An resolution-independent image described by its geometric characteristics rather than by pixels. |
| **Video card** | A circuit board containing the hardware required to drive the monitor of a computer. |
| **Video memory** | Memory required for the monitor to be able to render an image. |
| **Virtual memory** | Hard drive memory allocated to function as RAM. |
| **Visualise** | To imagine how something will look once it has been completed. |
| **Workflow** | Series of repeatable steps required to achieve a particular result within a digital imaging environment. |
| **Zip** | A storage disk manufactured by Iomega, available in either 100MB or 250MB capacity. |
| **Zoom tool** | A tool used for magnifying a digital image on the monitor. |

# Keyboard short-cuts

**⌥ = Option  ⇧ = Shift  ⌘ = Command**

| Action | Keyboard Short Cut |
|---|---|
| **Navigate and view** | |
| Fit image on screen | Double click hand tool in palette |
| View image at 100% | Double click zoom tool in palette |
| Zoom tool (magnify) | ⌘/Ctrl + Spacebar |
| Zoom tool (reduce) | ⌥/Alt ⌘/Ctrl |
| Full/standard screen mode | F |
| Show/hide Rulers | ⌘/Ctrl + R |
| Show/hide guides | ⌘/Ctrl + ; |
| Hide palettes | Tab key |
| | |
| **File Commands** | |
| Open | ⌘/Ctrl + O |
| Close | ⌘/Ctrl + W |
| Save | ⌘/Ctrl + S |
| Save As | ⇧ ⌘/Ctrl + S |
| Undo/Redo | ⌘/Ctrl + Z |
| Step Backward | ⌥/Alt ⌘/Ctrl + Z |
| | |
| **Selections** | |
| Add to selection | Hold ⇧ key and select again |
| Subtract from selection | Hold ⌥/Alt key and select again |
| Copy | ⌘/Ctrl + C |
| Cut | ⌘/Ctrl + C |
| Paste | ⌘/Ctrl + V |
| Paste Into | ⌘/Ctrl ⇧ + V |
| Free Transform | ⌘/Ctrl + T |
| Distort image in free transform | Hold ⌘ Key + move handle |
| Feather | ⌘/Ctrl ⌥/Alt + D |
| Select All | ⌘/Ctrl + A |
| Deselect | ⌘/Ctrl + D |
| Inverse selection | ⌘/Ctrl + I |
| Edit in Quick Mask Mode | Q |

## Painting

| | |
|---|---|
| Set default foreground and background colours | D |
| Switch between foreground and background colour | X |
| Enlarge brush size (with paint tool selected) | ] |
| Reduce brush size (with paint tool selected) | [ |
| Change opacity of brush in 10% increments (with paint tool selected) | Press number keys 0 - 9 |
| Fill with foreground colour | ⌥/Alt ⌫ |
| Fill with background colour | ⌘/Cntrl ⌫ |

## Colour adjustments

| | |
|---|---|
| Levels | ⌘/Cntrl + L |
| Curves | ⌘/Cntrl + M |
| Group or clip layer | ⌘/Cntrl + G |
| Disable/enable layer mask | ⇧ + click layer mask thumbnail |
| Preview layer mask | ⌥/Alt + click layer mask thumbnail |
| Select next adjustment point in curves | Ctrl + Tab |

## Layers and Channels

| | |
|---|---|
| Add new layer | ⇧ ⌘/Cntrl + N |
| Load Selection from Alpha channel or layer mask | ⌘/Cntrl + click thumbnail |
| Change opacity of active layer in 10% increments | Press number keys 0 - 9 |
| Add layer mask - Hide All | ⌥/Alt + Click 'Add layer mask' icon |
| Move layer down/up | ⌘/Ctrl + [ or ] |

## Crop

| | |
|---|---|
| Enter crop | Return key |
| Cancel crop | Esc key |
| Constrain proportions of crop marquee | Hold ⇧ key |
| Turn off magnetic guides when cropping | Hold ⌥/Alt ⇧ keys + drag handle |

# Web links

## Resources

| | |
|---|---|
| Essential Skills | http://www.photoeducationbooks.com |
| RMIT Photography | http://www.rmit.edu.au/adc/photography |
| Adobe Digital Imaging | http://www.adobe.com/digitalimag/main.html |
| Martin Evening | http://www.martinevening.com |
| Genesis | http://www.genesiswebsitedesign.com |
| ePHOTOzine | http://www.ephotozine.com |
| Digital Dog | http://www.digitaldog.net |
| Epson | http://www.epson.com |
| Computer darkroom | http://www.computer_darkroom.com |
| Inkjet Mall | http://www.inkjetmall.com |

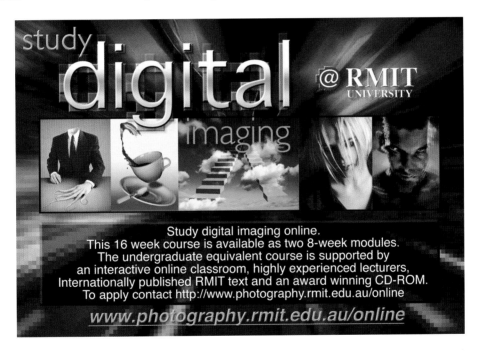

## Tutorials

| | |
|---|---|
| Adobe | http://www.adobe.com/products/tips/photoshop.html |
| Phong | http://www.phong.com |
| Russell Brown | http://www.russellbrown.com |
| Think Dan | http://www.thinkdan.com/tutorials/photoshop.html |
| Planet Photoshop | http://www.planetphotoshop.com |
| Ultimate Photoshop | http://www.ultimate-photoshop.com |
| Scan tips | http://www.scantips.com |

study digital imaging @ RMIT UNIVERSITY

Study digital imaging online.
8-week modules from beginners to advanced.
Undergraduate equivalent courses supported by
interactive online classrooms, experienced lecturers
and an Internationally published text.
Contact http://www.photography.rmit.edu.au/online

www.photography.rmit.edu.au/online

# Also available from Focal Press ...

## Adobe Photoshop 7.0 for Photographers
*Martin Evening*

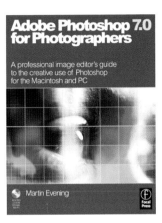

A professional image editor's guide to the creative use of
Photoshop for the Macintosh and PC.

Martin Evening's award-winning Adobe Photoshop for Photogra-
phers titles have become must-have reference sources – the only
Photoshop books written to deal directly with the needs of photog-
raphers. Whether you are an accomplished user or are just starting
out, this book contains a wealth of practical advice, hints and tips to
help you achieve professional-looking results.

Adobe Photoshop 7.0 for Photographers begins with an introduction to working with digital
images, providing essential, up-to-date information on everything from scanning devices to color
management and output issues.

- Benefit from Martin Evening's experience as an Alpha tester and official Adobe roadshow
  speaker for Photoshop 7.0
- Includes free CD-ROM containing invaluable movie tutorials and a selection of images to
  experiment with

### Reviews of Adobe Photoshop 6.0 for Photographers

'Someone has just re-written the bible, the Photoshop bible... Whether you are an expert or a
beginner, this is a book that talks your language.'
*Digital PhotoFX*

'A mine of useful information, aimed at not only helping photographers to produce the very best
quality images, but also gives techniques for image manipulation. For anyone involved with
image processing this is a must have book!'
*Photo Technique*

'This publication is a must for all photographers, independent of your level of experience with the
package, as it's written by a practising professional photographer with you, the photographer, in
mind.'
*The Association of Photographers*

August 2002 • 480pp • 650 photographs • 246 x 189mm • Paperback with CD-Rom
ISBN 0 240 51690 7

*To order your copy call +44 (0)1865 888180 (UK) or +1 800 366 2665 (USA)*
*or visit the Focal Press website: www.focalpress.com*

# Also available from Focal Press ...

## Photoshop 7.0 A to Z
## The Essential Visual Reference Guide
### *Peter Bargh*

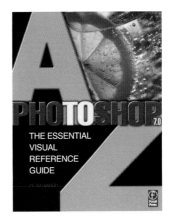

This quick, easy reference text to Photoshop tools, menus and features is a must-have purchase for all Photoshop users: students, professionals and amateurs.

It is one of a kind – giving an easily accessible visual guide to all those vital Photoshop terms. Keep it next to your computer screen as a constant reference, ready to save you hours of frustration when the meaning of that term or specific word is on the tip of your tongue.

Updated to cover the latest features from Photoshop 7.0 this new edition includes many more colour images and step-by-step examples to make this an even more comprehensive guide. Its full colour images provide numerous examples, which show you exactly what to expect and full details on how to achieve it.

Still deciding if it's worth upgrading to Photoshop 7.0? Pete Bargh provides a unique cross-reference chart showing the different features added in each Photoshop update to help make that decision. The extra appendices also include comprehensive visual listings of Photoshop fonts, useful shortcuts, Photoshop related Web sites and record data sheets that you can use to record your own techniques that work well so you can benefit from them again and again.

This is a must have reference for every Photoshop user.

- Save time with this easy A-Z guide to Photoshop, covering all versions from 3.0 to 7.0
- Get up to date with all the latest 7.0 version features
- Full colour images for easy guidance are used throughout

**Review of previous editions:**

'... this handy and simple-to-use paperback ... is a perfect adjunct to ... any other technique book dealing with Photoshop.'
*Professional Photographer*

August 2002 • 192pp • 246 x 189mm • paperback
ISBN 0 240 51912 4

# Also available from Focal Press ...

## Adobe Photoshop Elements 2.0
*Philip Andrews*

This complete and easy-to-follow introduction to Adobe Photoshop Elements has been updated throughout to show all the new features of version 2.0, including digital video frame acquisition; the liquefy filter; the selecting/masking brush and the effects browser.

- Save valuable time with this jargon-free introduction to digital imaging
- Real life examples, fully updated to cover all the new Elements 2.0 features, show you how to put each technique into practice

The associated website **www.guide2elements.com** makes sure you have all the tools you need to fine-tune your skills. Images featured in the book are provided online so you can try out each technique as you read – the quickest way to learn.

Philip Andrews is a photographer, author and lecturer at the Queensland School of Printing and Graphic Arts, Australia.

'... this is an easy to follow and highly informative digital imaging handbook specifically designed for users of Adobe's latest photo editing software, Photoshop Elements. Andrews' style suits entry level users as it is beautifully and well-illustrated with quality photography and non-threatening text.'
*Better Digital*

'Philip Andrews is a skilled and enthusiastic teacher, his book is clearly illustrated throughout and is refreshingly direct and easy to understand.'
*Martin Evening*

December 2002 • 288pp • 246 x 189mm • full colour throughout • paperback
ISBN 0 240 51918 3

*To order your copy call +44 (0)1865 888180 (UK) or +1 800 366 2665 (USA)*
*or visit the Focal Press website: www.focalpress.com*

# Also available from Focal Press ...

## Photographic Lighting: Essential Skills
Second Edition
*John Child and Mark Galer*

This book covers all the information that is essential for photographers to understand when working with light. New for this second edition is the 'Sensitivity and Image Capture' chapter which includes the latest on digital image sensors as well as film emulsions to help you choose the right medium for your work. Through a series of practical exercises, the student photographer is shown how to overcome the limitations of equipment and capture mediums, to achieve creative and professional results. With theory kept to a minimum, this book shows how to tackle difficult lighting conditions and manipulate light for mood and atmosphere using basic and advanced metering techniques.

For captured and created imagery, TTL and hand-held metering techniques are also demonstrated. Controlling introduced lighting and ambient light together with advanced metering techniques and lighting ratios are covered. Illustrated throughout with author and student work, including a new 8-page colour plate section, this is an inspirational guide as well as a highly structured learning tool.

- Save time, with one easy volume learn how to make your photographic lighting work for you
- Put your skills into practice with innovative practical activities
- Use the inspirational images as a guide to what you can achieve

'This book is fantastic! ...The terminology is easy to understand and techniques are explained in a no nonsense format. Excellent for beginners to intermediate photographers. I have had this book for a few months now and through practicing and completing the revision exercises, I have a better understanding of the techniques used for photograhic lighting situations - location and studio.'
*Amazon.com reader review of Photographic Lighting*

January 2002 • 160pp • 246 x 189mm • 100 photographs • paperback
ISBN 0 240 51670 2

*To order your copy call +44 (0)1865 888180 (UK) or +1 800 366 2665 (USA)
or visit the Focal Press website: www.focalpress.com*

# Also available from Focal Press ...

## Studio Photography: Essential Skills
Second Edition
*John Child*

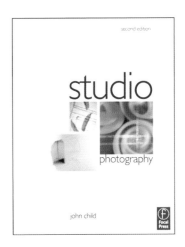

John Child has updated and improved his inspirational studio photography guide to further stimulate your creative ideas. Fully illustrated with brand new student and author work, a colour section is now also included to show the photographic effects to their full advantage.

You are guided through the use of studio equipment for a wide variety of different purposes. With a strong commercial orientation, the emphasis is highly practical and focuses on technique, communication and design within the genres of still life, advertising illustration, portraiture and fashion.

This successful guide is an essential tool for those working with small, medium and large format cameras in a controlled environment where the image output is to film or digital file. You are encouraged to experiment whether you have expensive equipment, or are using natural light sources; either way you will see how it is possible to achieve acceptable results and develop your skills.

- Benefit from the successful, highly structured learning approach to ensure you understand the fundamental skills
- Reinforce your skills with a wide variety of practical activities
- Learn all the essential principles of studio photography

'The book gradually introduces the reader to increasingly sophisticated arrangements, with each chapter adding a new layer of technical skill... this is a very useful and practical book.'
*Amateur Photographer Magazine*

'... students of photography should find the well-laid-out theoretical information, practical advice, revision exercises and detailed assignments a useful resource to guide them through their course. The structured format means you can dip into any chapter for a quick re-cap ...'
*Professional Printer*

October 2001 • 200pp • 246 x 189mm • 100 photographs • paperback
ISBN 0 240 51668 0

*To order your copy call +44 (0)1865 888180 (UK) or +1 800 366 2665 (USA)*
*or visit the Focal Press website: www.focalpress.com*

# Focal Press

**www.focalpress.com**
Join Focal Press on-line
As a member you will enjoy the following benefits:

- an email bulletin with **information on new books**

- a regular **Focal Press Newsletter**:
  - featuring a selection of new titles
  - keeps you informed of **special offers, discounts and freebies**
  - alerts you to **Focal Press news and events** such as author signings and seminars

- complete access to **free content** and reference material on the focalpress site, such as the focalXtra articles and commentary from our authors

- a **Sneak Preview** of selected titles (sample chapters) *before* they publish

- a chance to have your say on our **discussion boards** and **review books** for other Focal readers

Focal Club Members are invited to give us feedback on our products and services.
Email: worldmarketing@focalpress.com – we want to hear your views!

Membership is **FREE**. To join, visit our website and register. If you require any further information regarding the on-line club please contact:

Lucy Lomas-Walker
Email: l.lomas@elsevier.com
Tel: +44 (0) 1865 314438
Fax: +44 (0)1865 314572
Address: Focal Press, Linacre House,
Jordan Hill, Oxford, UK, OX2 8DP

## Catalogue
For information on all Focal Press titles, our full catalogue is available online at www.focalpress.com and all titles can be purchased here via secure online ordering, or contact us for a free printed version:

**USA**
Email: christine.degon@bhusa.com
Tel: +1 781 904 2607 T

**Europe and rest of world**
Email: j.blackford@elsevier.com
el: +44 (0)1865 314220

## Potential authors
If you have an idea for a book, please get in touch:

**USA**
editors@focalpress.com

**Europe and rest of world**
focal.press@repp.co.uk